SHOPPING BAG
D E S I G N

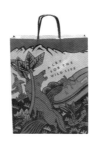

ROCKPORT PUBLISHERS

ROCKPORT PUBLISHERS, INC. • ROCKPORT, MASSACHUSETTS

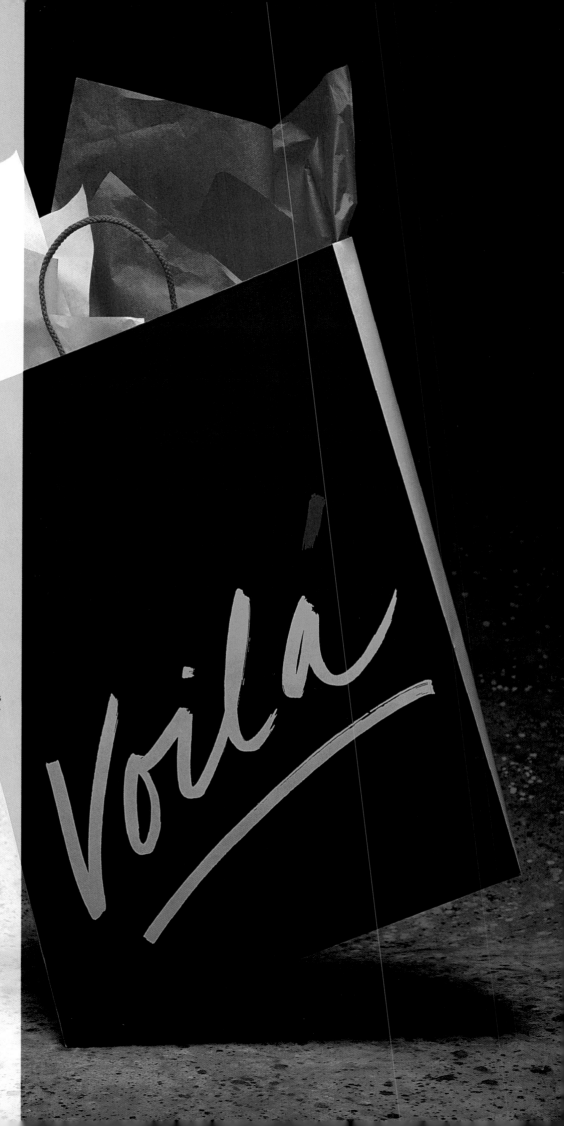

Design/Layout
Sara Day
Eilis McDonald

Editor
Rosalie Grattaroti

Production Manager
Barbara States

First published in the United States of
America by:
Rockport Publisher, Inc.
146 Granite Street
Rockport, Massachusetts 01966
Telephone: (508) 546-9590
Fax: (508) 546-7141
Telex: 5106019284 ROCKORT PUB

Distributed by North Light, and imprint of
F & W Publications
1507 Dana Avenue
Cincinnati, Ohio 45207
Telephone: (513) 531-2222

Other Distribution by:
Rockport Publishers, Inc.
Rockport, Massachusetts 01966

ISBN 1-56496-077-3

10 9 8 7 6 5 4 3 2 1

Printed in Singapore

PREFACE

This has been a truly extraordinary period in the development of our industry. Up until about ten years ago, custom printed shopping bags available from U.S. manufacturers came only in standard sizes with twisted paper handles –and they had to be ordered in very large quantities.

If you wanted something different, or special, you had to go overseas to get it produced. It usually took over three months to get your bags, and often there were some very interesting surprises, even disasters, when the shipment arrived. In 1985, we saw an opportunity to offer custom manufacturing with a four-week delivery time to the American market, and started Pacobond, Inc. in Los Angeles. It has been non-stop ever since, and we've worked with the most creative and exciting companies from all over the United States.

We have seen that the availability of custom manufacturing services which we provide, has precipitated a tremendous explosion of ingenious ideas for design and promotional use of the shopping bag.

Clients can now order bags in every conceivable size and shape, using all kinds of special materials for both the handles and the bag itself. Bags can have multi-color printing on a vast variety of stocks, with embossing, foil stamping, laser die cutting, special coatings and laminating, both on the outside and the inside of the bag. We get calls from clients every day to discuss their innovative ideas. I look forward with great anticipation to the exciting growth that lies ahead for us all.

—Gerard Seradarian

Vice President
Pacobond, Inc.
Sun Valley
California

INTRODUCTION

One of the most important accessories today is the very familiar *shopping bag*, now in common use throughout many countries of the world. Created to carry all sorts of items, large and small, the *"bag"* has also become a status symbol for many carriers, and one of the least costly forms of advertising for any organization that is giving away a bag.

Usually made of paper, the shopping bags of today are laminated, embossed, hot stamped, and even laser cut. They are shaped as squares, rectangles, triangles, and hexagons. There appears to be no limit to the application of creative formats.

The bag has come a long way from its antecedent, a band box, or a hat box. These boxes were carried extensively in the 19th and early 20th centuries. This mode of carrier was used for a variety of small items by many levels of society. Most of these boxes were made of cardboard, covered in wallpapers, fabrics, and other materials that fueled a very large cottage industry.

The first inexpensive machine-made paper bag appeared in 1933. Prior to that time, the paper carrier bag had handles that were stapled to cardboard and glued into the bag. Today, shopping bags are made of kraft papers, art papers, fine papers, and hand-made papers from India, Japan, Thailand, and other countries. Other convertible materials are also used. Currently, shopping bags are printed on web presses using flexography, as well as sheet fed presses using gravure and offset printing.

Practically every industry uses a shopping bag: advertising, retail stores, museums, libraries, and conventions, to name just a few. Gift-type shops carry beautifully printed shopping bags, many with museum-grade art, as well as bags celebrating birthdays, anniversaries, and many other special occasions.

Many gift bags have also become the gift wrap of today. These bags simplify gift giving and enhance aesthetic values. As technology makes further advances, we will continue to see exciting developments, as there is no limit to creative bag design, graphics, and new concepts that will serve the ever increasing usage of shopping bags throughout the world.

—Joyce Mintzer

Ms. Mintzer is Executive Vice President of S. Posner Sons Inc., a creative packaging company founded in 1889 by her grandfather.

1

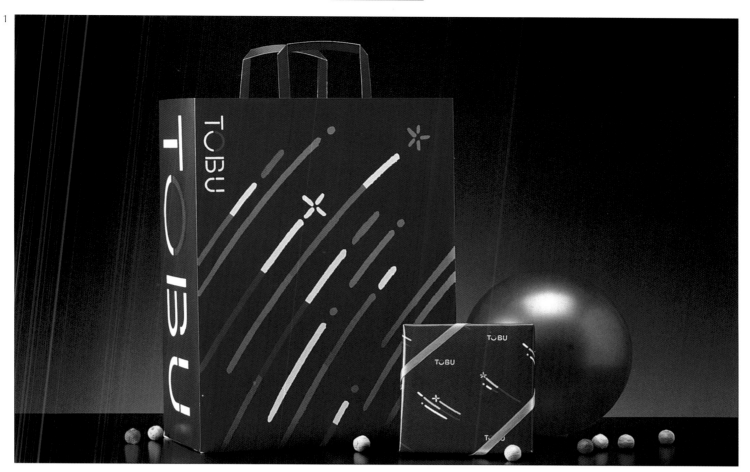

2

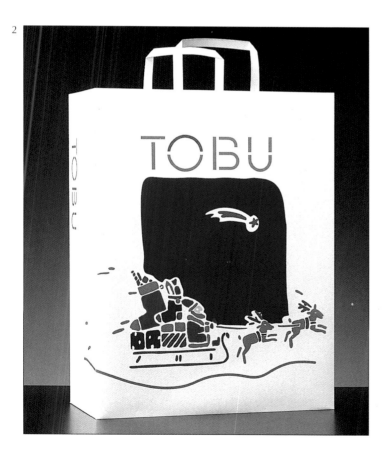

3

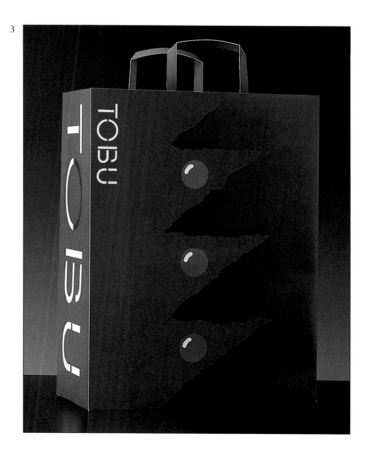

1
Design Firm Carre Noir
Designer Piotr Bojanoski
Client/Store Tobu (Japan)
Number of Colors 4

2
Design Firm Carre Noir
Designer Piotr Bojanoski
Client/Store Tobu (Japan)
Number of Colors 4

3
Design Firm Carre Noir
Designer Piotr Bojanoski
Client/Store Tobu (Japan)
Number of Colors 4

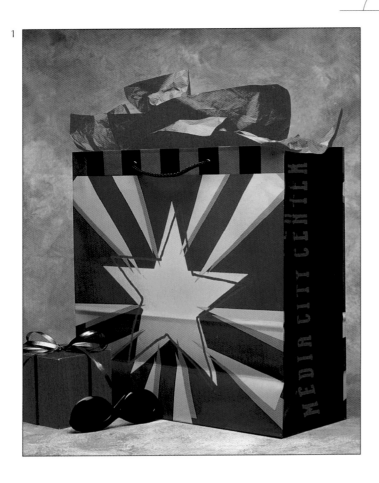

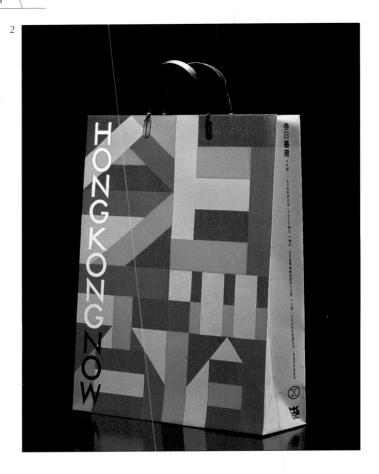

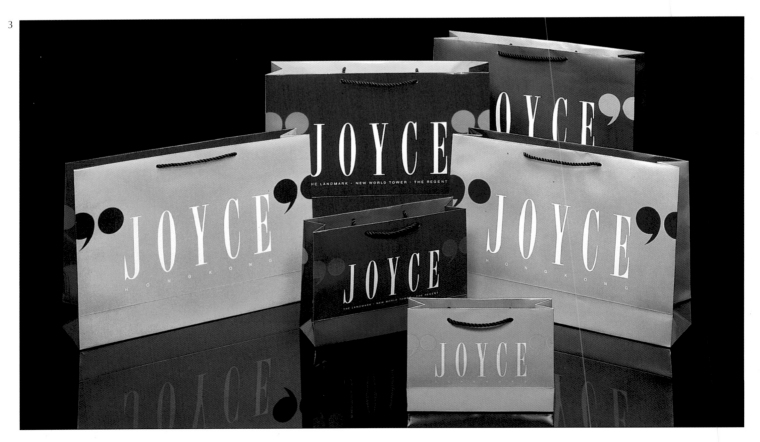

1
Design Firm Morla Design
Art Director Jennifer Morla
Designer Jennifer Morla/Sharrie Brooks
Client/Store Media City Center
Number of Colors 7

2
Design Firm Alan Chan Design Company
Art Director Alan Chan
Designer Alan Chan
Client/Store Sogo Department Store (Taiwan)
Number of Colors 4

3
Design Firm Alan Chan Design Company
Art Director Alan Chan
Designer Alan Chan
Illustrator/Artist Alan Chan/Phillip Leung
Client/Store Joyce Boutique Ltd.
Number of Colors 4

1
Design Firm Alan Chan Design Company
Art Director Alan Chan
Designer Alan Chan/Phillip Leung
Illustrator/Artist Gary Cheung

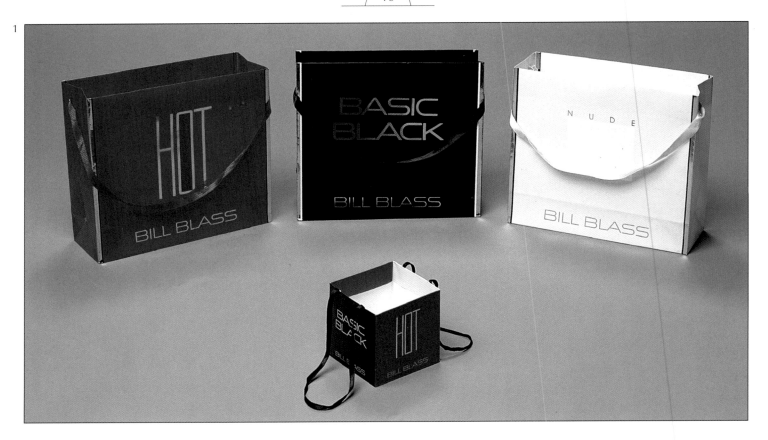

1

2

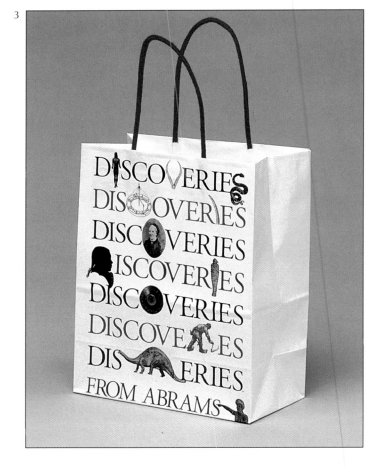

3

1
Design Firm S. Posner Sons, Inc.
Client/Store Revlon
Number of Colors Nude–3 color, hot stamp;
Red and Black–2 color, hot stamp

2
Design Firm Goldstein Gallery & Collections
Art Director Suzanne Baizerman
Designer Greg Wright/Krueger Wright Design
Illustrator/Artist Kendra Dukich
Client/Store Goldstein Gallery Exhibition
Number of Colors 2

3
Design Firm Harry N. Abrams, Inc.
Art Director Ray Hooper
Designer Ray Hooper
Client/Store "Discoveries" Series
Number of Colors 4

1

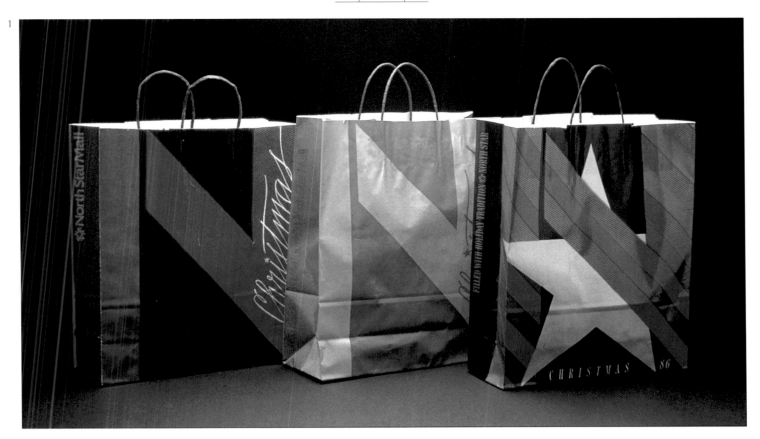

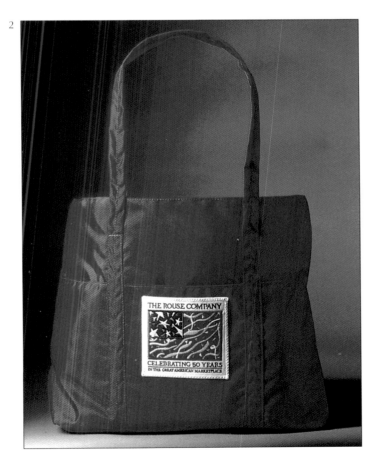

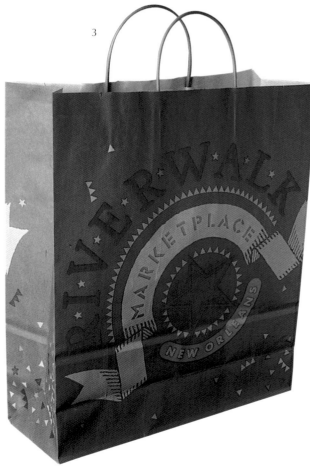

1
Design Firm SullivanPerkins
Art Director Ron Sullivan
Designer Linda Helton/Ron Sullivan
Illustrator/Artist Linda Helton/Ron Sullivan
Client/Store The Rouse Company
Number of Colors 4

2
Design Firm SullivanPerkins
Art Director Ron Sullivan
Designer Clark Richardson
Illustrator/Artist Clark Richardson
Client/Store The Rouse Company
Number of Colors 4

3
Design Firm SullivanPerkins
Art Director Ron Sullivan
Designer Art Garcia
Illustrator/Artist Art Garcia
Client/Store The Rouse Company
Number of Colors 6

1
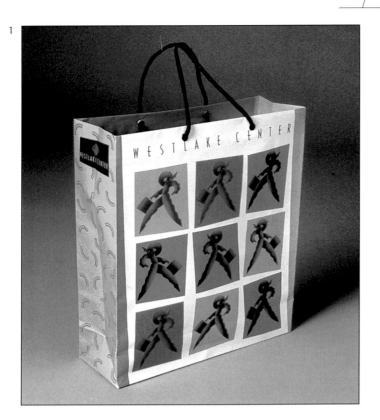

2
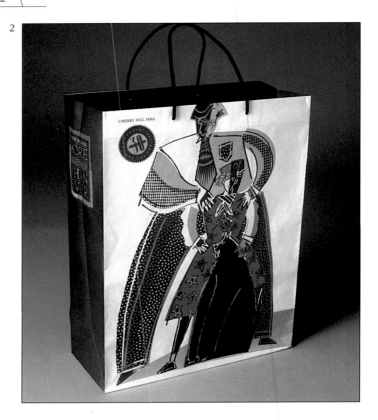

3
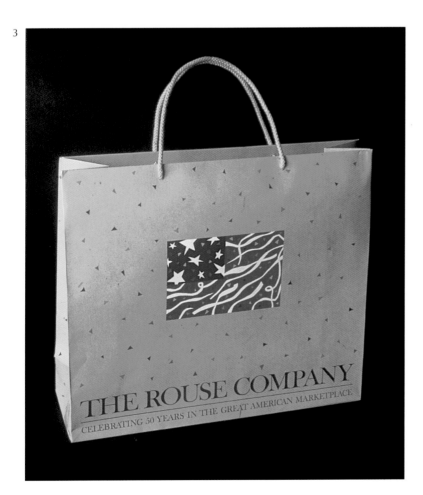

1
Design Firm SullivanPerkins
Art Director Ron Sullivan
Designer Jon Flaming
Illustrator/Artist Jon Flaming
Client/Store The Rouse Company
Number of Colors 4

2
Design Firm SullivanPerkins
Art Director Ron Sullivan
Designer Jon Flaming
Illustrator/Artist Jon Flaming
Client/Store The Rouse Company
Number of Colors 4

3
Design Firm SullivanPerkins
Art Director Ron Sullivan
Designer Clark Richardson
Illustrator/Artist Clark Richardson
Client/Store The Rouse Company
Number of Colors 6

1

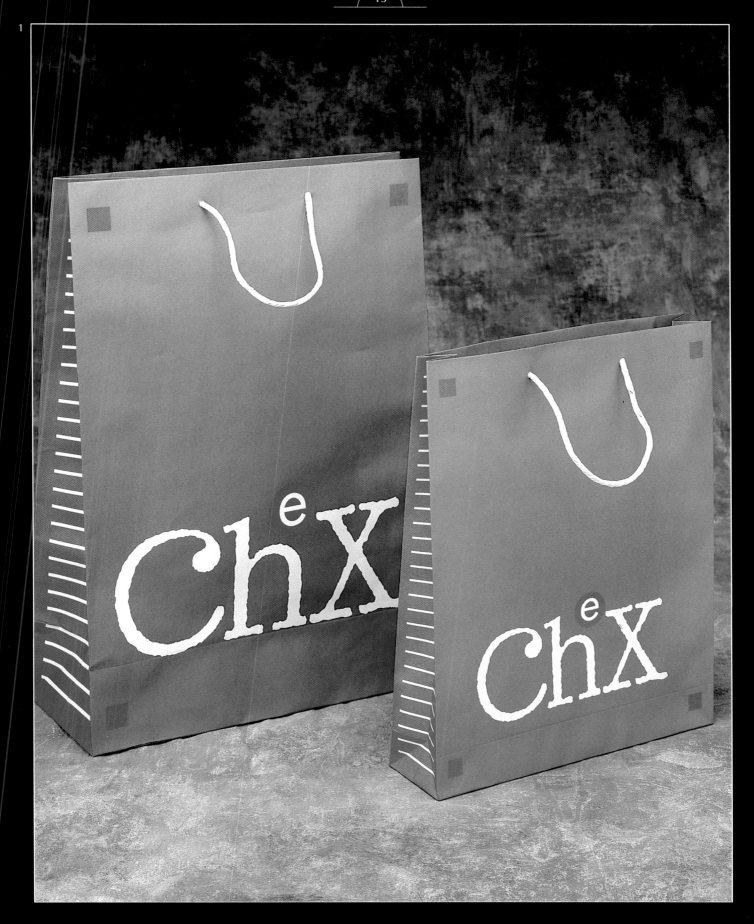

1
Design Firm Kan Tai-keung Design & Associates Ltd.
Art Director Freeman Lau Siu Hong
Designer Freeman Lau Siu Hong
Client/Store Chex International Sales Ltd.

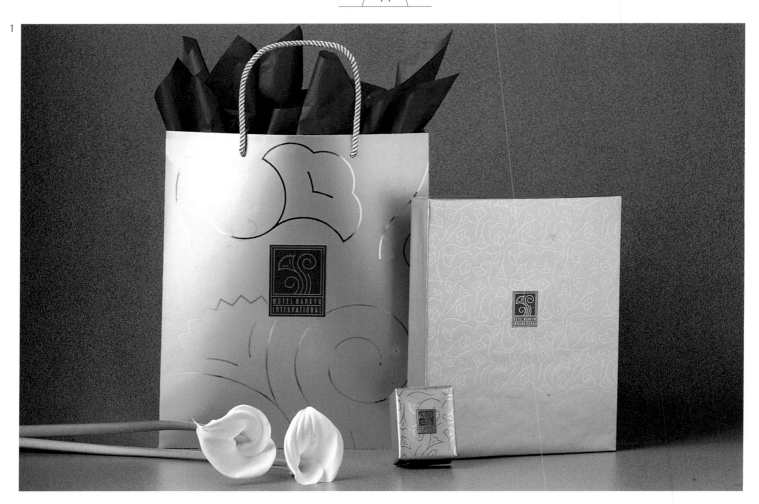

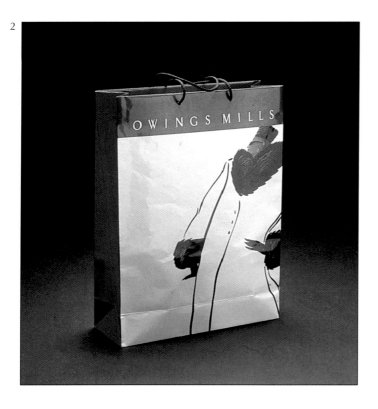

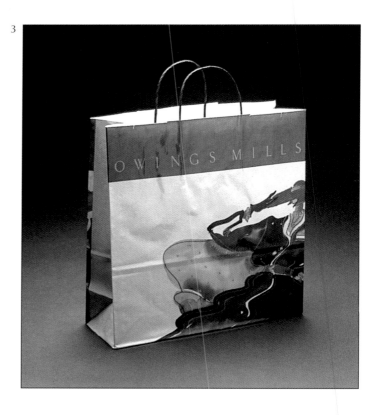

1
Design Firm Pentagram Design
Art Director Colin Forbes/Michael Gericke
Designer Michael Gericke/Donna Ching
Illustrator/Artist McRay Magleby
Client/Store Hotel Hankyu International
Number of Colors 4

2
Design Firm SullivanPerkins
Art Director Ron Sullivan
Designer Jon Flaming
Illustrator/Artist Jon Flaming
Client/Store The Rouse Company
Number of Colors 4

3
Design Firm SullivanPerkins
Art Director Ron Sullivan
Designer Jon Flaming
Illustrator/Artist Jon Flaming
Client/Store The Rouse Company
Number of Colors 4

1

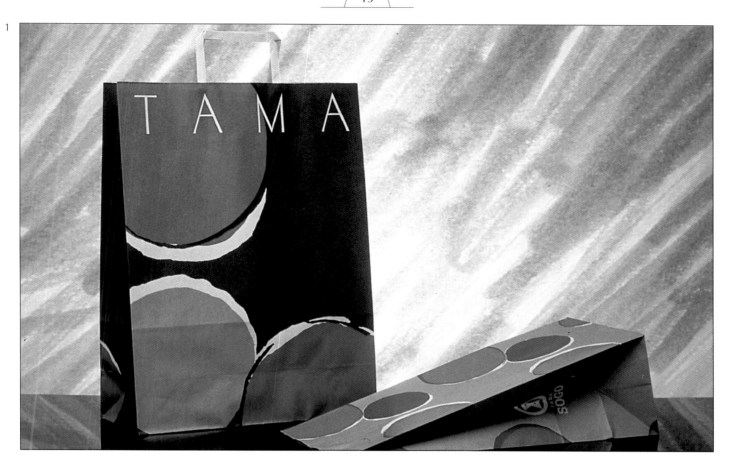

2

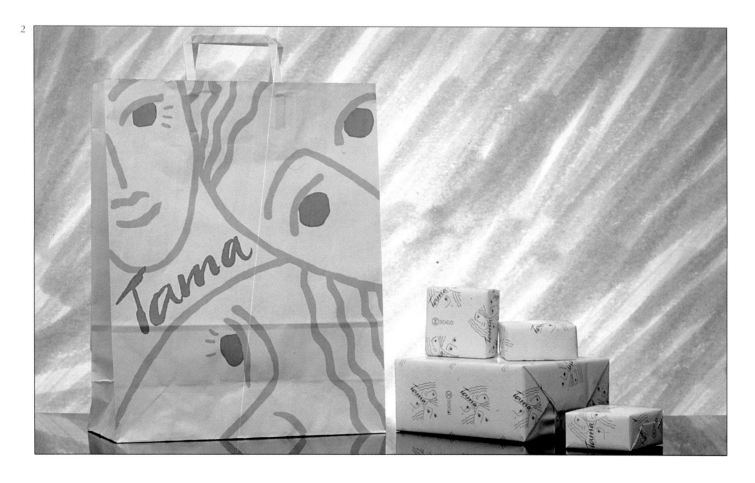

1
Design Firm Carre Noir
Illustrator/Artist Mrs. Béatrice Mariotti
Client/Store Tama Sogo (Japan)
Number of Colors 2

2
Design Firm Carre Noir
Illustrator/Artist Mrs. Béatrice Mariotti
Client/Store Tama Sogo (Japan)
Number of Colors 2

1

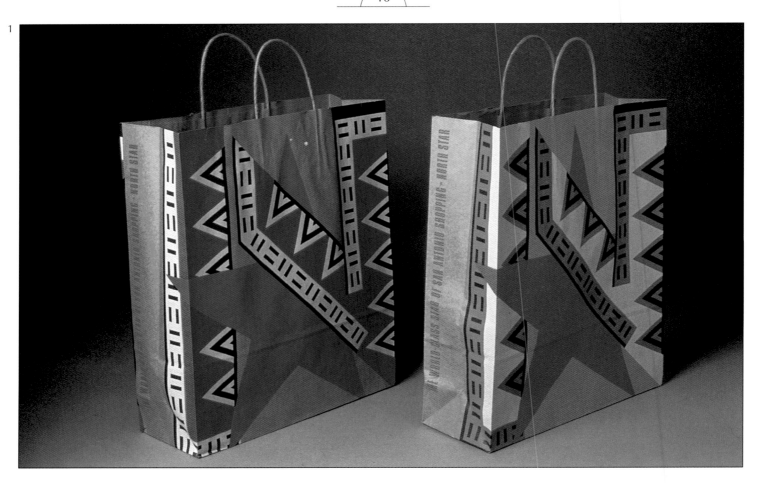

2

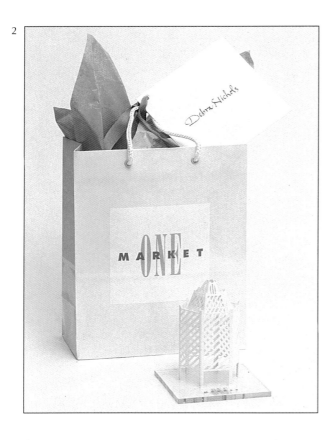

3

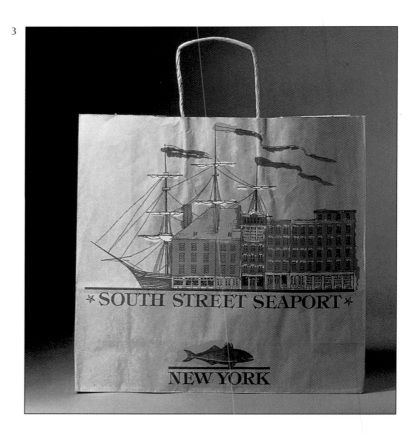

1
Design Firm SullivanPerkins
Art Director Ron Sullivan
Designer Clark Richardson/Linda Helton
Illustrator/Artist Clark Richardson/Linda Helton
Client/Store The Rouse Company
Number of Colors 4

2
Design Firm Debra Nichols Design
Art Director Debra Nichols
Designer Debra Nichols/Roxanne Malek
Client/Store One Market Association
 CB Commercial Real Estate
Number of Colors 6

3
Design Firm SullivanPerkins
Art Director Ron Sullivan
Designer Ron Sullivan
Illustrator/Artist Ron Sullivan
Client/Store The Rouse Company
Number of Colors 4

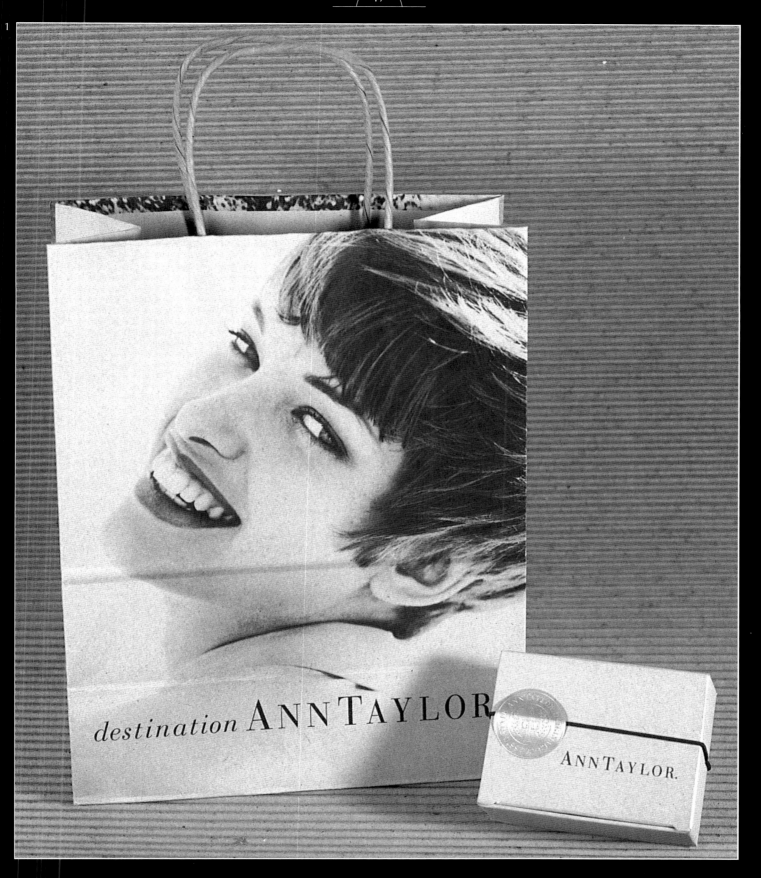

1
Design Firm Cato Gobé
Art Director Marc Gobé
Designer Peter Lavine
Client/Store Ann Taylor

1

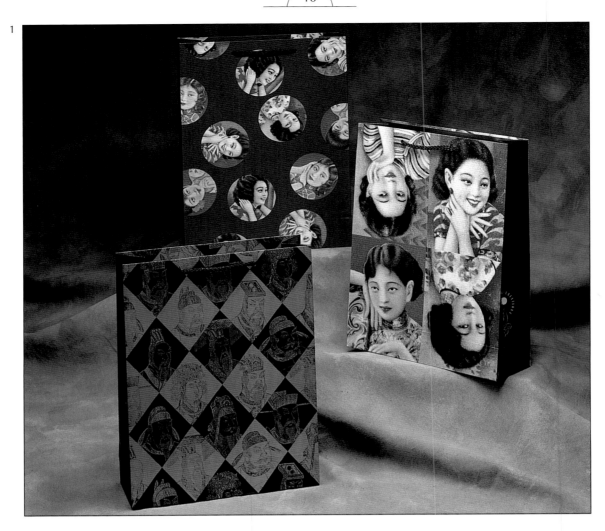

2

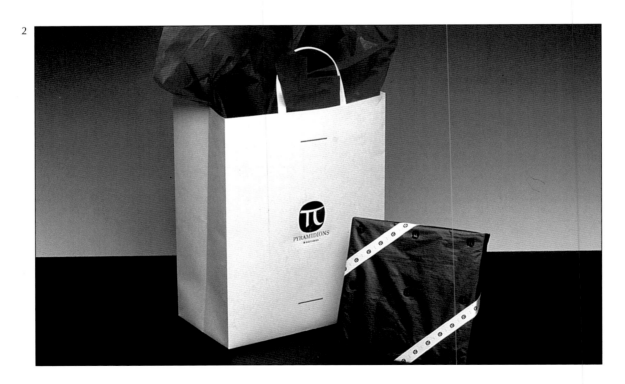

1
Design Firm Alan Chan Design Company
Art Director Alan Chan
Designer Alan Chan/Cetric Leung/
 Gary Cheung/Chen Shun Tsoi/Peter Lo
Client/Store Alan Chan Creations Ltd.
Number of Colors 2 and 4

2
Design Firm Carre Noir
Illustrator/Artist Benoit Higel
Client/Store Les Pyramidions
Number of Colors 2

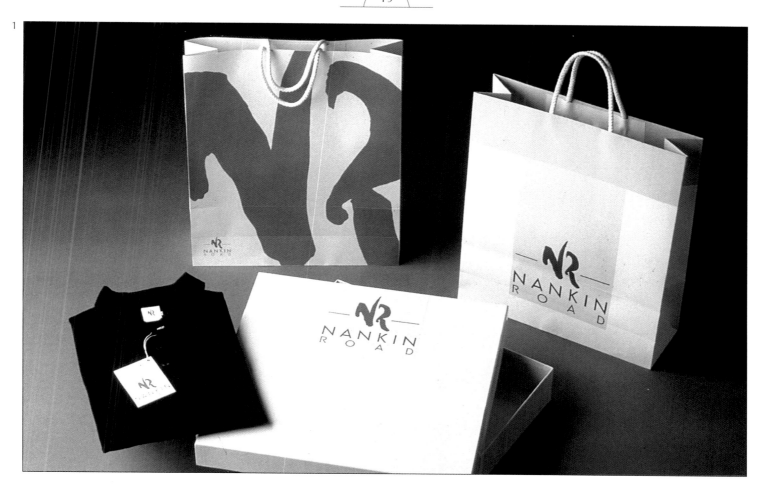

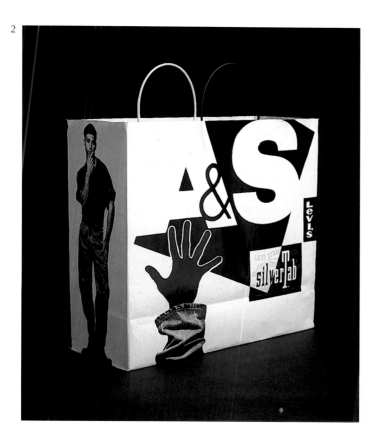

1
Design Firm Carre Noir
Illustrator/Artist Jean-Michel Rotach
Client/Store Nankin Road (Republic of China)
Number of Colors 2

2
Design Firm Abraham & Strauss
Art Director Paul Horscroft
Designer Paul Horscroft
Client/Store A&S Levi's Bag
Number of Colors Black and White

3
Design Firm Alan Chan Design Company
Art Director Alan Chan
Designer Alan Chan/Phillip Leung
Client/Store Le Salon Orient
Number of Colors 2

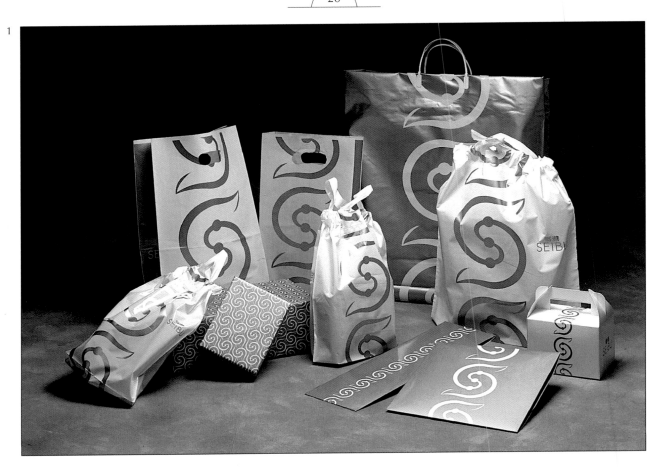

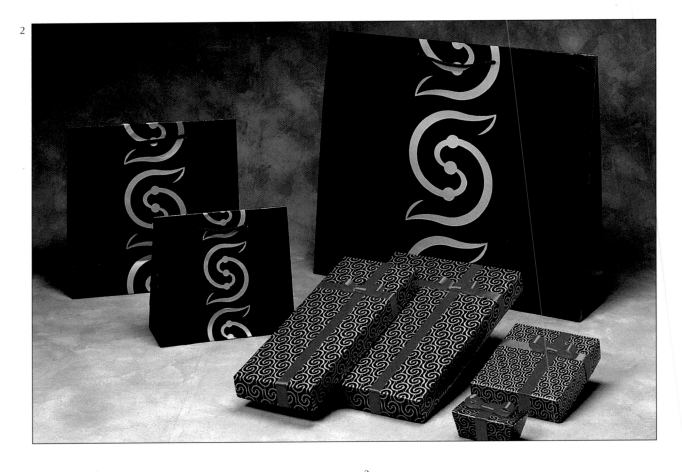

1
Design Firm Alan Chan Design Company
Art Director Alan Chan
Designer Alan Chan/Phillip Leung
Client/Store Hong Kong Seibu Enterprise Co., Ltd.
Number of Colors 2

2
Design Firm Alan Chan Design Company
Art Director Alan Chan
Designer Alan Chan/Phillip Leung
Client/Store Hong Kong Seibu Enterprise Co., Ltd.
Number of Colors 2

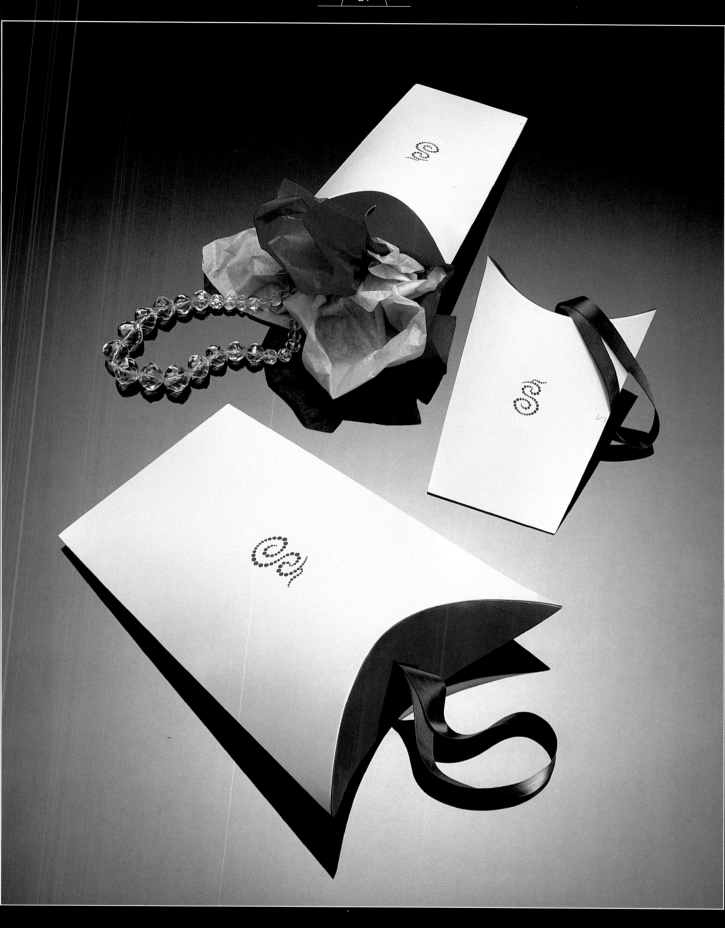

1

Design Firm Alan Chan Design Company
Art Director Alan Chan
Designer Alan Chan/Phillip Leung
Client/Store Le Salon Orient
Number of Colors 2

1

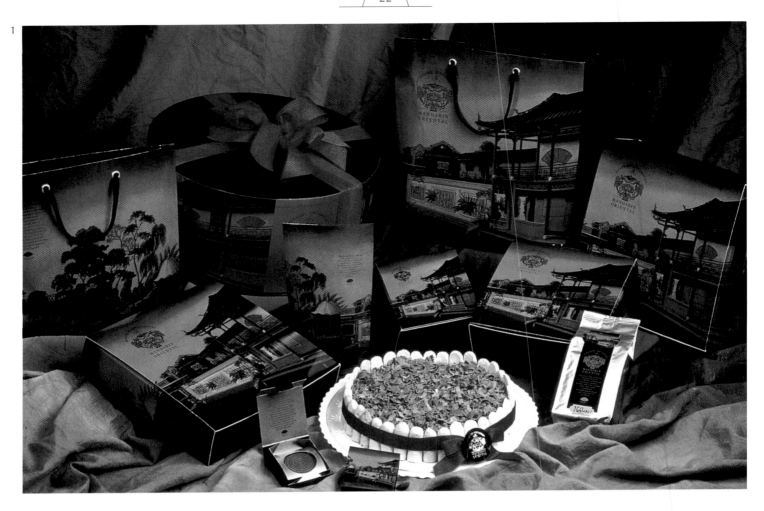

2

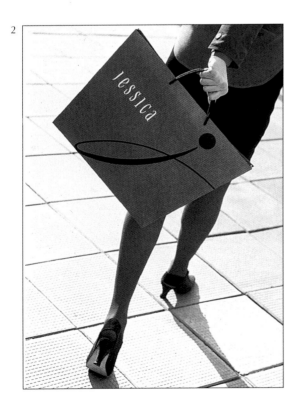

3

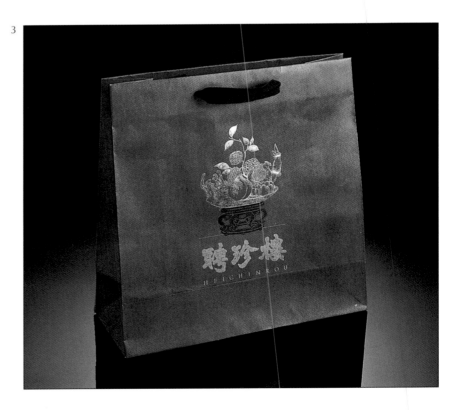

1
Design Firm Alan Chan Design Company
Art Director Alan Chan
Designer Alan Chan/Phillip Leung
Client/Store Mandarin Oriental Hong Kong
 Cake Shop
Number of Colors 5

2
Design Firm Alan Chan Design Company
Art Director Alan Chan
Designer Alan Chan/Phillip Leung
Client/Store Jessica Boutique
Number of Colors 2

3
Design Firm Alan Chan Design Company
Art Director Alan Chan
Designer Alan Chan/Alvin Chan
Client/Store Heichink Restaurant
Number of Colors 4

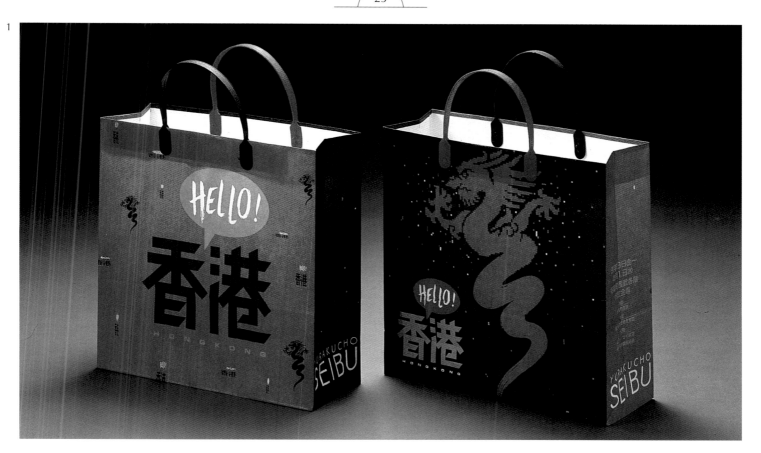

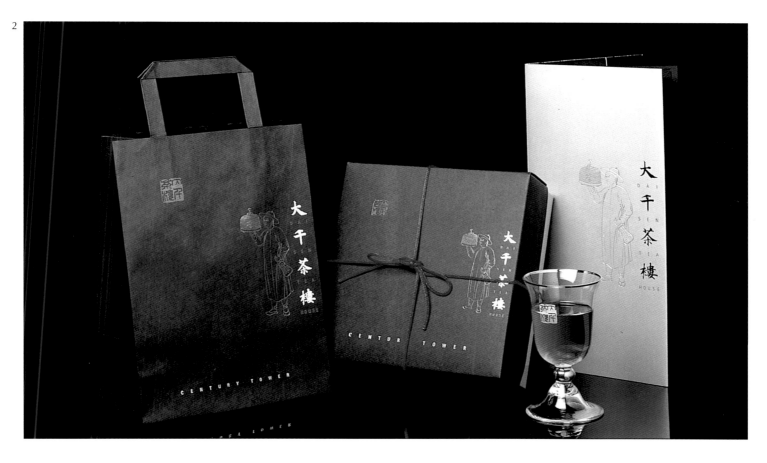

1
Design Firm Alan Chan Design Company
Art Director Alan Chan
Designer Alan Chan/Alvin Chan/Phillip Leung
Client/Store Yurakucho Seibu c/o Hong Kong
 Trade Development Council
Number of Colors 5

2
Design Firm Alan Chan Design Company
Art Director Alan Chan
Designer Alan Chan/Phillip Leung
Client/Store Dai Sen Tea House
Number of Colors 2

1

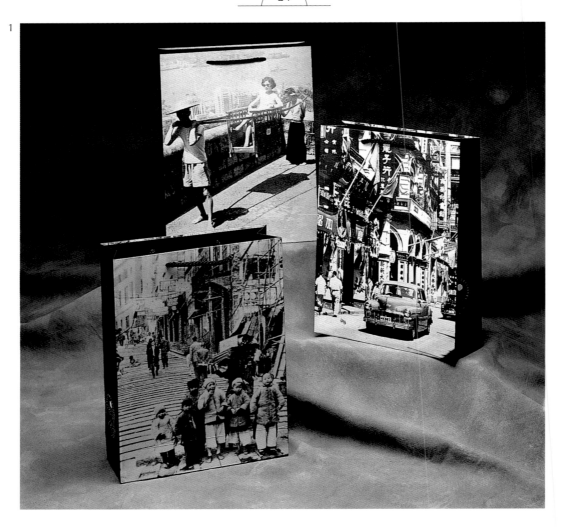

2

1
Design Firm Alan Chan Design Company
Art Director Alan Chan
Designer Alan Chan/Cetric Leung/Gary Cheung/
 Chen Shun Tsoi/Peter Lo
Client/Store Alan Chan Creations, Ltd.
Number of Colors 2 and 4

2
Design Firm Alan Chan Design Company
Art Director Alan Chan
Designer Alan Chan/Cetric Leung/Gary Cheung/
 Chen Shun Tsoi/Peter Lo
Client/Store Alan Chan Creations, Ltd.
Number of Colors 2 and 4

1

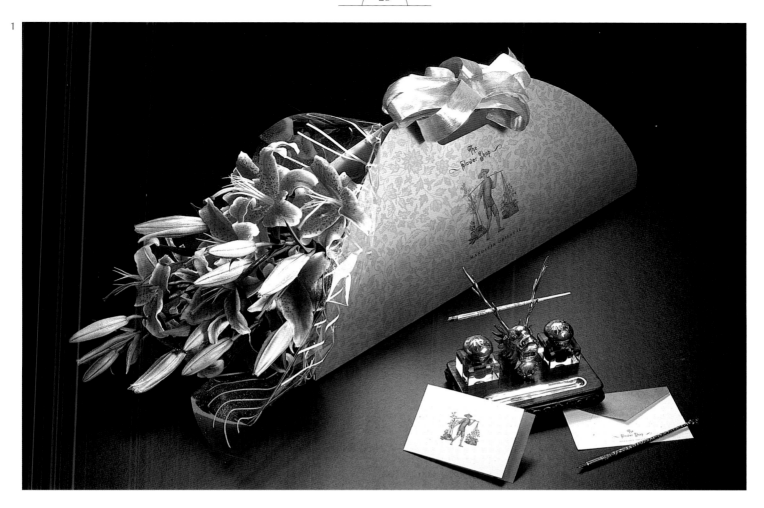

2

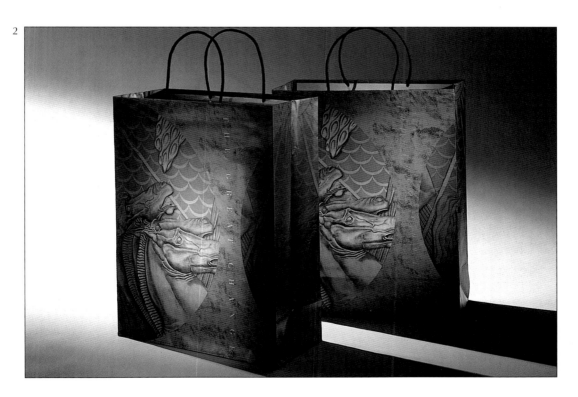

1
Design Firm Alan Chan Design Company
Art Director Alan Chan
Designer Alan Chan/Chen Shun Tsoi
Illustrator/Artist Alan Cracknel
Client/Store The Flower Shop, Mandarin
 Oriental HK
Number of Colors 5

2
Design Firm Dayton's, Hudson's, Marshall
 Field's In-House
Art Director Bill Thorburn
Designer Bill Thorburn
Client/Store Dayton's
Number of Colors 5

Commemorates the opening of a brand new
store. Artwork is from the ceiling of one section
of the store.

1

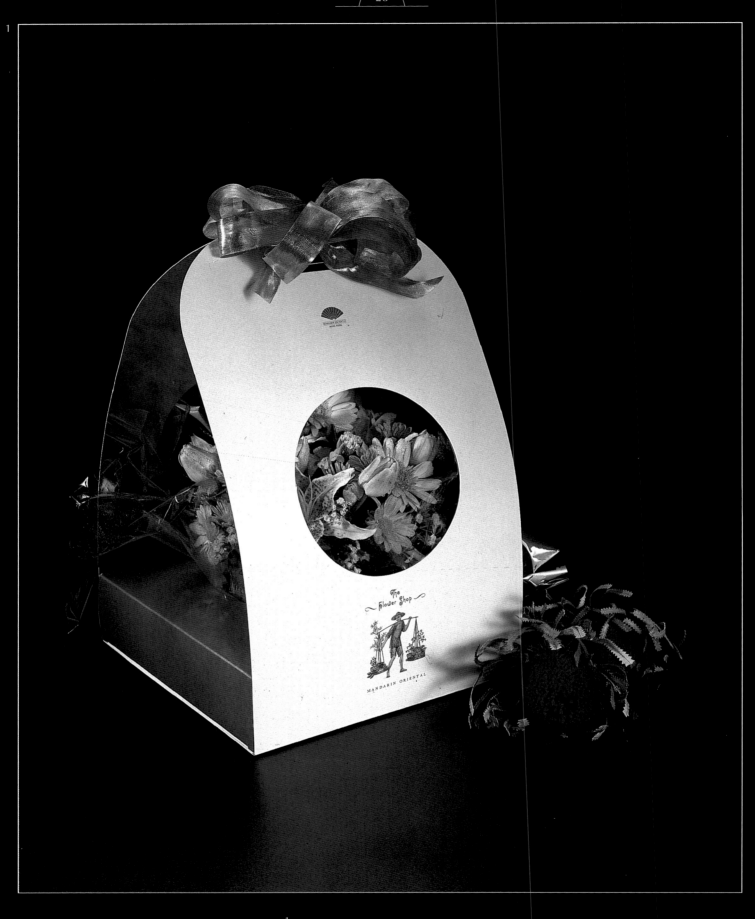

1
Design Firm Alan Chan Design Company
Art Director Alan Chan
Designer Alan Chan/Chen Shun Tsoi
Illustrator/Artist Alan Cracknel
Client/Store The Flower Shop, Mandarin
Oriental HK
Number of Colors 5

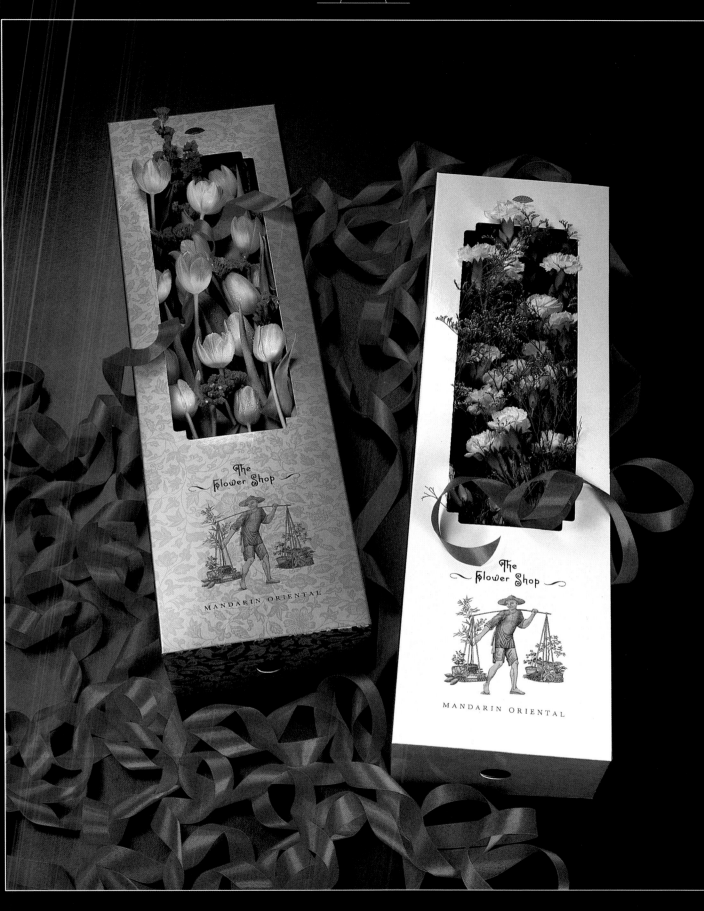

1
Design Firm Alan Chan Design Company
Art Director Alan Chan
Designer Alan Chan/Chen Shun Tsoi
Illustrator/Artist Alan Cracknel
Client/Store The Flower Shop, Mandarin
Oriental HK
Number of Colors 5

1

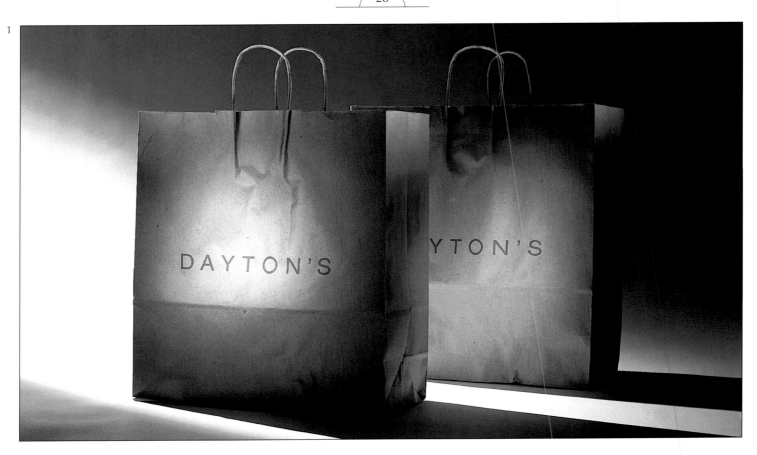

2

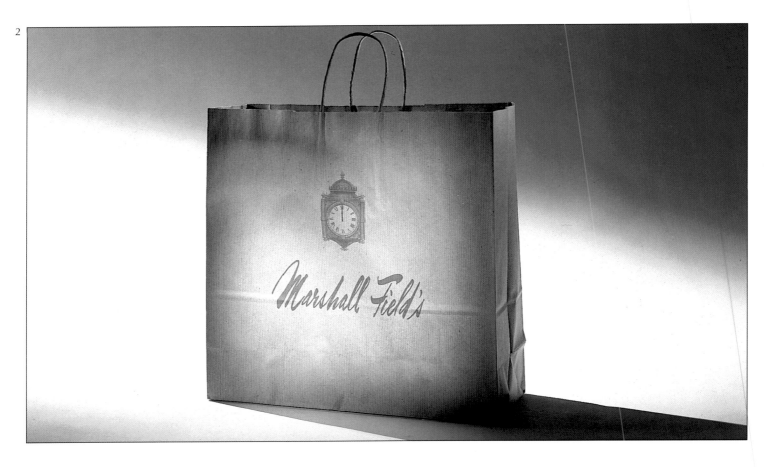

1, 2
Design Firm Dayton's, Hudson's, Marshall Field's
 In-House
Art Director Connie Soteropulos
Designer Connie Soteropulos/Matt Eller
Client/Store Dayton's, Hudson's, Marshall Field's
Number of Colors 1

These are part of our permanent shopping bag and packaging system. They are printed with water-based inks on recycled paper composed of at least 60% post-consumer waste.

1

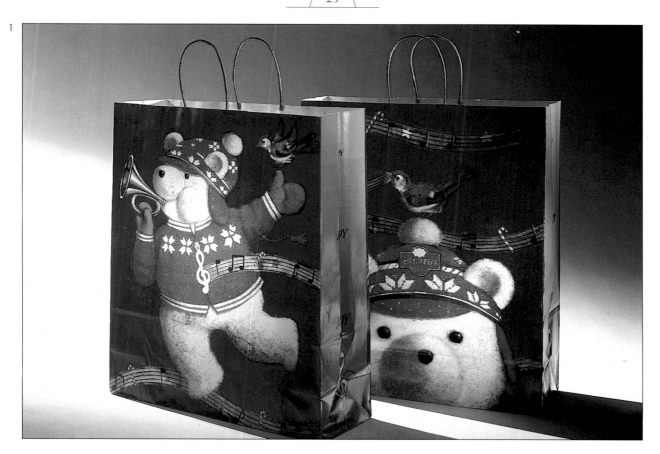

2

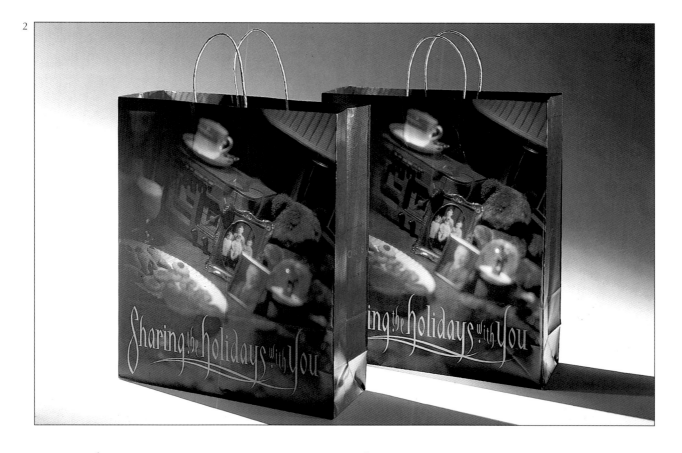

1
Design Firm Dayton's, Hudson's, Marshall Field's
In-House
Art Director Cheryl Watson
Designer Cheryl Watson
Illustrator/Artist Mike Reed
Client/Store Dayton's, Hudson's, Marshall Field's
Number of Colors 5

2
Design Firm Dayton's, Hudson's, Marshall Field's
In-House
Art Director Cheryl Watson
Designer Cheryl Watson
Client/Store Dayton's, Hudson's, Marshall Field's
Number of Colors 5

1

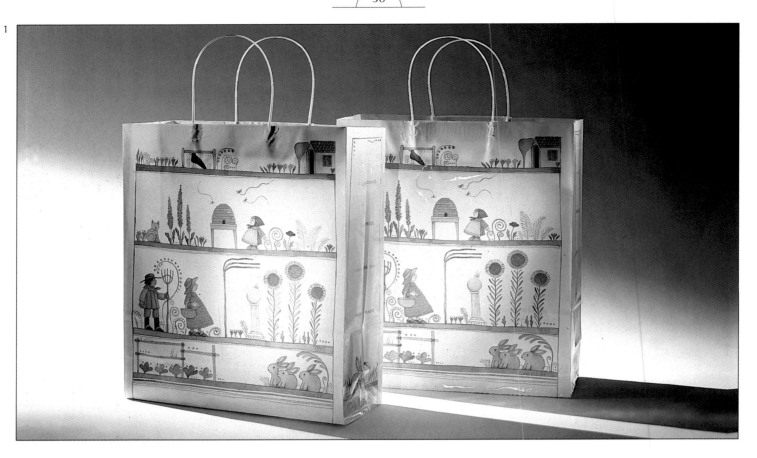

2

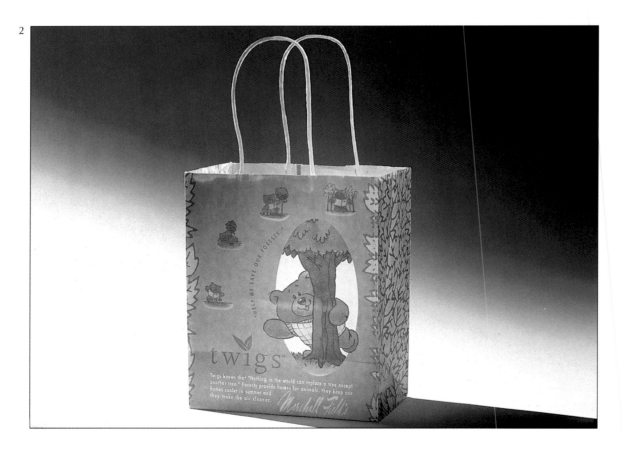

1

Design Firm Dayton's, Hudson's, Marshall Field's In-House
Art Director Connie Soteropulos
Designer Connie Soteropulos
Illustrator/2Artist Tomie dePaola
Client/Store Dayton's, Hudson's
Number of Colors 4

Children's author and illustrator Tomie dePaola illustrated this bag to promote the spring flower show at Dayton's flagship store.

2

Design Firm Dayton's, Hudson's, Marshall Field's In-House
Art Director Kent Hensley
Client/Store Dayton's, Hudson's, Marshall Field's
Number of Colors 4

This bag is given away in our restaurants for children's meals accompanied by an activity book and matching placemat.

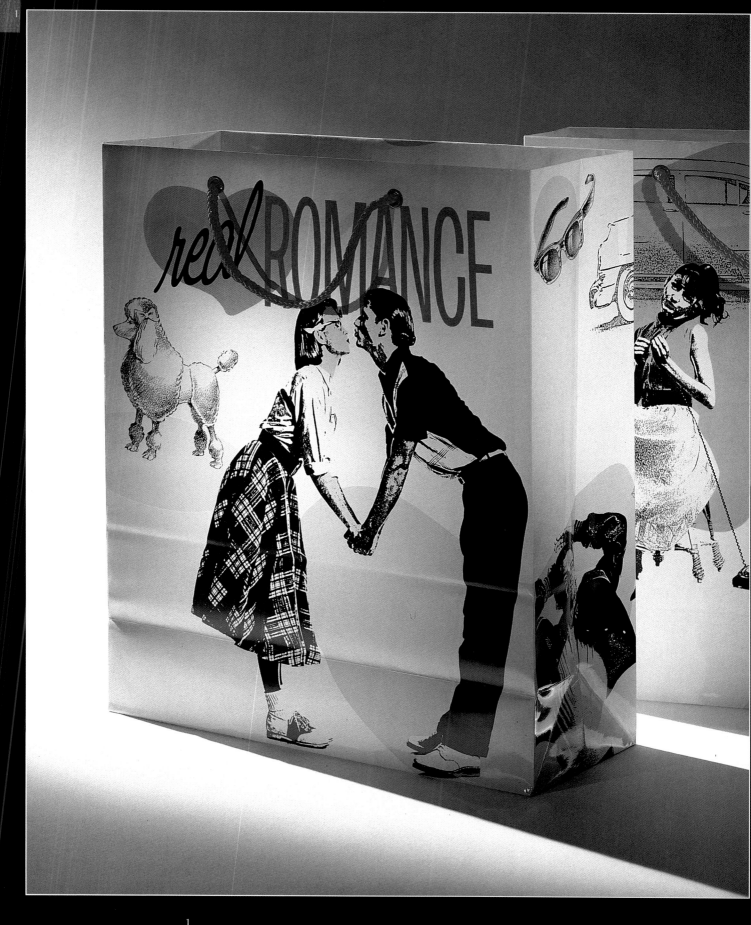

1

Design Firm Dayton's, Hudson's,
 Marshall Field's In-House
Art Director Kent Hensley
Designer Linda Senechal
Client/Store Dayton's, Hudson's
Number of Colors 6

This bag was for sale as "gift wrap" and
also promoted our Valentine's Day
promotional theme.

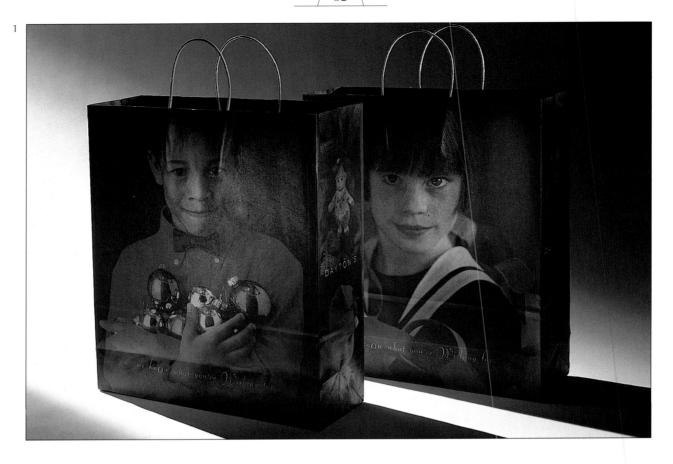

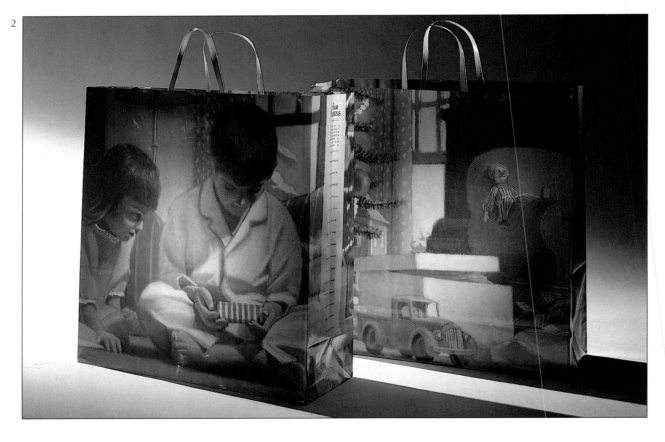

1
Design Firm Dayton's, Hudson's, Marshall Field's
 In-House
Art Director Amy Quinlivan
Designer Amy Quinlivan
Photographer Calliope/Tom Berthaiume
Client/Store Dayton's, Hudson's, Marshall Field's
Number of Colors 4

2
Design Firm Dayton's, Hudson's, Marshall Field's
 In-House
Art Director Connie Soteropulos
Designer Connie Soteropulos
Illustrator/Artist Christopher vanAllsburg
Client/Store Dayton's, Hudson's
Number of Colors 5

1

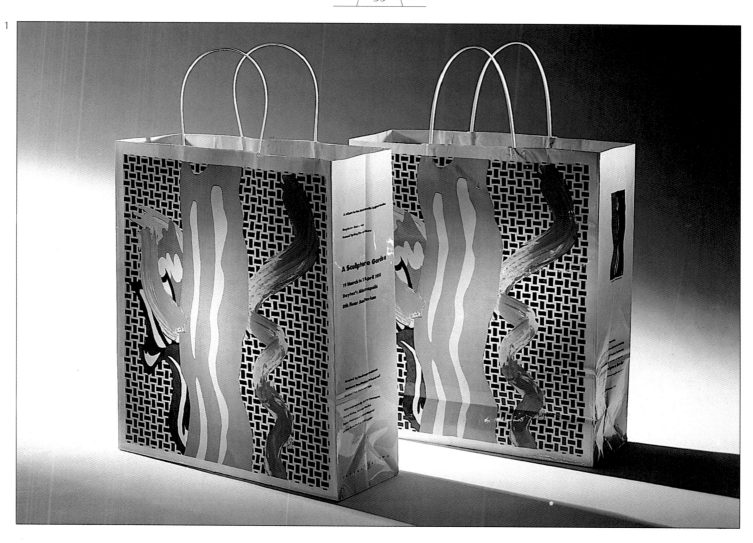

2

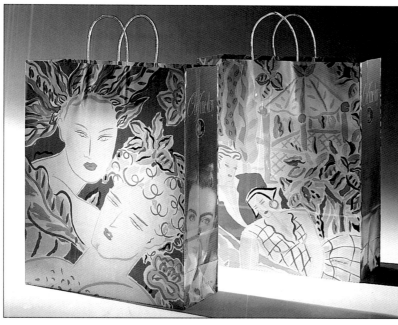

3

1
Design Firm Dayton's, Hudson's,
 Marshall Field's In-House
Art Director Connie Soteropulos/Cheryl Watson
Designer Connie Soteropulos/Cheryl Watson
Illustrator/Artist Roy Lichtenstein
Client/Store Dayton's
Number of Colors 4

2
Design Firm Dayton's, Hudson's,
 Marshall Field's In-House
Art Director Cheryl Watson
Designer Cheryl Watson
Illustrator/Artist Paula Munck
Client/Store Dayton's, Hudson's
Number of Colors 4

3
Design Firm Gregory group, inc.
Art Director Jon Gregory
Designer Jon Gregory
Client/Store Fontana Center
Number of Colors 2

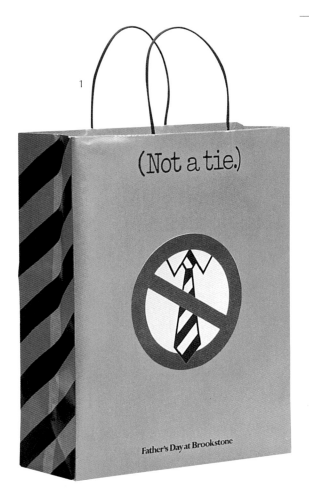

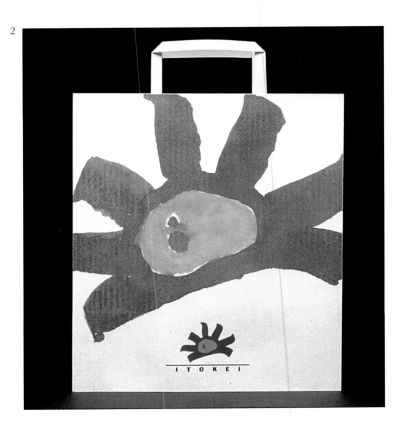

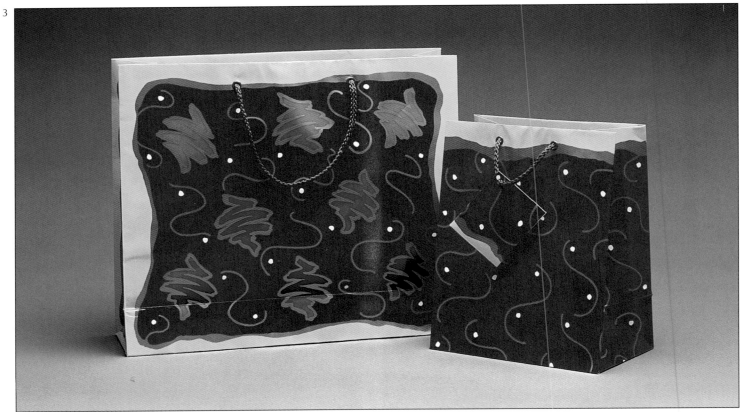

1
Design Firm Pentagram Design
Art Director Michael Bierut
Illustrator/Artist Michael Bierut/Dorit Lev
Client/Store Brookstone
Number of Colors 2 and Black

1
Design Firm Carre Noir
Illustrator/Artist Benoit Higel
Client/Store Itokei (Japan)
Number of Colors 4

3
Design Firm Pier 1 Imports
Art Director Helen A. Firlik
Designer Helen A. Firlik
Illustrator/Artist Helen A. Firlik
Client/Store Pier 1 Imports
Number of Colors 4

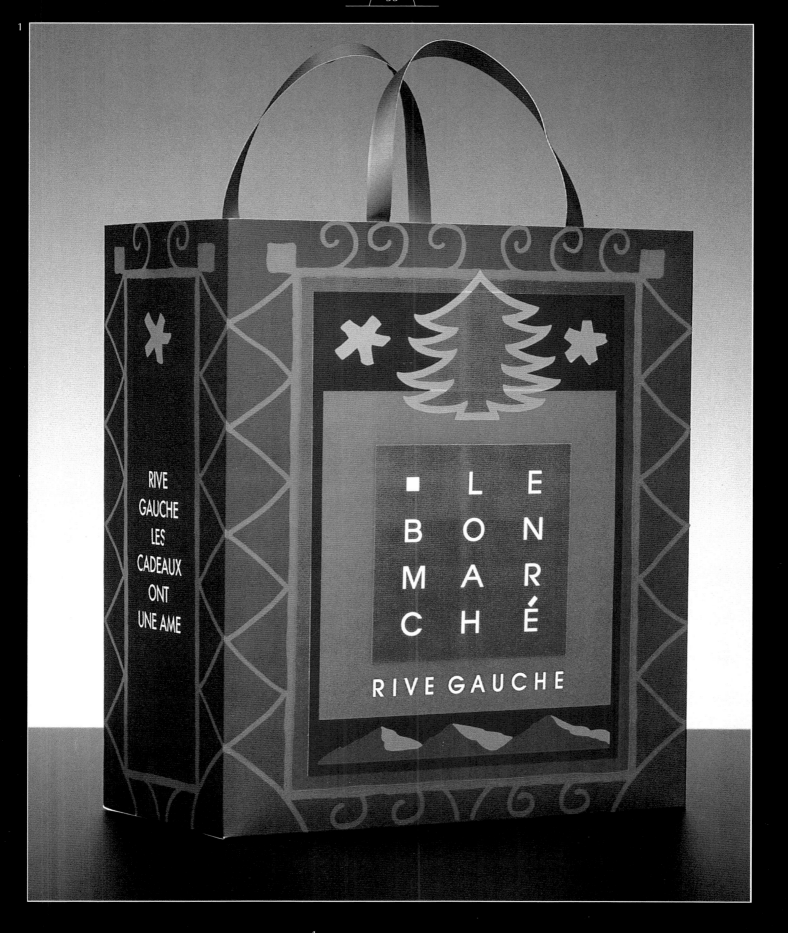

1
Design Firm Carre Noir
Illustrator/Artist Béatrice Mariotti
Client/Store Le Bon Marche (Paris)
Number of Colors 5

1

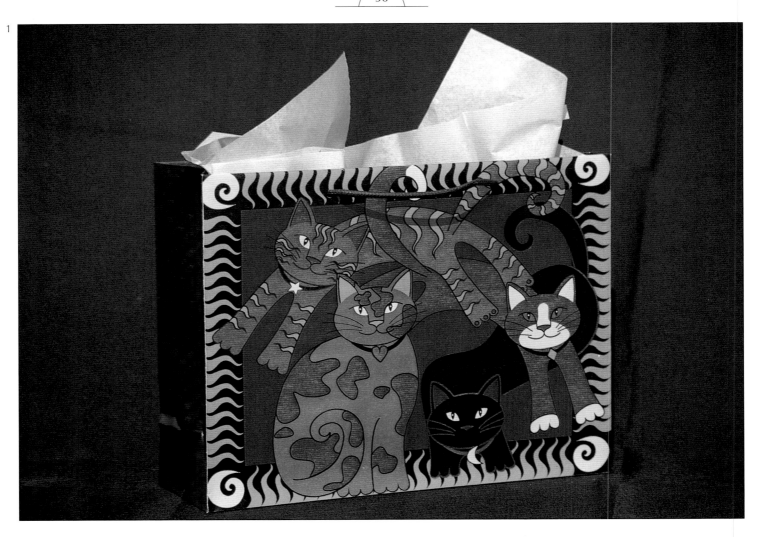

2

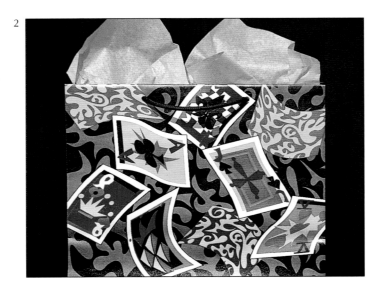

3

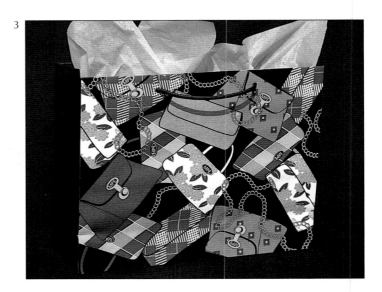

1
Design Firm The Watermark Collection
Art Director Lori Wynn-Ferber
Designer Zorch Designs
Illustrator/Artist Joel Shafor
Client/Store Matisse pour Elle
Number of Colors 6

2
Design Firm The Watermark Collection
Art Director Lori Wynn-Ferber
Designer Zorch Designs
Illustrator/Artist Joel Shafor
Client/Store Matisse pour Elle
Number of Colors 6

3
Design Firm The Watermark Collection
Art Director Lori Wynn-Ferber
Designer Zorch Designs
Illustrator/Artist Joel Shafor
Client/Store Matisse pour Elle
Number of Colors 6

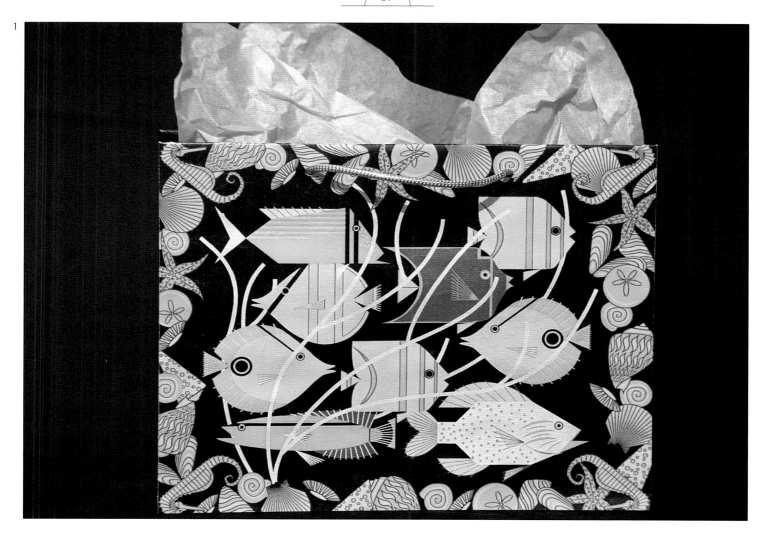

1
Design Firm The Watermark Collection
Art Director Lori Wynn-Ferber
Designer Zorch Designs
Illustrator/Artist Joel Shafor
Client/Store Matisse pour Elle
Number of Colors 6

2
Design Firm The Watermark Collection
Art Director Lori Wynn-Ferber
Designer Zorch Designs
Illustrator/Artist Joel Shafor
Client/Store Matisse pour Elle
Number of Colors 6

3
Design Firm The Watermark Collection
Art Director Lori Wynn-Ferber
Designer Zorch Designs
Illustrator/Artist Joel Shafor
Client/Store Matisse pour Elle
Number of Colors 6

1

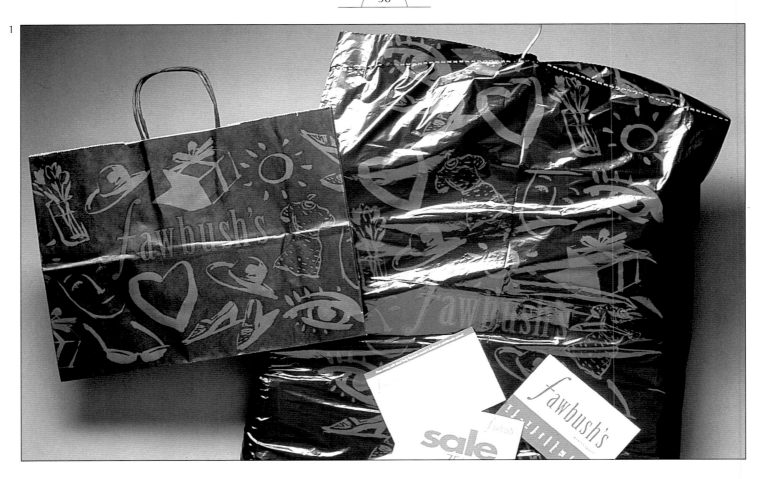

2

3

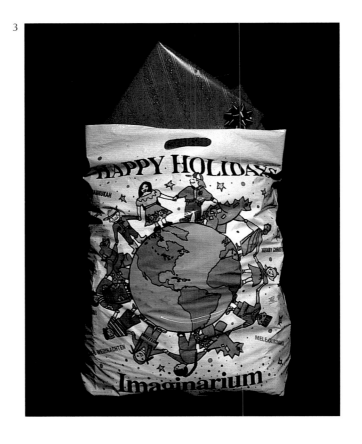

1
Design Firm Tilka Design
Art Director Jane Tilka
Designer Jane Tilka
Client/Store Fawbush's
Number of Colors 2

2
Design Firm SullivanPerkins
Art Director Ron Sullivan
Designer Art Garcia
Illustrator/Artist Art Garcia/Jon Flaming
Client/Store Donahue Schriber
Number of Colors 4

3
Design Firm Hunt Weber Clark Design
Art Director Nancy Hunt-Weber
Designer Nancy Hunt-Weber
Illustrator/Artist Nancy Hunt-Weber
Client/Store Imaginarium Toy Stores
Number of Colors 4

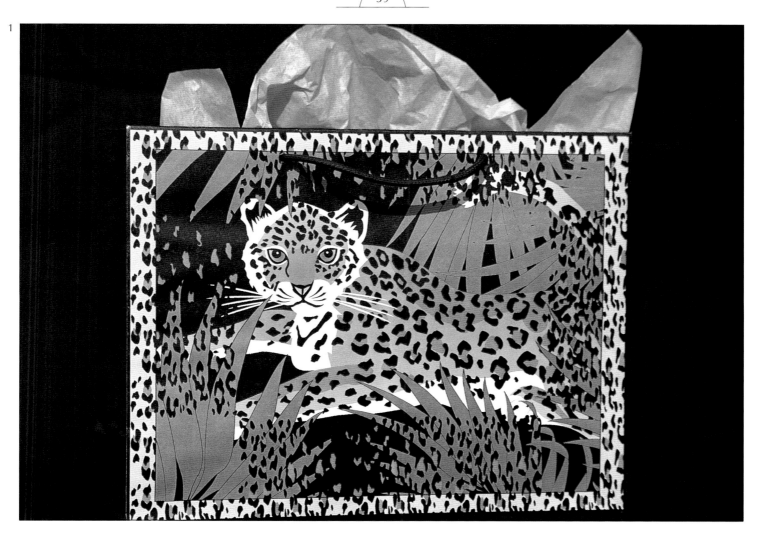

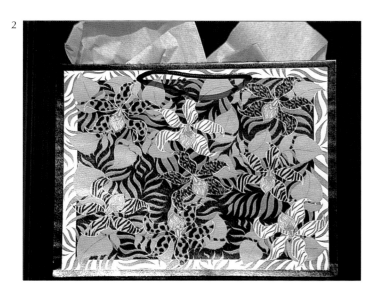

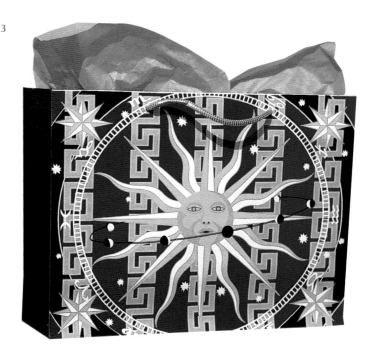

1
Design Firm The Watermark Collection
Art Director Lori Wynn-Ferber
Designer Zorch Designs
Illustrator/Artist Joel Shafor
Client/Store Matisse pour Elle
Number of Colors 6

2
Design Firm The Watermark Collection
Art Director Lori Wynn-Ferber
Designer Zorch Designs
Illustrator/Artist Joel Shafor
Client/Store Matisse pour Elle
Number of Colors 6

3
Design Firm The Watermark Collection
Art Director Lori Wynn-Ferber
Designer Zorch Designs
Illustrator/Artist Joel Shafor
Client/Store Matisse pour Elle
Number of Colors 6

1

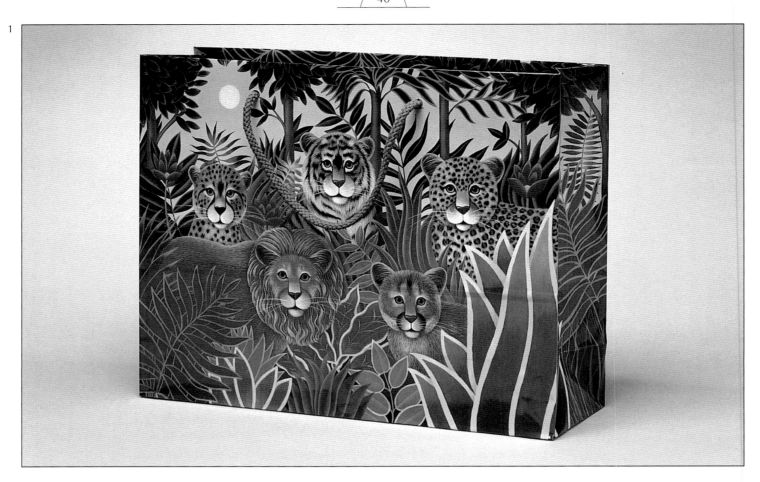

2

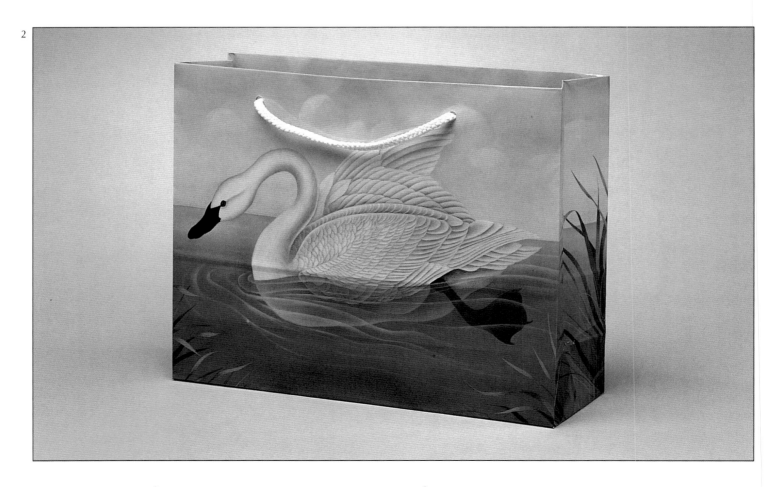

1
Art Director Linda DeVito Soltis
Illustrator/Artist Linda DeVito Soltis
Client/Store The Stephen Lawrence Company

2
Art Director Linda DeVito Soltis
Illustrator/Artist Linda DeVito Soltis
Client/Store The Stephen Lawrence Company

1

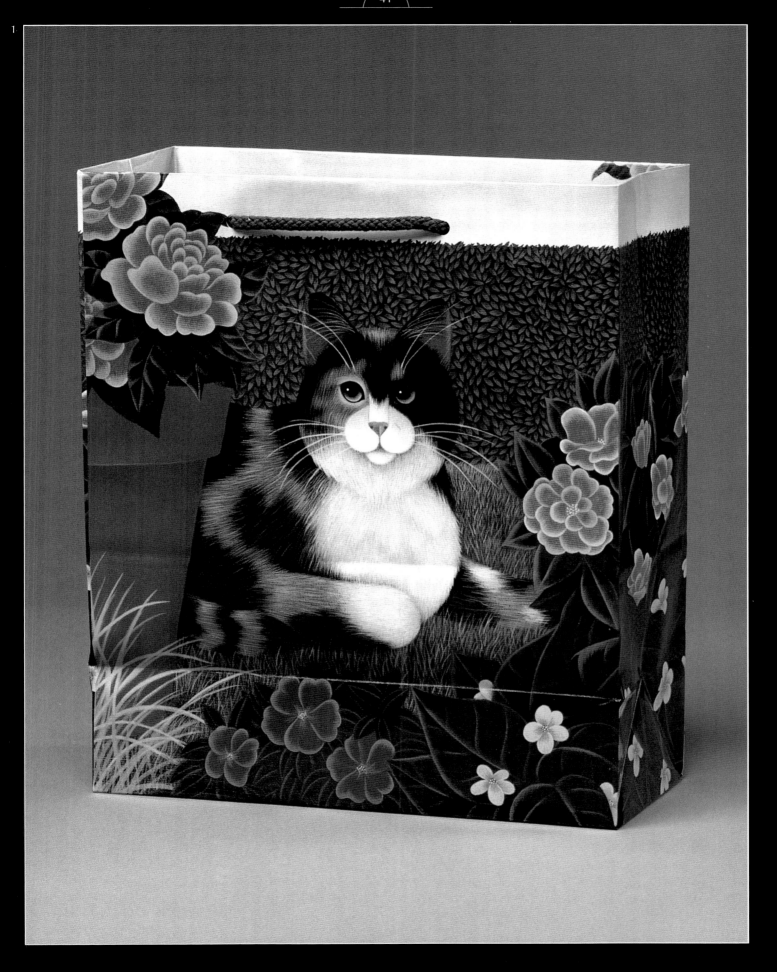

Art Director Linda DeVito Soltis
Illustrator/Artist Linda DeVito Soltis
Client/Store The Stephen Lawrence Company

1

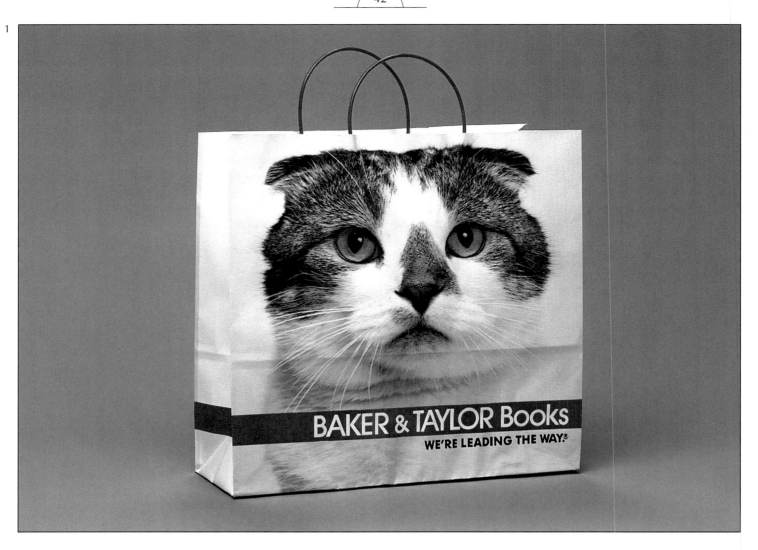

2

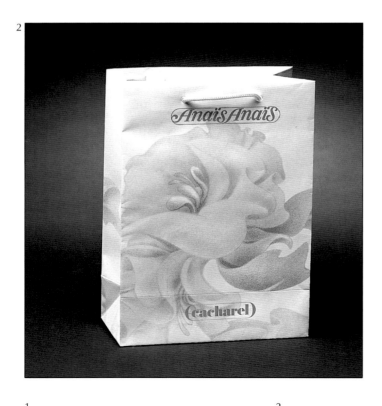

3

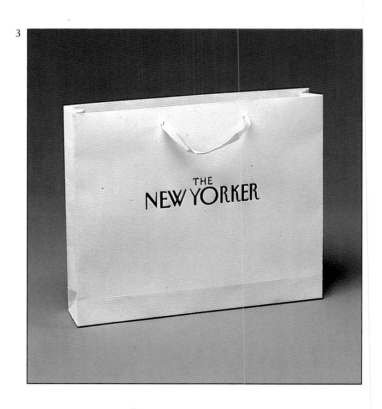

1
Design Firm/Manufacturer Equitable Bag Co., Inc.
Client/Store Baker & Taylor Books
Number of Colors 5

2
Design Firm S. Posner Sons, Inc.
Client/Store Designer Fragrance Cosmair
Number of Colors 4 color process

3
Design Firm S. Posner Sons, Inc.
Art Director Gary Van Dis
Client/Store The New Yorker Magazine
Number of Colors Hot stamp

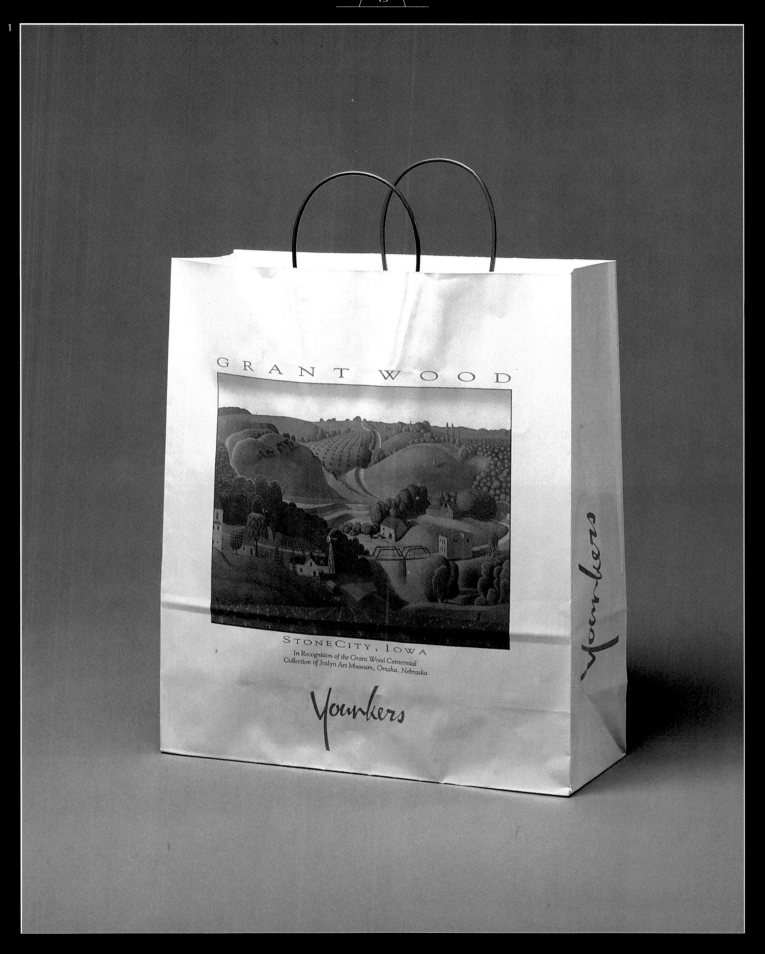

1
Design Firm/Manufacturer Equitable Bag Co., Inc.
Client/Store Yonkers
Number of Colors 5

1

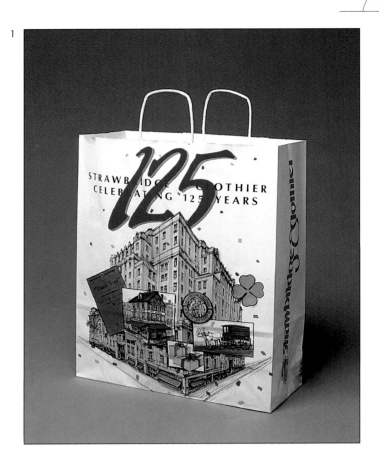

2

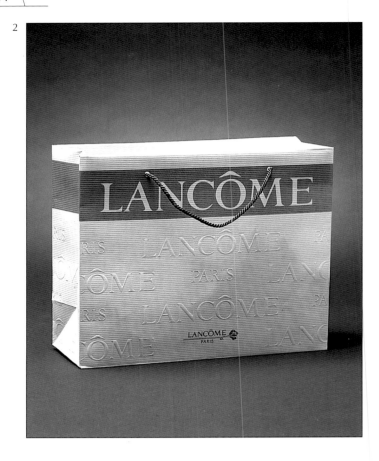

3

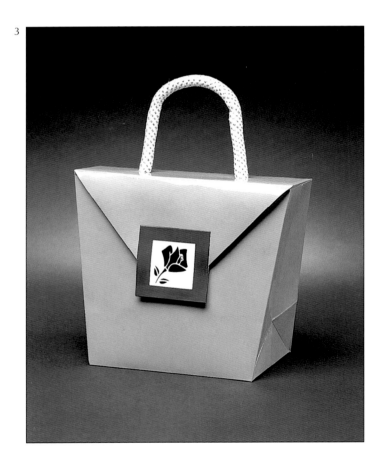

4

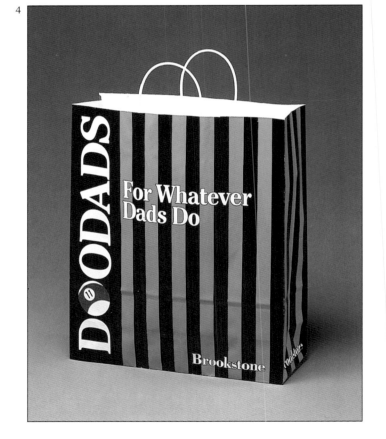

1
Design Firm/Manufacturer
 Equitable Bag Co., Inc.
Client/Store Strawbridge & Clothier
Number of Colors 5

2
Design Firm S. Posner Sons, Inc.
Client/Store Lancome
Number of Colors 1 color,
 blind emboss

3
Design Firm S. Posner Sons, Inc.
Client/Store Lancome
Number of Colors 2 color,
 hot stamp

4
Design Firm/Manufacturer
 Equitable Bag Co., Inc.
Client/Store Brookstone
Number of Colors 3

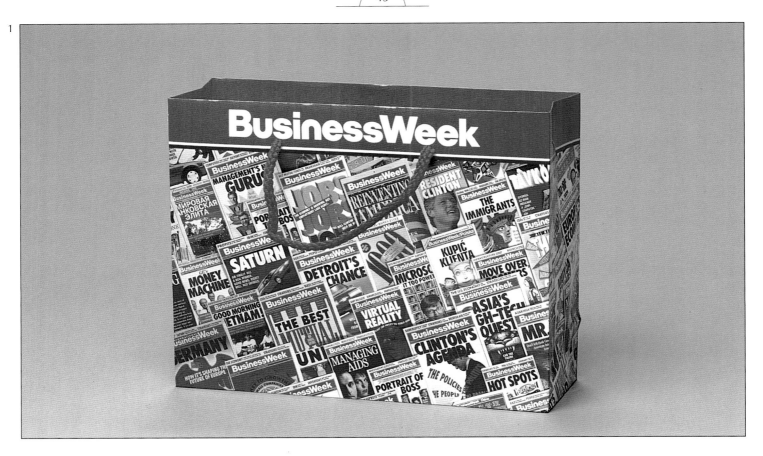

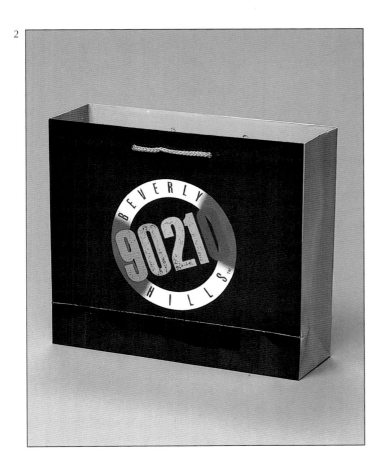

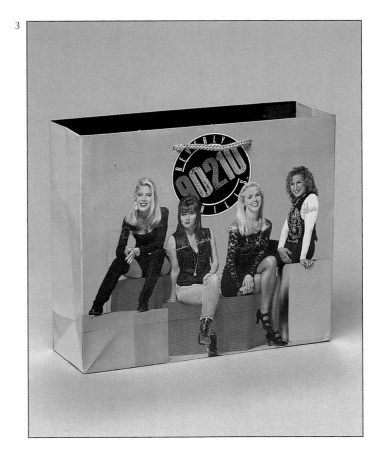

1
Design Firm S. Posner Sons, Inc.
Client/Store Business Week Magazine
Number of Colors 4 color process

2, 3
Design Firm S. Posner Sons, Inc.
Client/Store Tsumura International
Number of Colors 3 color (yellow/pink,
pink/green, blue/green)

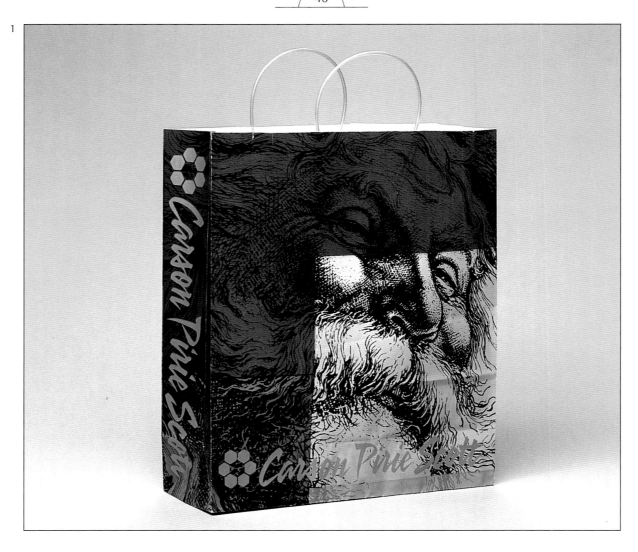

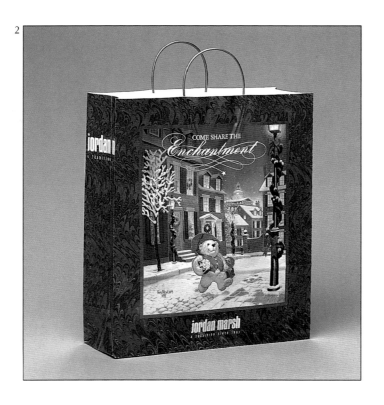

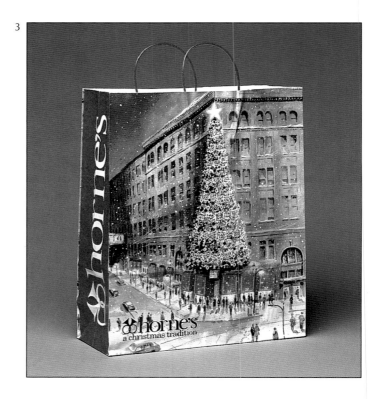

1
Design Firm/Manufacturer Equitable Bag Co., Inc.
Client/Store Carson Pirie Scott
Number of Colors 6

2
Design Firm/Manufacturer Equitable Bag Co., Inc.
Client/Store Jordan Marsh
Number of Colors 7

3
Design Firm/Manufacturer Equitable Bag Co., Inc.
Client/Store Horne's
Number of Colors 5

1

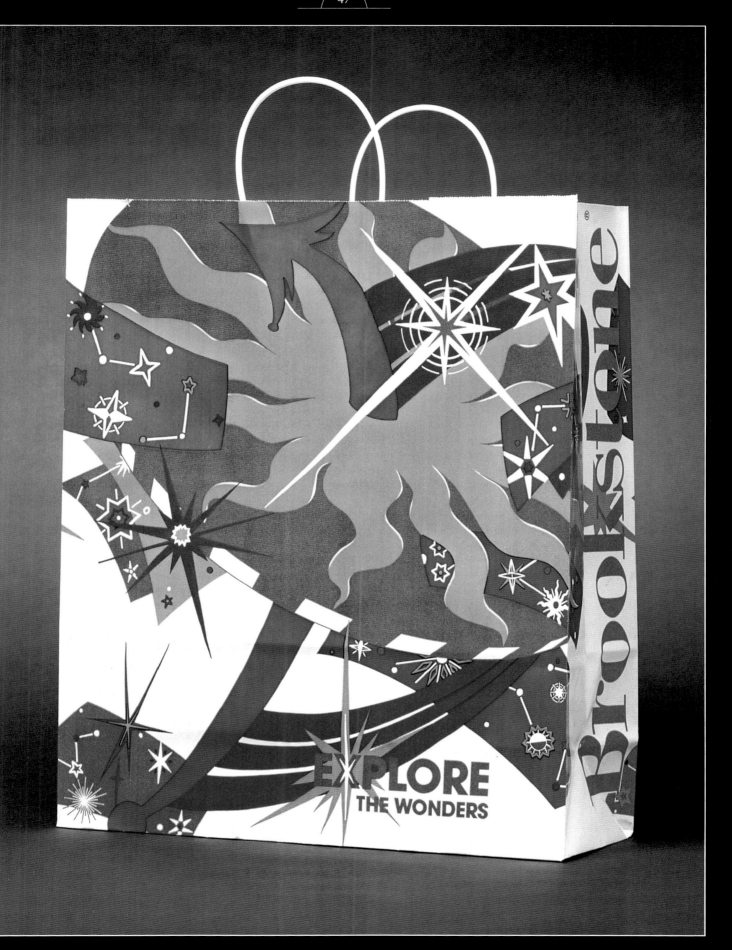

1
Design Firm/Manufacturer Equitable Bag Co., Inc.
Client/Store Brookstone
Number of Colors 5

1

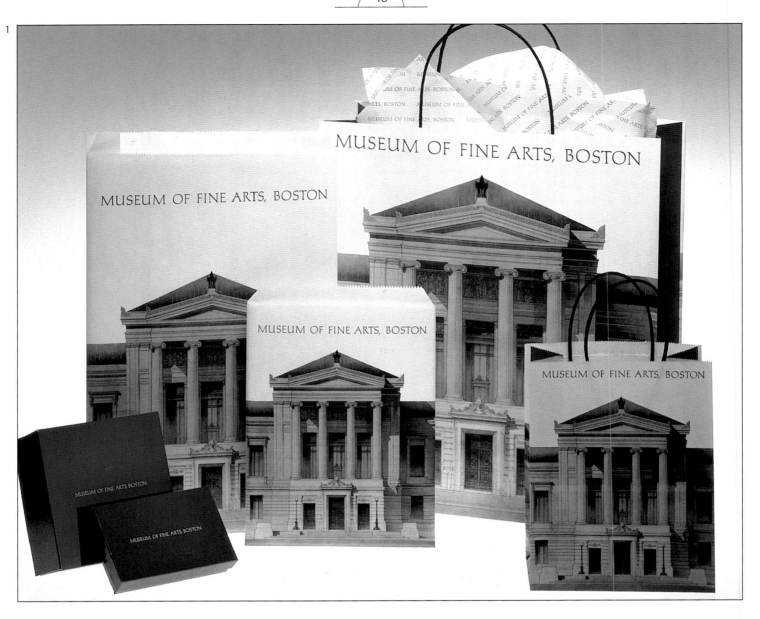

2

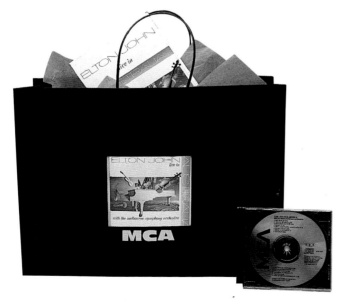

3

1
Design Firm Museum Of Fine Arts, Boston
 In-House
Designer Wallace F. Marosek
Illustrator/Artist Guy Lowell
Client/Store Musem Of Fine Arts, Boston
Number of Colors 2 (duotone)

2
Design Firm Modern Arts Packaging
Art Director Cynthia Delihas
Designer Cynthia Delihas
Client/Store MCA Records, California
This bag is designed with a die-cut window
with a pouch to house a CD.

3
Art Director Thom A. Lager
Designer Thom A. Lager

1

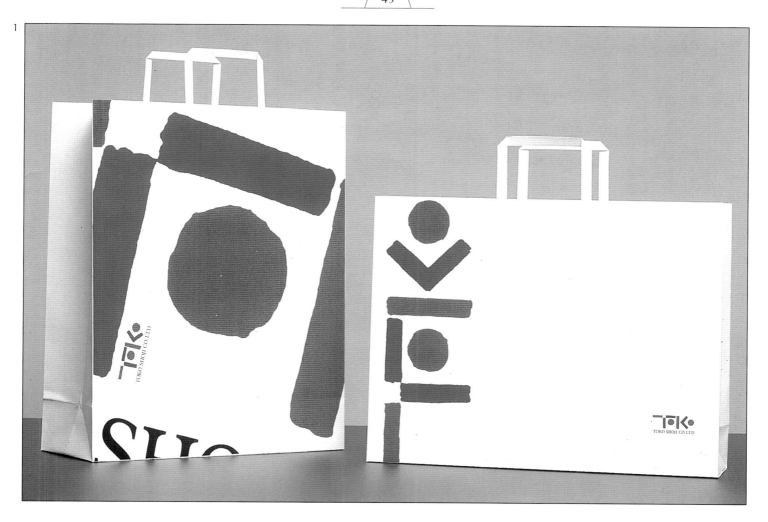

2

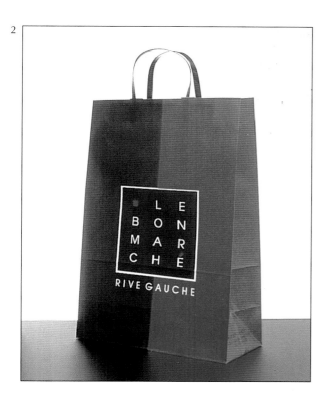

3

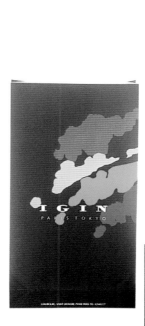
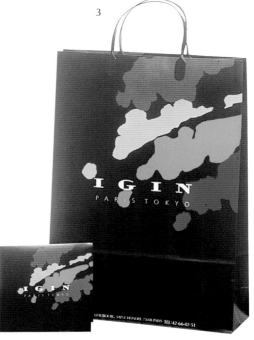

1
Design Firm Carre Noir
Designer Roger Saingt
Client/Store Toko (Japan)
Number of Colors 3

2
Design Firm Carre Noir
Designer Béatrice Mariotti
Client/Store Le Bon March (Paris)
Number of Colors 2

3
Design Firm Carre Noir
Designer Michel Disle
Client/Store Igin (Paris)
Number of Colors 5

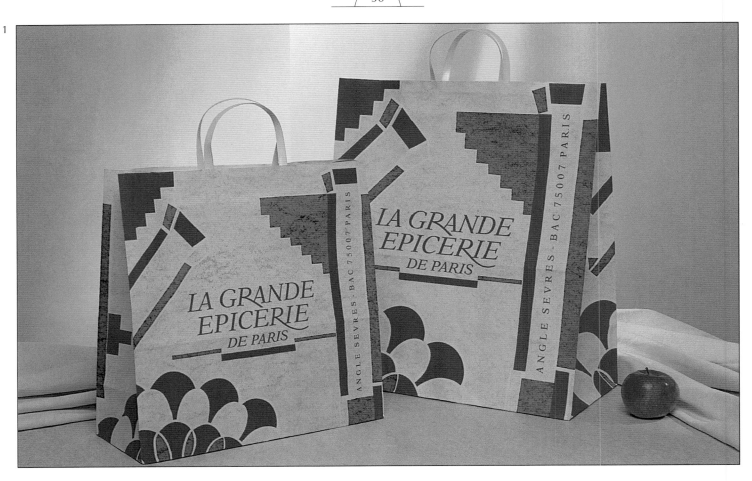

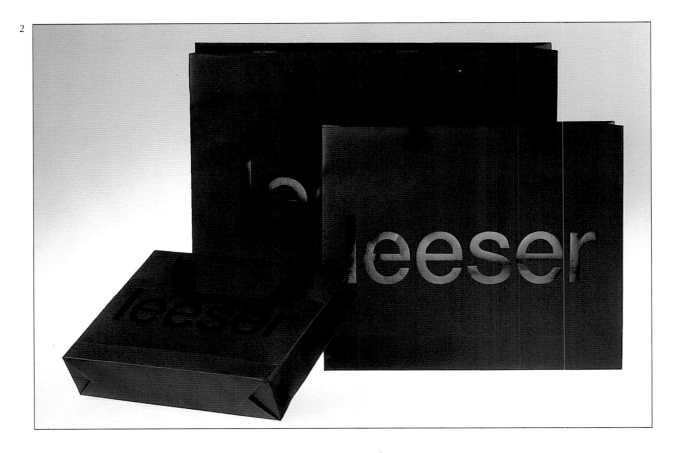

1
Design Firm Carre Noir
Designer Béatrice Mariotti
Client/Store La Grande Epicerie (Paris)
Number of Colors 5

2
Design Firm Samenwerkende Ontwerpers
Art Director Marianne Vos
Designer Marianne Vos
Client/Store Leeser
Number of Colors 1

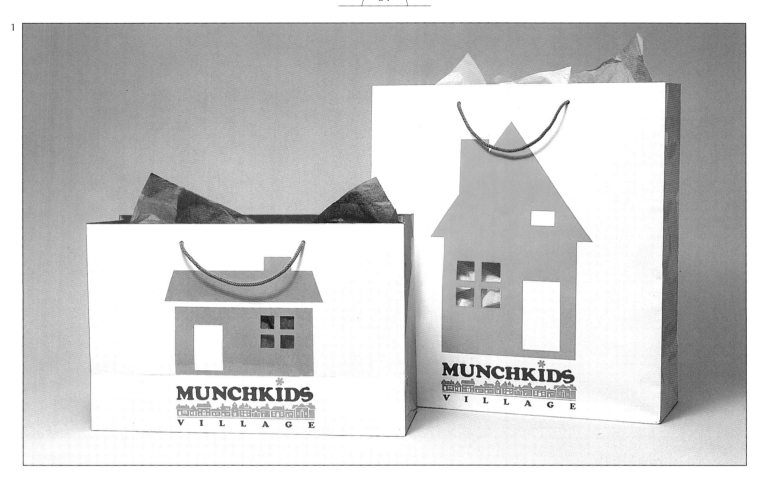

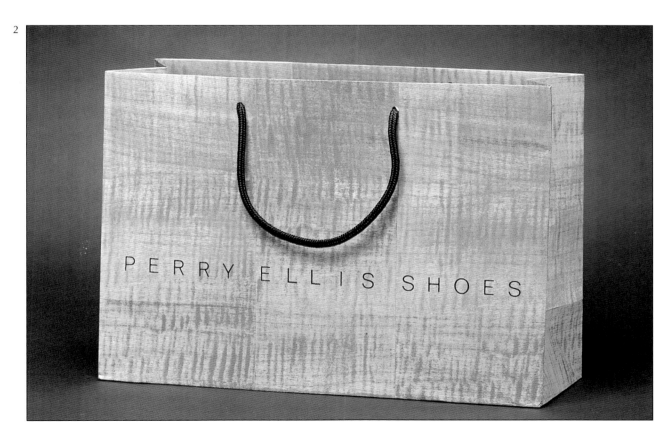

1
Design Firm Modern Arts Packaging
Art Director Cynthia Delihas
Designer Cynthia Delihas/Alexandra Min
Client/Store Munchkids Village

2
Design Firm Martha Voutas Productions Inc.
Designer Greg Lippman
Client/Store Perry Ellis
Distributor S. Posner Sons, Inc.
Number of Colors 4 color process

1

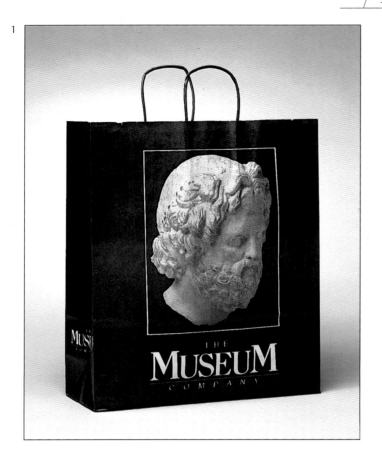

2

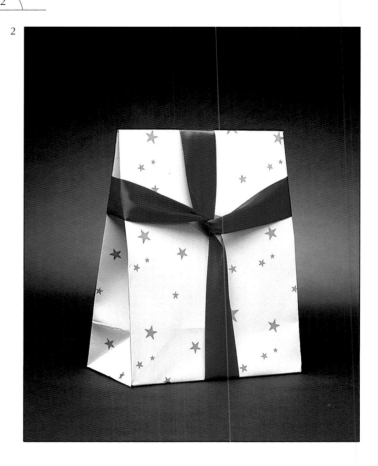

3

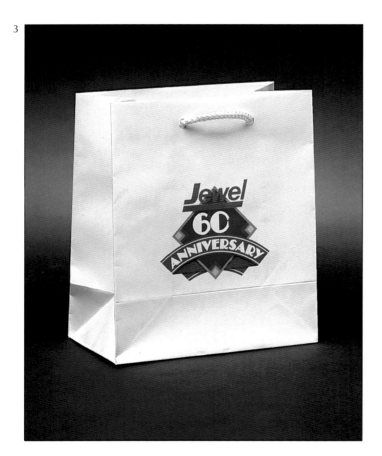

4

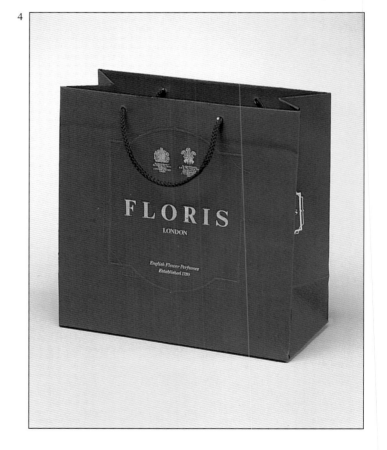

1
Design Firm/Manufacturer
 The Equitable Bag Co., Inc.
Designer Jamie Pelino
Client/Store The Museum Company
Number of Colors 2

2
Design Firm S. Posner Sons, Inc.
Client/Store Cosmair
Number of Colors 1

3
Design Firm S. Posner Sons, Inc.
Client/Store Jewel Corp.
Number of Colors 4 color process

4
Design Firm S. Posner Sons, Inc.
Client/Store The Walker Group
Number of Colors Blind emboss,
 hot stamp

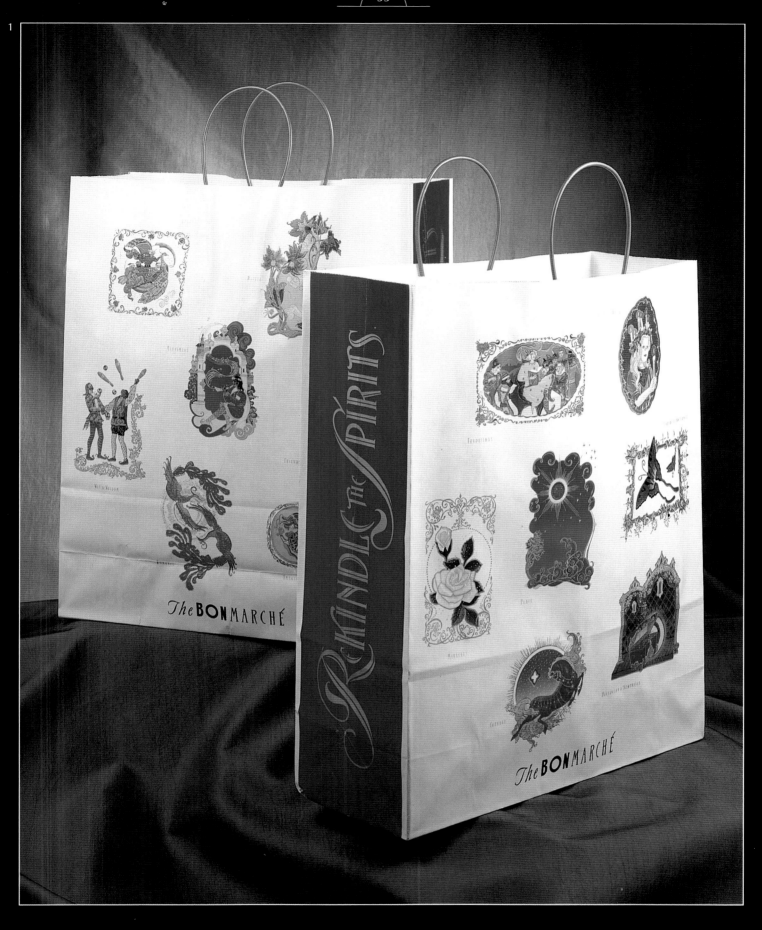

1
Design Firm The Bon Marché
Art Director Jean Delatyrée
Designer Jean Delatyrée
Illustrator/Artist Bryn Barnard
Client/Store The Bon Marché
Number of Colors 6

1

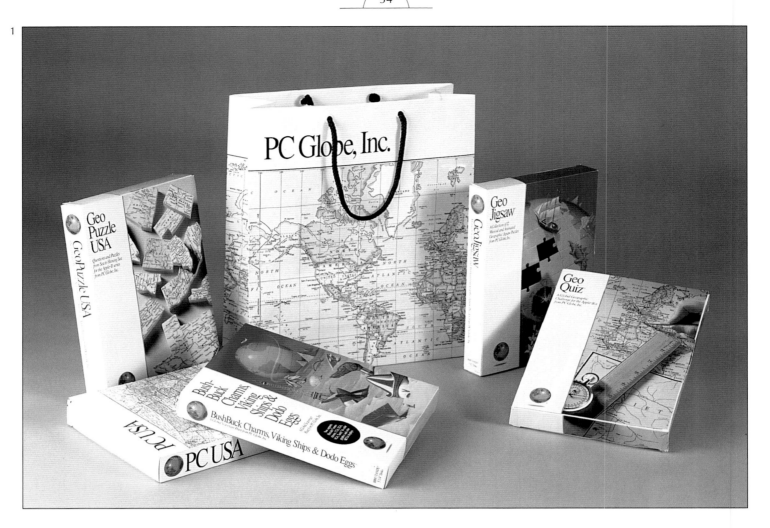

2

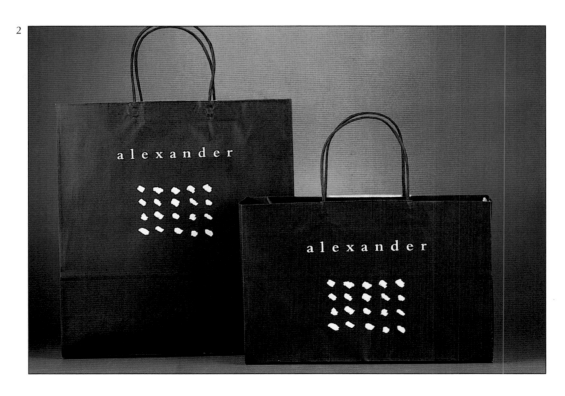

1
Design Firm Richardson or Richardson
Art Director Forrest Richardson
Designer Debi Young Mees
Client/Store PC Globe, Inc.
Number of Colors 4 color process

2
Design Firm Gregory group, inc.
Art Director Jon Gregory
Designer Jon Gregory
Client/Store Alexander
Number of Colors 2

1

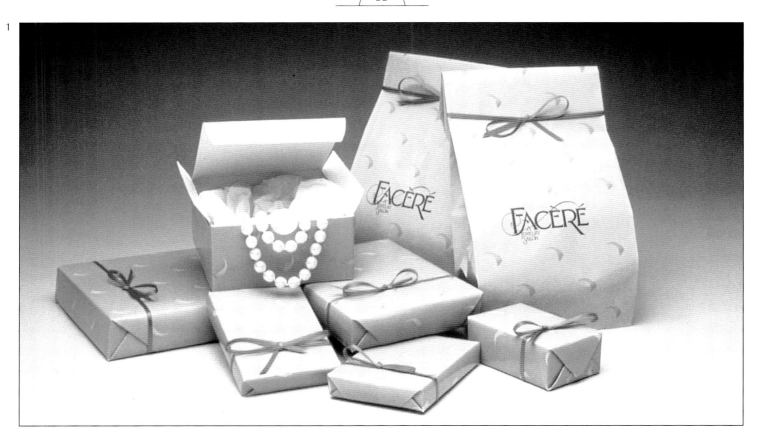

2

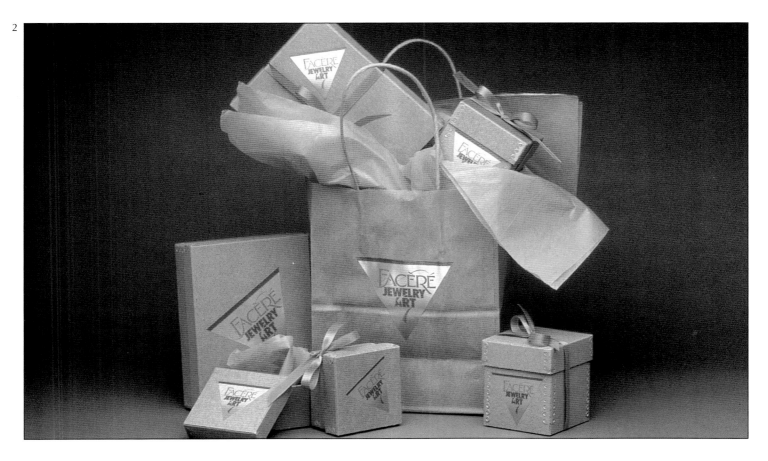

1
Design Firm Hornall Anderson Design Works
Art Director Jack Anderson
Designer Jack Anderson/Juliet Shen
Illustrator/Artist Bruce Hale
Client/Store Facere Jewelry Art
Number of Colors sticker–2, bags and
 wrapping paper–4

2
Design Firm Hornall Anderson Design Works
Art Director Jack Anderson
Designer Jack Anderson/Juliet Shen
Illustrator/Artist Bruce Hale
Client/Store Facere Jewelry Art
Number of Colors sticker–2, bags and
 wrapping paper–4

1

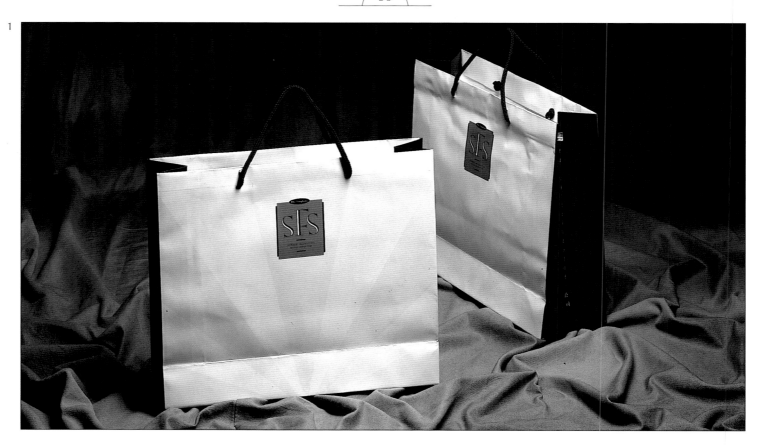

2

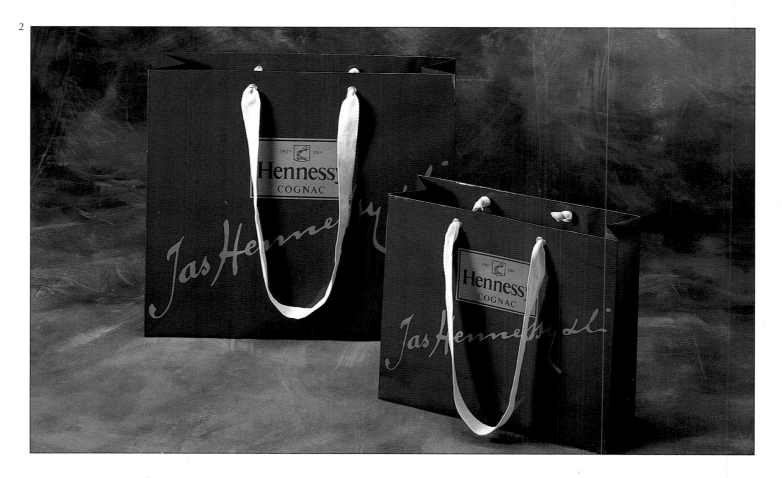

1
Design Firm Leslie Chan Design Co., Ltd.
Art Director Leslie Chan Wing Kei
Designer Leslie Chan Wing Kei/Mindy Wang
Client/Store Amway Taiwan Limited
Number of Colors 4 PMS colors, 1 metallic color,
 matt lamination

2
Design Firm Leslie Chan Design Co., Ltd.
Art Director Leslie Chan Wing Kei
Designer Leslie Chan Wing Kei/Mindy Wang
Client/Store Jardine Richo Monde Limited
Number of Colors 1 PMS color, 1 metallic color,
 foil stamp

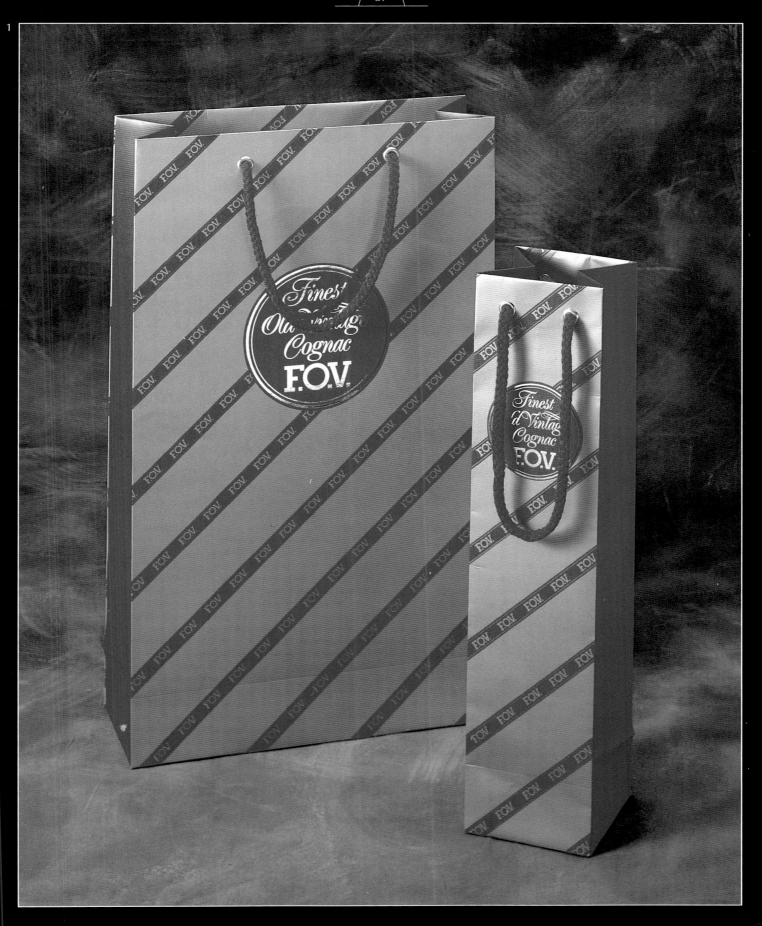

1
Design Firm Leslie Chan Design Co., Ltd.
Art Director Leslie Chan Wing Kei
Designer Leslie Chan Wing Kei/Tong Song W
Client/Store Jardine Richo Monde Limited
Number of Colors 1 PMS color, 1 metallic
 color, foil stamp

1

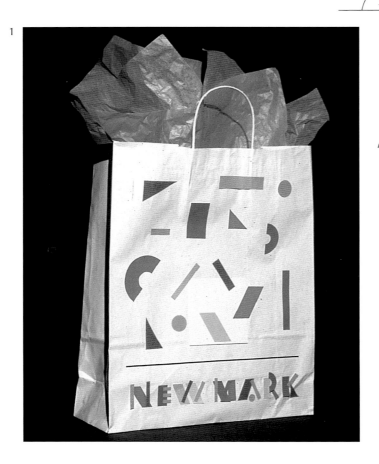

2

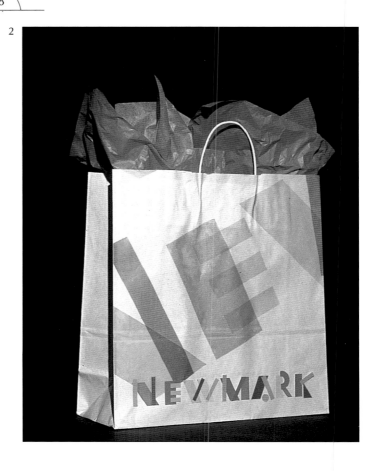

3

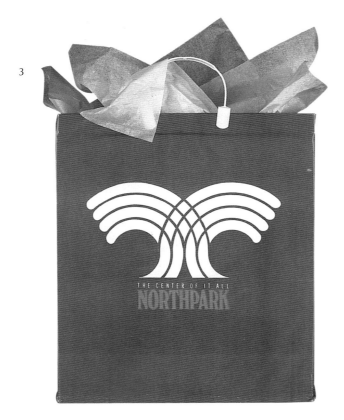

4

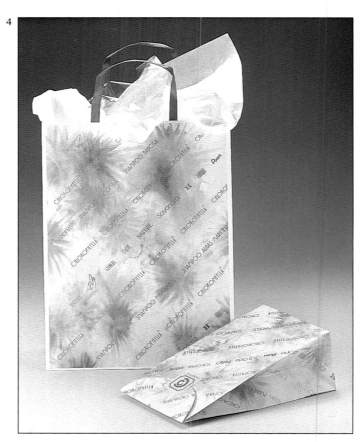

1
Design Firm Debra Nichols Design
Art Director Debra Nichols
Desinger Debra Nichols/
 Catherine Montalbo
Client/Store Newmark
Number of Colors 7

2
Design Firm Debra Nichols Design
Art Director Debra Nichols
Desinger Debra Nichols/
 Catherine Montalbo
Client/Store Newmark
Number of Colors 7

3
Design Firm Gregory group, inc.
Art Director Jon Gregory
Desinger Jon Gregory
Client/Store Northpark Center
Number of Colors 2

4
Design Firm K.S. Design
Art Director Kazuko Suzuki Sato
Desinger Mirian M. Murata
Illustrator/Artist Airton H. Sato
Client/Store Chlrophylla Cosmeticos
Number of Colors 3

1

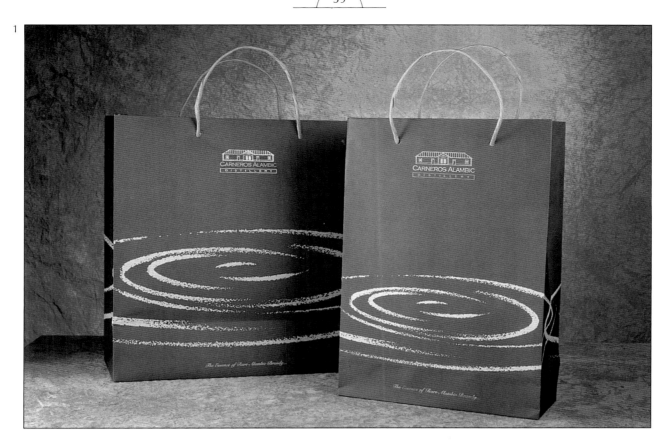

2

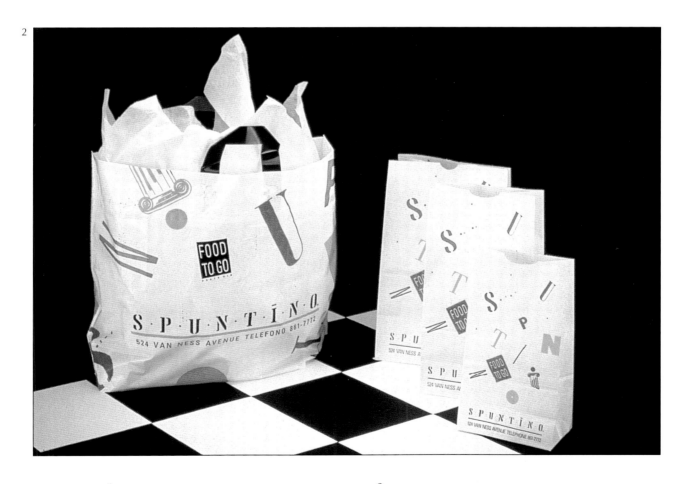

1
Design Firm JRDC
Art Director Judi Radice/Kenishi Nishiwaki
Designer Jeanne Namkung/Profile
Illustrator/Artist Jeanne Namkung/Profile
Client/Store Carneros Alambic Distillery
Number of Colors 1 PMS color, foil stamp

2
Design Firm JRDC
Art Director Judi Radice
Designer Ferris Crane
Client/Store Spuntino Restaurant
Number of Colors 4 colors on plastic, 3 on paper

1

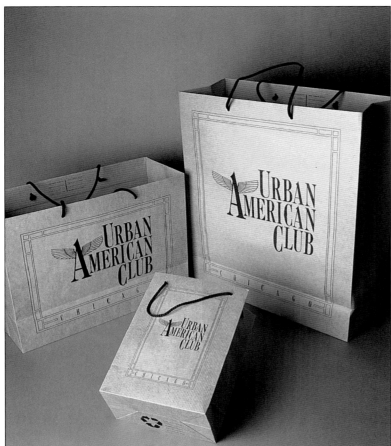

2

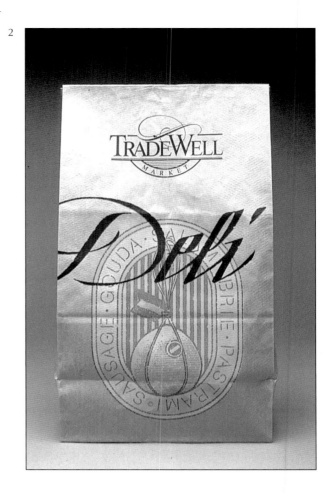

3

1
Design Firm Qually & Company Inc.
Art Director Robert Qually
Designer Robert Qually
Client/Store Jerry Kamhi Urban American Club
Number of Colors 2 or 1 plus clear varnish

2
Design Firm Hornall Anderson Design Works
Art Director Jack Anderson
Designer Jack Anderson/Mary Hermes/Cheri
 Huber/Julie Tanagi-Lock
Illustrator/Artist Jani Drewfs
Client/Store Tradewell
Number of Colors 4

3
Design Firm Hornall Anderson Design Works
Art Director Jack Anderson
Designer Jack Anderson/Mary Hermes/Cheri
 Huber/Julie Tanagi-Lock
Illustrator/Artist Jani Drewfs
Client/Store Tradewell
Number of Colors 4

1

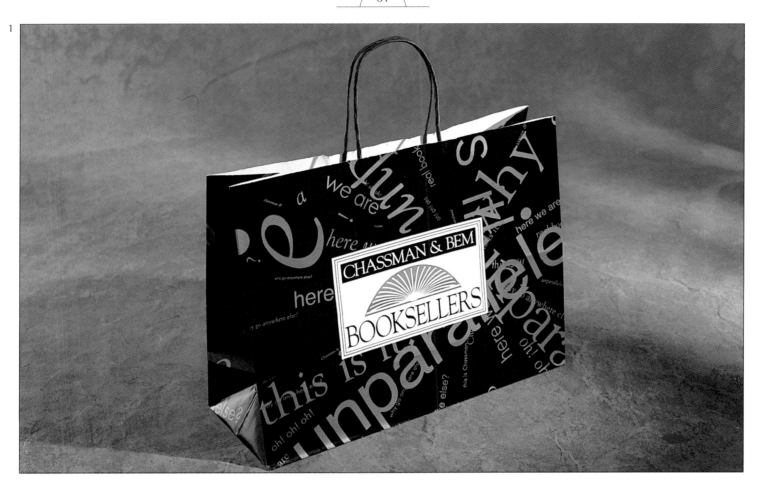

2

1
Design Firm Jager Di Paola Kemp Design
Art Director Michael Jager
Designer Michael Jager/Giovanna Jager
Client/Store Chassmen & Bem Bookstore

2
Design Firm Clifford Selbert Design
Art Director Clifford Selbert/Robin Perkins
Designer Clifford Selbert/Robin Perkins
Client/Store Boston Globe Project

1

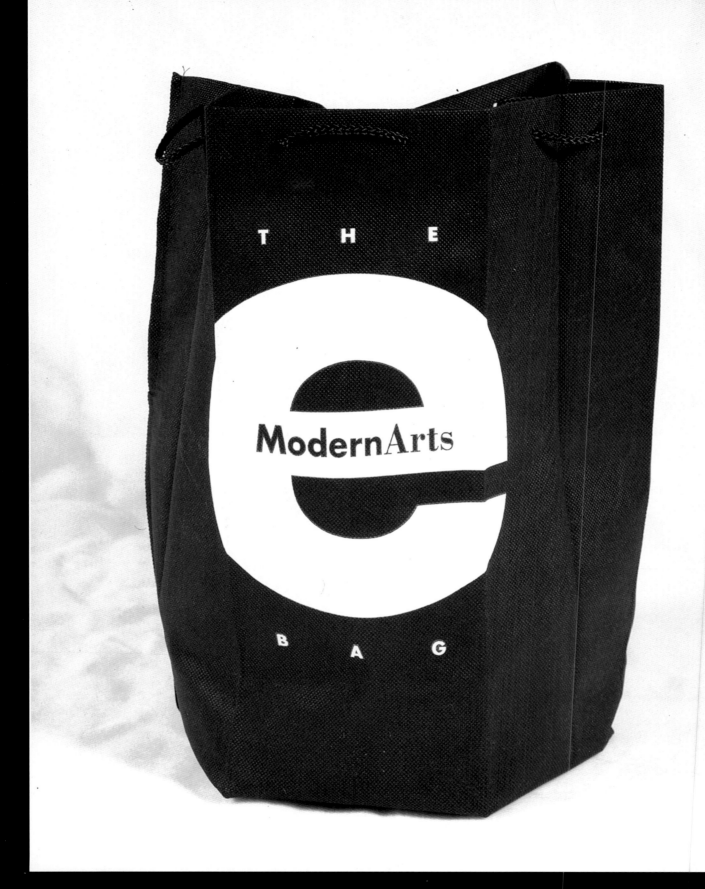

1
Design Firm Design Frame
Art Director James Sebastian
Designer James Sebastian/Frank Nichols
Client/Store Modern Arts Packaging, Inc.
Manufacturer Modern Arts Packaging, Inc.

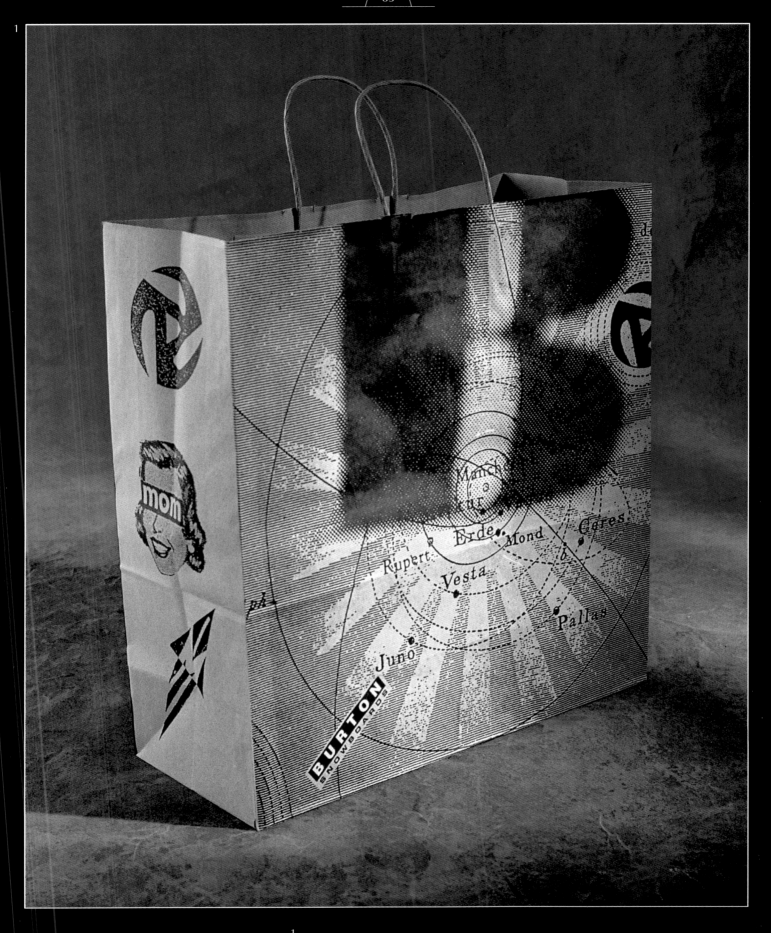

1
Design Firm Jager Di Paola Kemp Design
Art Director Michael Jager
Designer Adam Levite
Client/Store Burton Snowboards

1

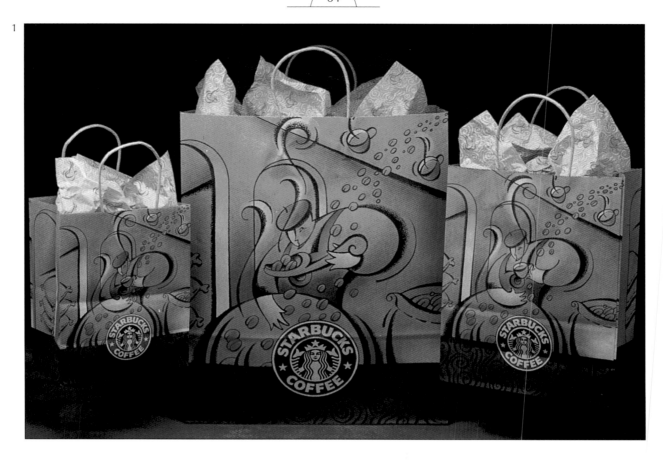

2

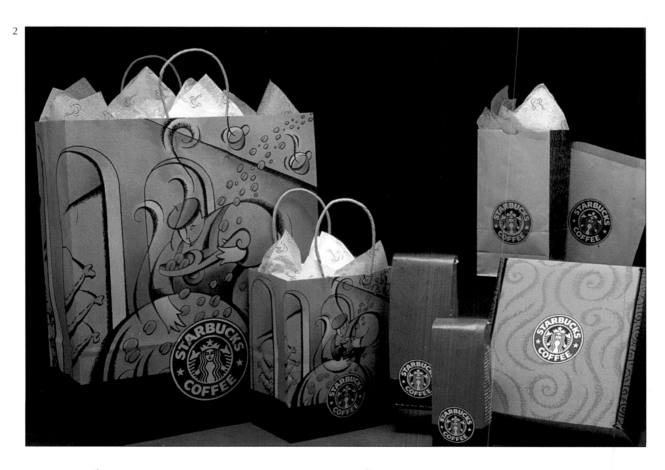

1
Design Firm Hornall Anderson Design Works
Art Director Jack Anderson
Designer Julie Tanagi-Lock/David Bates
Artist/Illustrator Julia LaPine
Client/Store Starbucks Coffee Company
Number of Colors 6

2
Design Firm Hornall Anderson Design Works
Art Director Jack Anderson
Designer Julie Tanagi-Lock/David Bates
Artist/Illustrator Julia LaPine
Client/Store Starbucks Coffee Company
Number of Colors 6

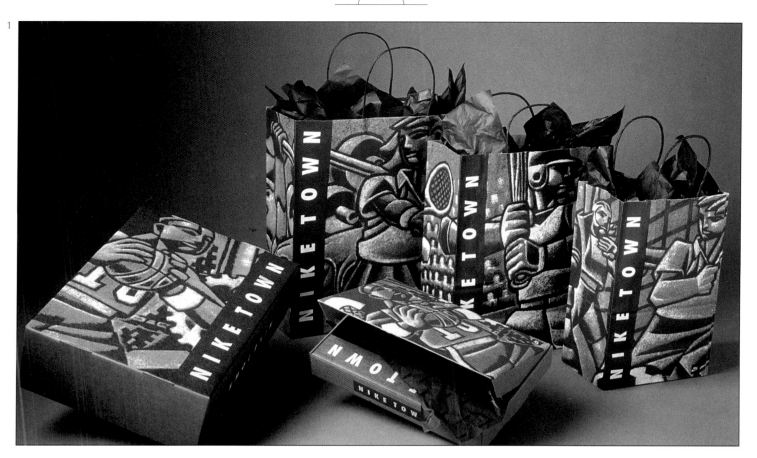

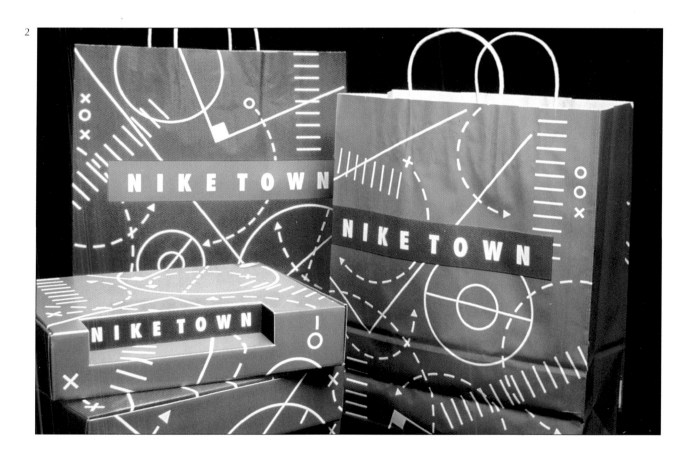

1	2
Design Firm Nike Design	**Design Firm** Nike Design
Art Director Alan Colvin	**Art Director** Alan Colvin
Designer Alan Colvin	**Designer** Alan Colvin
Illustrator/Artist Douglas Fraser	**Illustrator/Artist** Alan Colvin/David Gill
Client/Store Nike Town	**Client/Store** Nike Town
Number of Colors 3 per bag	**Number of Colors** 3

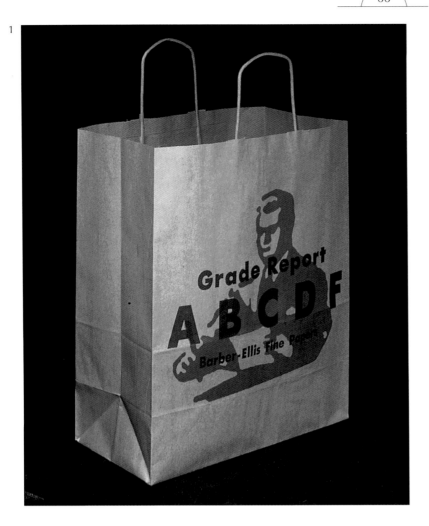

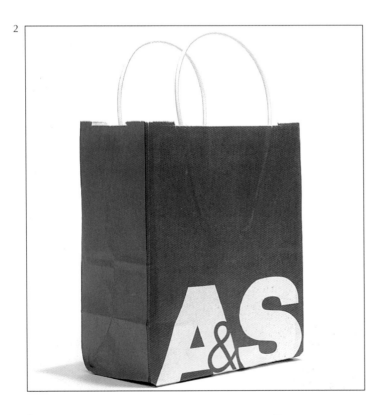

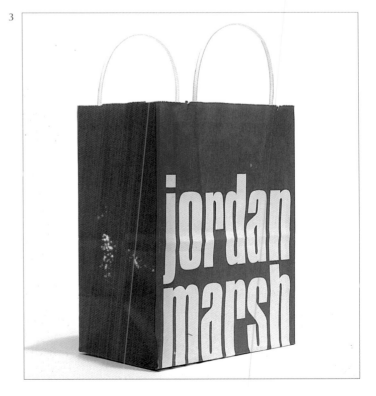

1
Design Firm Charles S. Anderson
Designer Charles S. Anderson
Client/Store Baber Ellis Fine Papers

2
Design Firm Abraham & Straus
Art Director Paul Horscroft
Designer Paul Horscroft
Client/Store A&S
Number of Colors 2

3
Design Firm Abraham & Straus
Art Director Paul Horscroft
Designer Paul Horscroft
Client/Store Jordan Marsh
Number of Colors 2

1

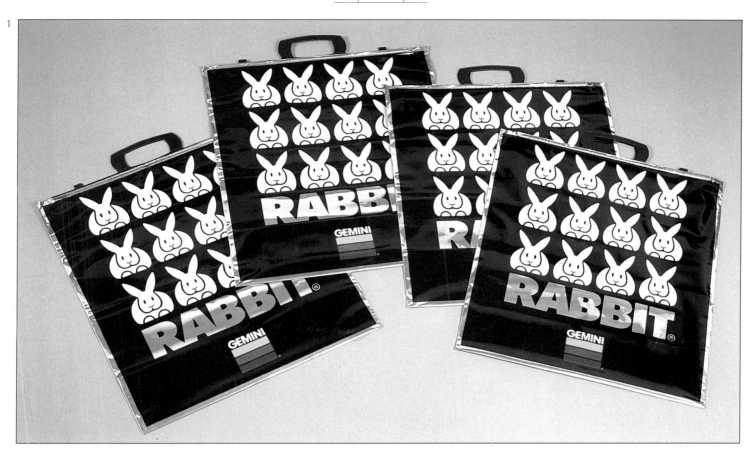

2

3

1
Design Firm Ronald Emmerling Design, Inc.
Art Director Ronald Emmerling
Designer Ronald Emmerling
Client/Store Gemini Industries, Inc.
Number of Colors 5

2
Design Firm Gregory group, inc.
Art Director Jon Gregory
Designer Jon Gregory
Client/Store Loyd. Paxton Works of Art
Number of Colors 2

3
Design Firm Mark Palmer Design
Art Director Mark Palmer
Designer Mark Palmer/8Curtis Palmer
Computer Production Curtis Palmer
Client/Store Peter Rabbit Farms
Number of Colors 3

1

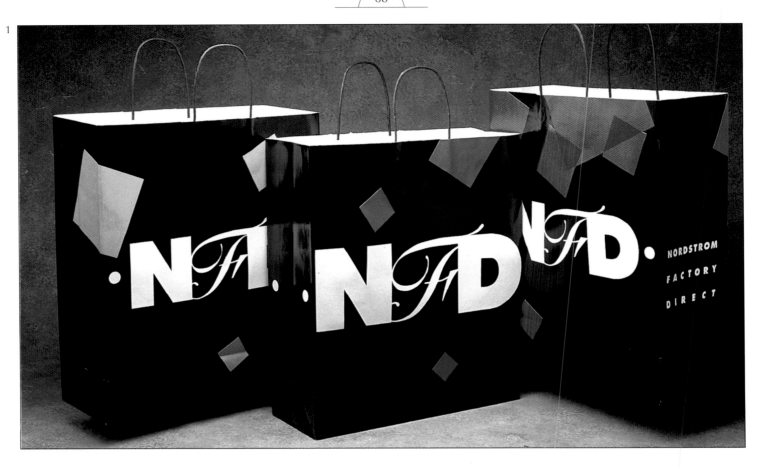

2

1
Design Firm Hornall Anderson Design Works
Art Director Jack Anderson
Designer Jack Anderson/David Bates
Client/Store Nordstrom Factory Direct
Number of Colors 3

2
Design Firm Sonia Navvab Akbar
Art Director Sonia Navvab Akbar
Designer Sonia Navvab Akbar
Illustrator/Artist Sonia Navvab Akbar
Client/Store OSO (Fashion)
Number of Colors 2

1

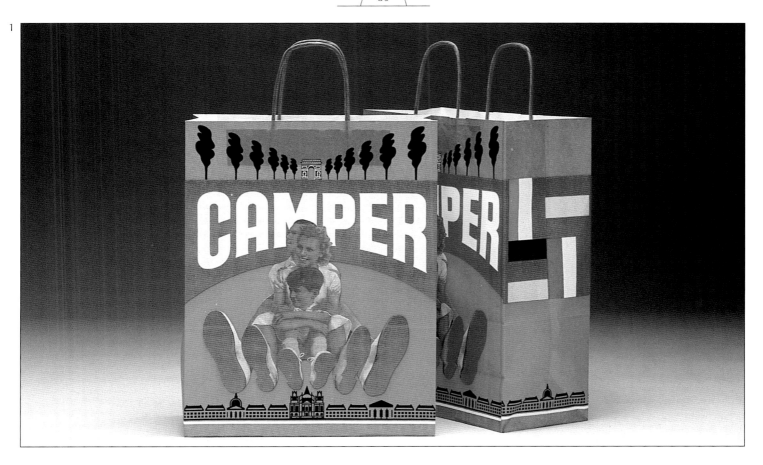

2

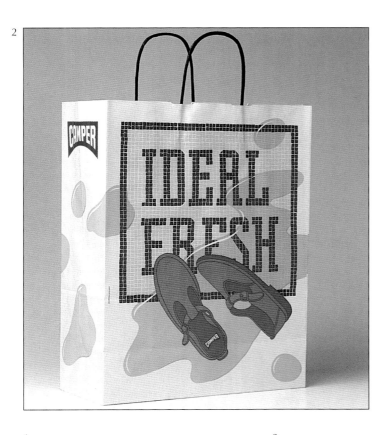

3

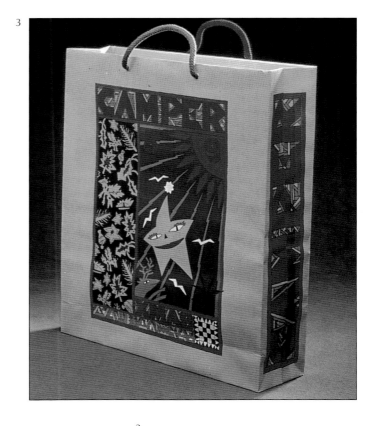

1
Design Firm CR Communication &
Design Services
Art Director Carlos Rolando
Designer Carlos Rolando
Illustrator/Artist Carlos Rolando
Client/Store Camper; leading brand of
casual shoes
Number of Colors 4 or 2

2
Design Firm CR Communication &
Design Services
Art Director Carlos Rolando
Designer Carlos Rolando
Illustrator/Artist Carlos Rolando
Client/Store Camper; leading brand of
casual shoes
Number of Colors 4 or 2

3
Design Firm CR Communication &
Design Services
Art Director Carlos Rolando
Designer Carlos Rolando
Illustrator/Artist Carlos Rolando
Client/Store Camper; leading brand of
casual shoes
Number of Colors 4 or 2

1

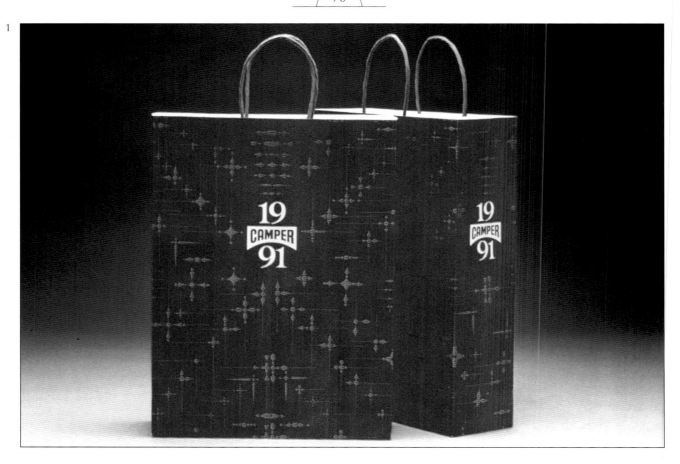

2

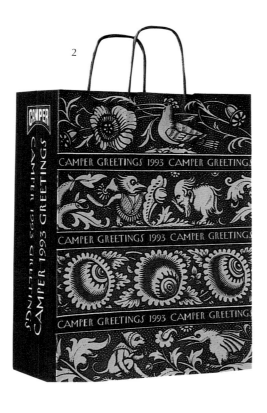

3

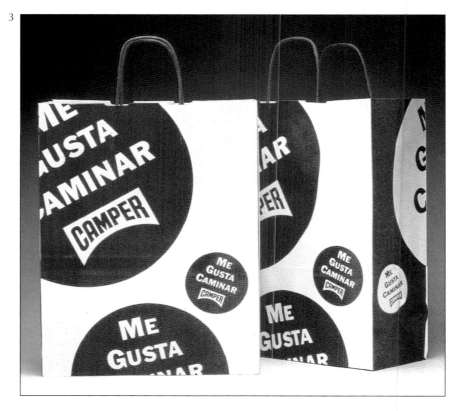

1
Design Firm CR Communication &
 Design Services
Art Director Carlos Rolando
Designer Carlos Rolando
Illustrator/Artist Carlos Rolando
Client/Store Camper; leading brand of
 casual shoes
Number of Colors 4 or 2

2
Design Firm CR Communication &
 Design Services
Art Director Carlos Rolando
Designer Carlos Rolando
Illustrator/Artist Carlos Rolando
Client/Store Camper; leading brand of
 casual shoes
Number of Colors 4 or 2

3
Design Firm CR Communication &
 Design Services
Art Director Carlos Rolando
Designer Carlos Rolando
Illustrator/Artist Carlos Rolando
Client/Store Camper; leading brand of
 casual shoes
Number of Colors 4 or 2

1

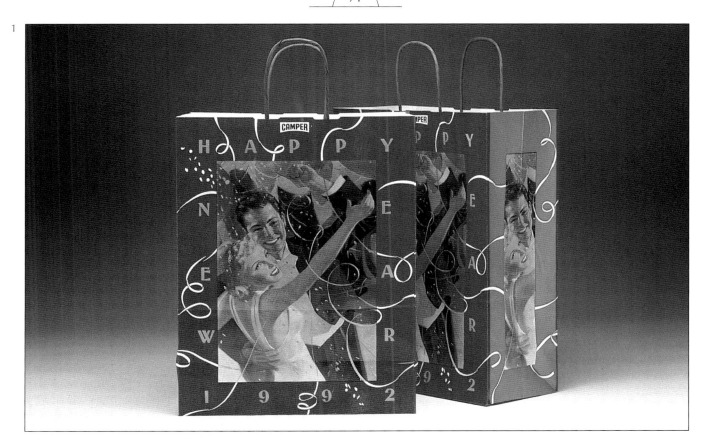

2

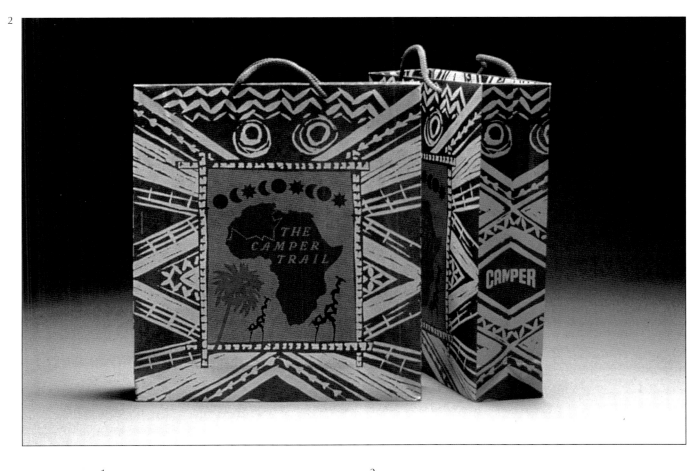

1
Design Firm CR Communication & Design Services
Art Director Carlos Rolando
Designer Carlos Rolando
Illustrator/Artist Carlos Rolando
Client/Store Camper Stores
Number of Colors 4

2
Design Firm CR Communication & Design Services
Art Director Carlos Rolando
Designer Carlos Rolando
Illustrator/Artist Carlos Rolando
Client/Store Camper; leading brand of casual shoes
Number of Colors 4 or 2

1

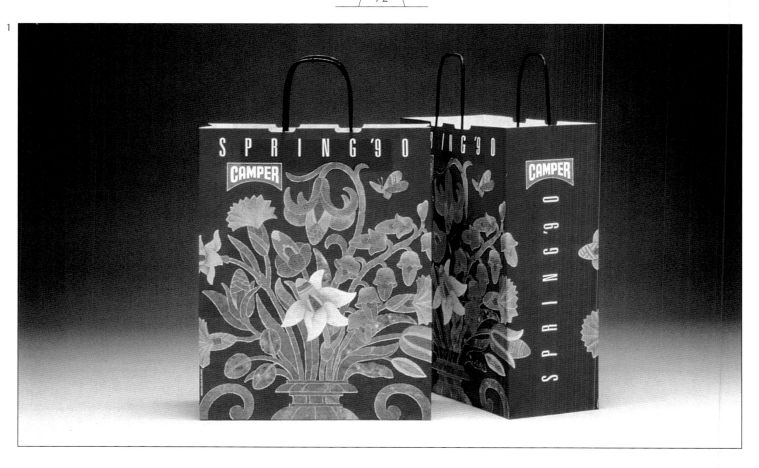

2

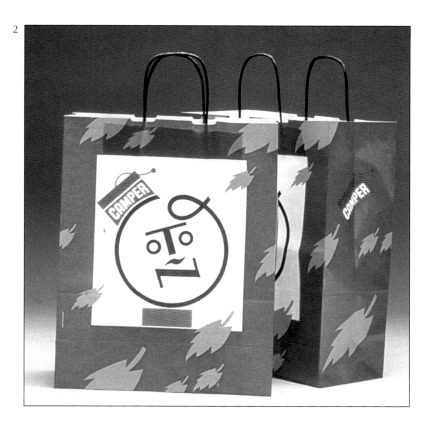

3

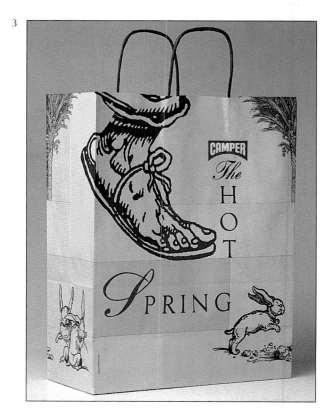

1
Design Firm CR Communication &
 Design Services
Art Director Carlos Rolando
Designer Carlos Rolando
Illustrator/Artist Carlos Rolando
Client/Store Camper; leading brand of
 casual shoes
Number of Colors 4 or 2

2
Design Firm CR Communication &
 Design Services
Art Director Carlos Rolando
Designer Carlos Rolando
Illustrator/Artist Carlos Rolando
Client/Store Camper; leading brand of
 casual shoes
Number of Colors 4 or 2

3
Design Firm CR Communication &
 Design Services
Art Director Carlos Rolando
Designer Carlos Rolando
Illustrator/Artist Carlos Rolando
Client/Store Camper; leading brand of
 casual shoes
Number of Colors 4 or 2

1

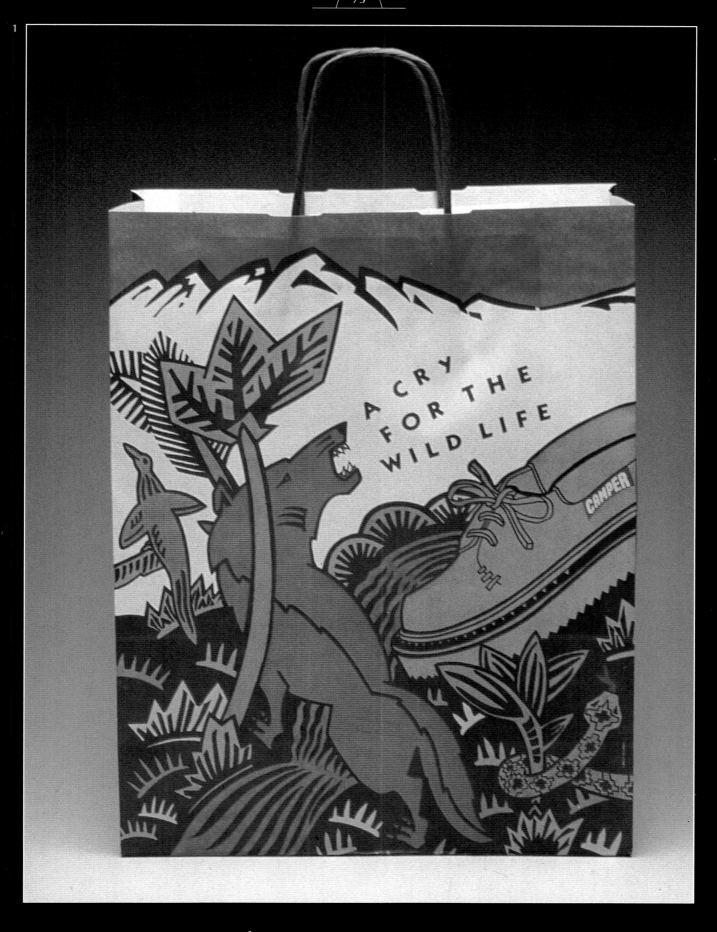

1
Design Firm CR Communication & Design Services
Art Director Carlos Rolando
Designer Carlos Rolando
Illustrator/Artist Carlos Rolando
Client/Store Camper; leading brand of casual shoes
Number of Colors 4 or 2

1

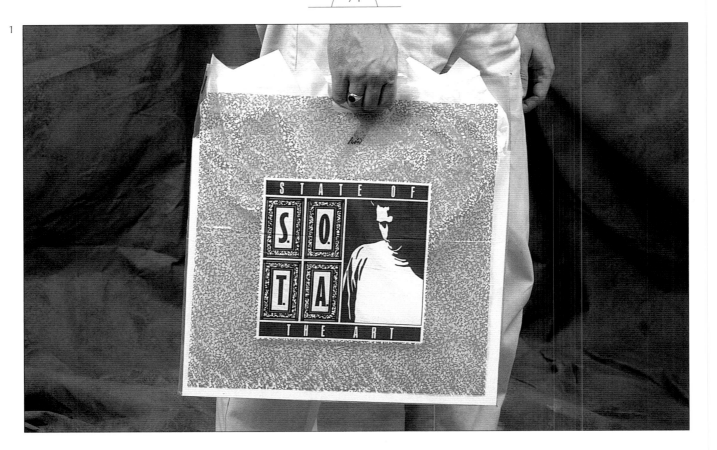

2

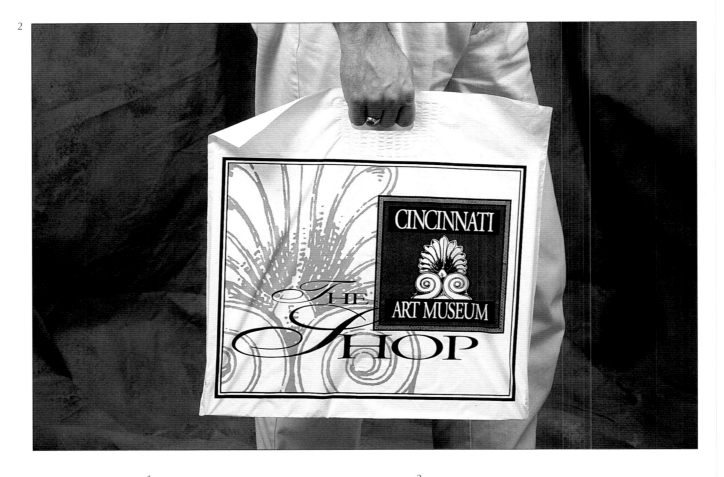

1
Design Firm Marsh, Inc.
Art Director Greg Conyers
Designer Greg Conyers
Illustrator/Artist Greg Conyers
Client/Store State of the Art Men's Store
Number of Colors 3

2
Design Firm Marsh, Inc.
Art Director Greg Conyers
Designer Greg Conyers
Illustrator/Artist Greg Conyers
Client/Store Cincinnati Art Museum
Number of Colors 3

1

2

3

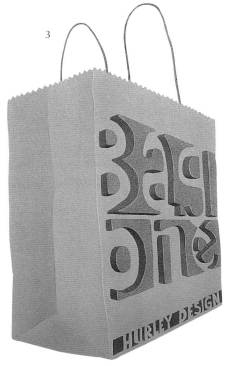

1
Design Firm Hurley Design Associates
Designer Greg Hurley
Illustrator/Artist Greg Hurley
Client/Store Conceptual
Number of Colors 3

2
Design Firm Hurley Design Associates
Designer Teresa Hurley
Illustrator/Artist Greg Hurley
Client/Store Conceptual
Number of Colors 3

3
Design Firm Hurley Design Associates
Designer Greg Hurley
Illustrator/Artist Greg Hurley
Client/Store Conceptual
Number of Colors 2

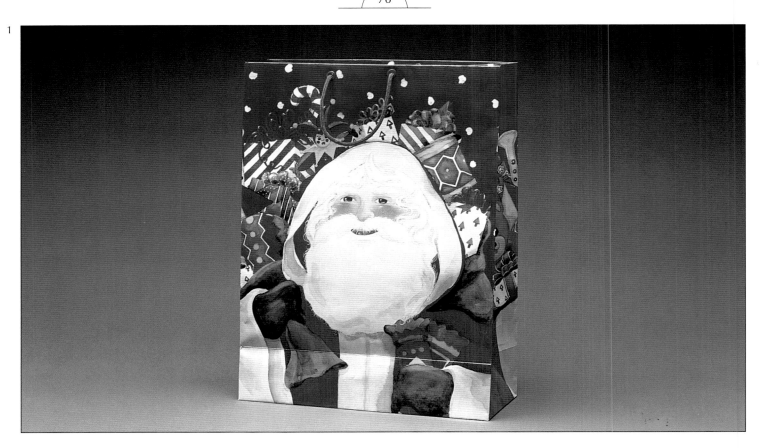

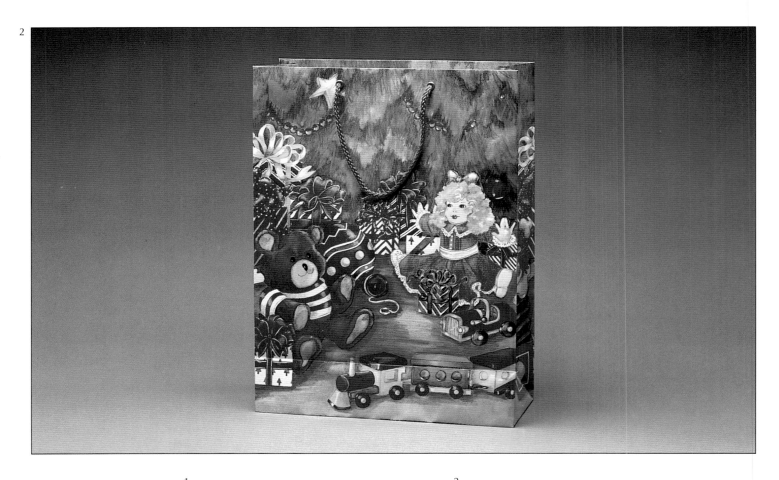

1
Design Firm Pier 1 Imports
Art Director Helene A. Firlik
Designer Helene A. Firlik
Illustrator/Artist Helene A. Firlik
Client/Store Pier 1 Imports
Number of Colors Full color

2
Design Firm Pier 1 Imports
Art Director Helene A. Firlik
Designer Helene A. Firlik
Illustrator/Artist Helene A. Firlik
Client/Store Pier 1 Imports
Number of Colors Full color

1

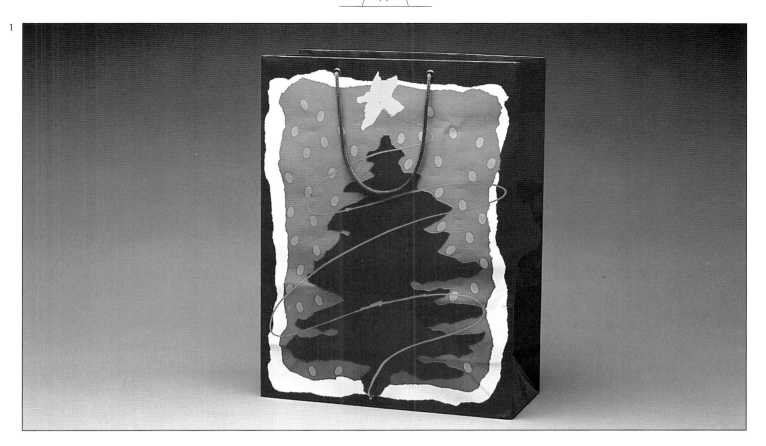

2

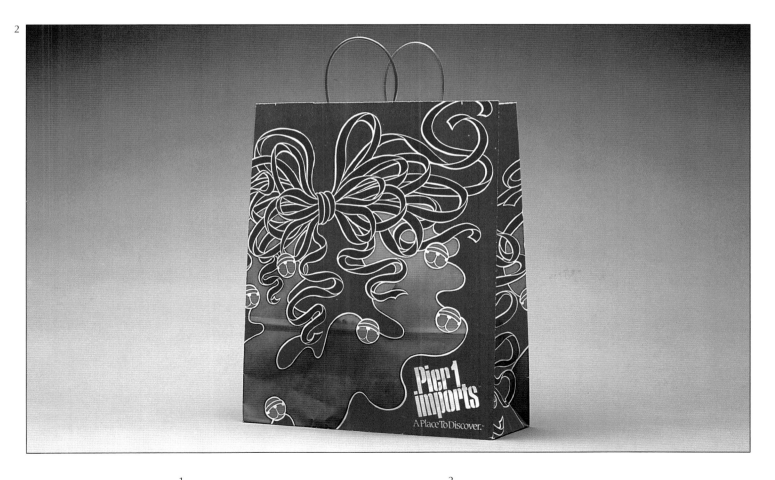

1
Design Firm Pier 1 Imports
Art Director Helene A. Firlik
Designer Helene A. Firlik
Illustrator/Artist Helene A. Firlik
Client/Store Pier 1 Imports
Number of Colors 6

2
Design Firm Pier 1 Imports
Art Director Helene A. Firlik
Designer Helene A. Firlik
Illustrator/Artist Helene A. Firlik
Client/Store Pier 1 Imports
Number of Colors 4

1
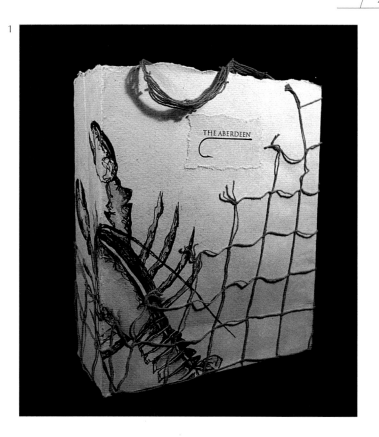

2
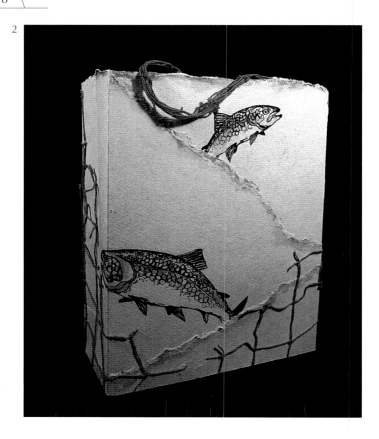

3
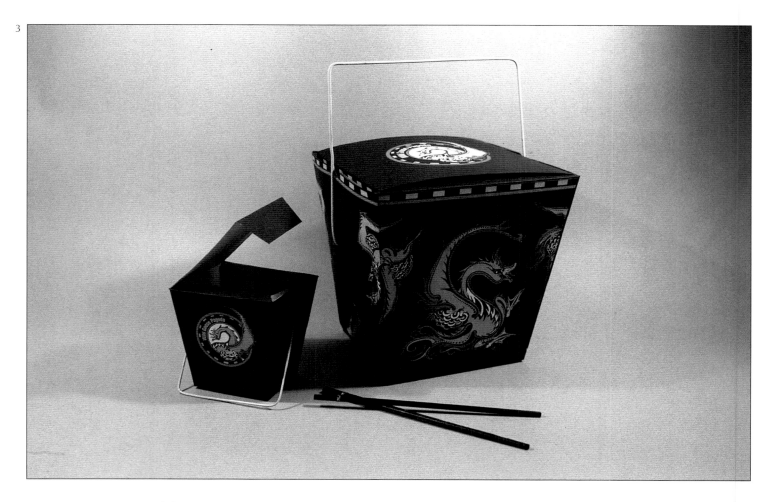

1, 2
Design Firm Art 497.I - Penn State University
Art Director Kristin Sommese
Designer Gennifer Ball
Client/Store The Aberdeen (Seafood Shop)
Number of Colors 4

3
Design Firm Art 497.I - Penn State University
Art Director Kristin Sommese
Designer Robinson Smith
Client/Store Wild Goose Pagoda
Number of Colors 4

1

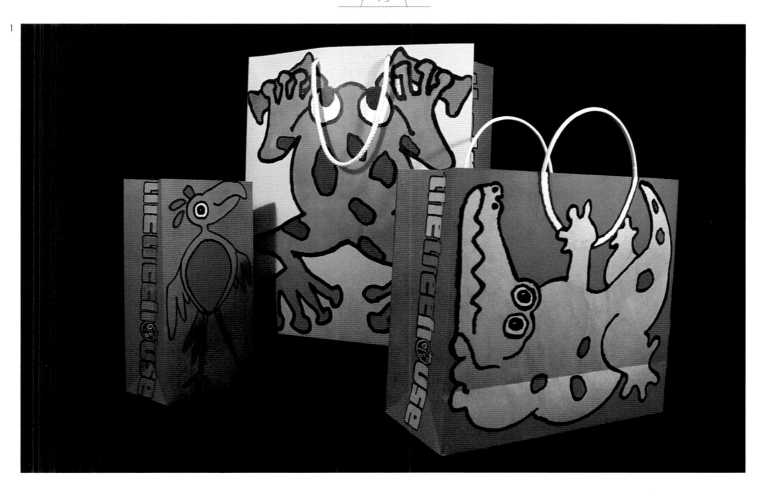

2

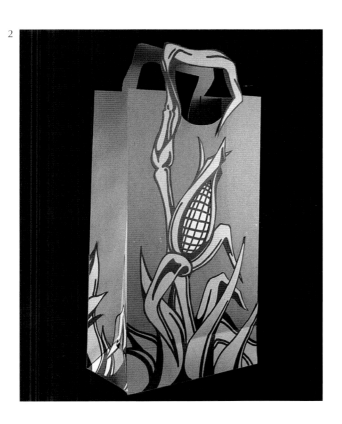

3

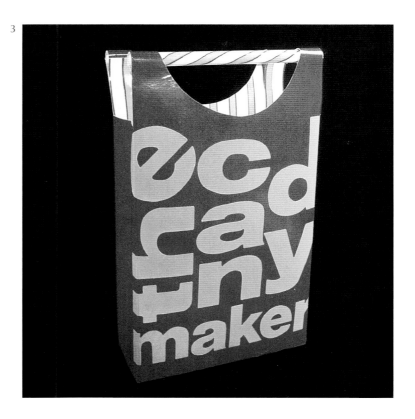

1
Design Firm Art 497.I - Penn State University
Art Director Kristin Sommese
Designer Dara Schminke
Illustrator/Artist Dara Schminke
Client/Store The Treehouse (Children's
Educational Toy and Book Store)
Number of Colors 5

2
Design Firm Art 497.I - Penn State University
Art Director Kristin Sommese
Designer Robinson Smith
Illustrator/Artist Robinson Smith
Client/Store Cornball (Novelty Shop)
Number of Colors 4

3
Design Firm Art 497.I - Penn State University
Art Director Kristin Sommese
Designer Wendy Seldomridge
Client/Store The Candy Maker
Number of Colors 2
Handles are edible!

1

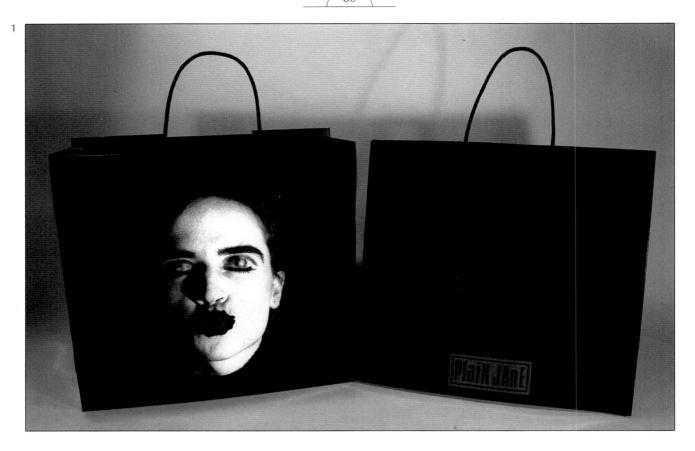

2

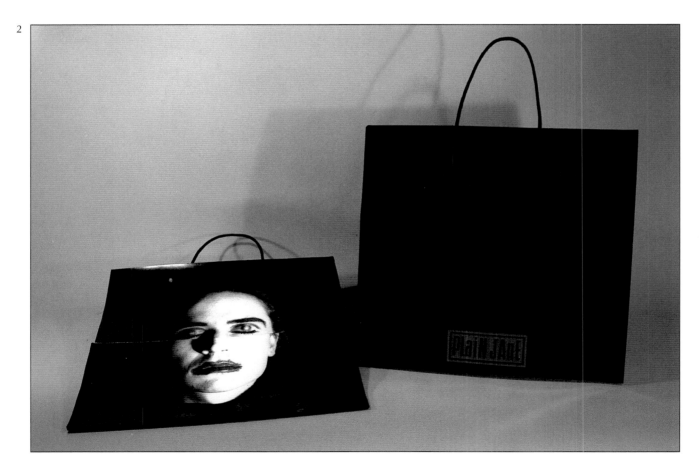

1, 2
Design Firm Art 497.I - Penn State University
Art Director Kristin Sommese
Designer Soung Wiser
Photographer Soung Wiser
Client/Store Plain Jane (Androgynous Clothing)
Number of Colors 3

This bag was designed so that the facial
expression changes when the bag is folded flat.

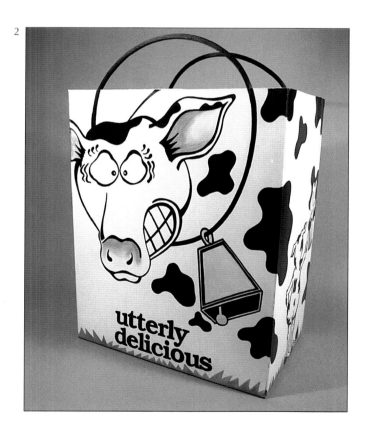

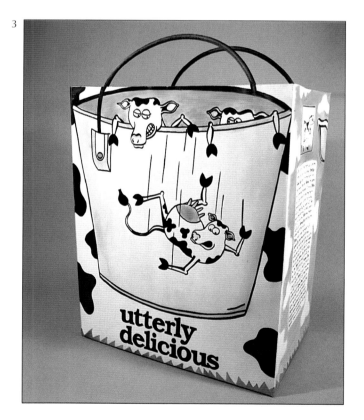

1
Design Firm Art 497.I - Penn State University
Art Director Kristin Sommese
Designer Kim Mingo
Client/Store Le Fromage (Cheese Shop)
Number of Colors 5

2, 3
Design Firm Art 497.I - Penn State University
Art Director Kristin Sommese
Designer Sal Lentini
Illustrator/Artist Sal Lentini
Client/Store Utterly Delicious (Dairy)
Number of Colors 5

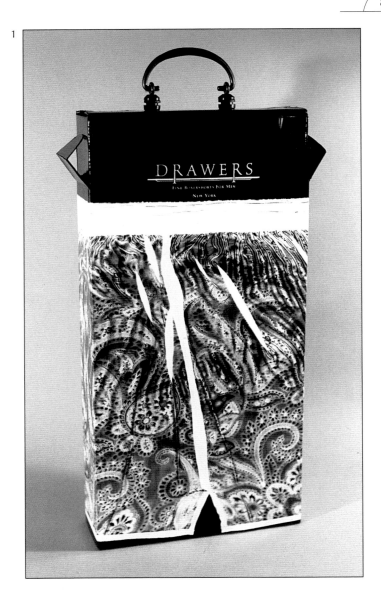

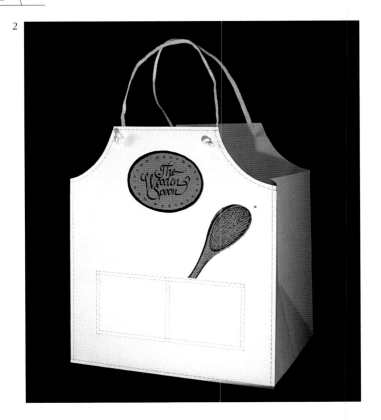

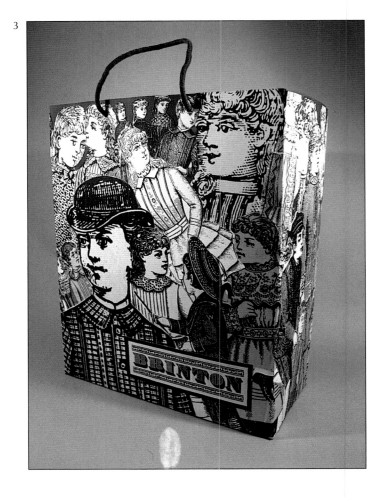

1
Design Firm Art 497.I - Penn State University
Art Director Kristin Sommese
Designer Brian Hatcher
Photographer Brian Hatcher
Client/Store Drawers (Men's Lingerie Store)
Number of Colors 2

2
Design Firm Art 497.I - Penn State University
Art Director Kristin Sommese
Designer Lee Miller
Client/Store The Wooden Spoon (Bakery)
Number of Colors 3

3
Design Firm Art 497.I - Penn State University
Art Director Kristin Sommese
Designer Mark Brinton
Client/Store Brinton (Antique Clothing Shop)
Number of Colors 4

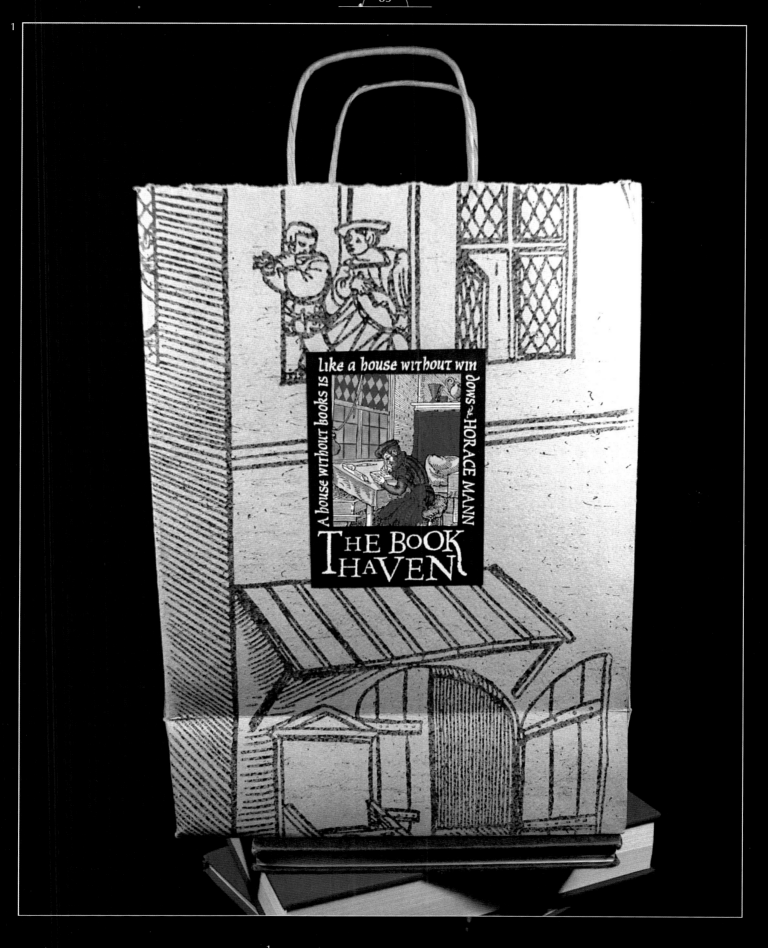

1
Design Firm Art 497.I - Penn State University
Art Director Kristin Sommese
Designer Bethany Bowles
Client/Store The Book Haven
Number of Colors 5

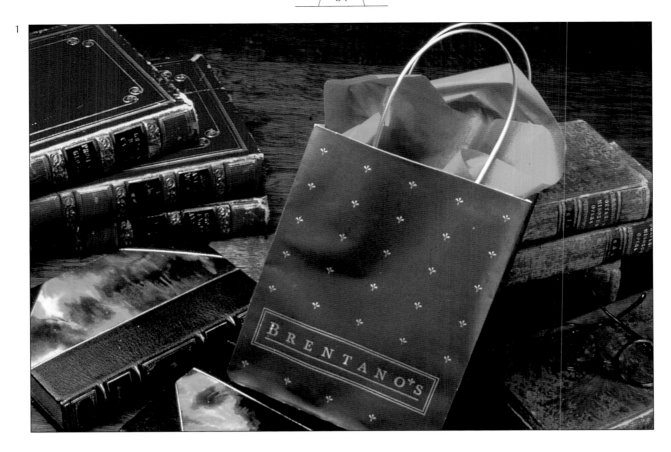

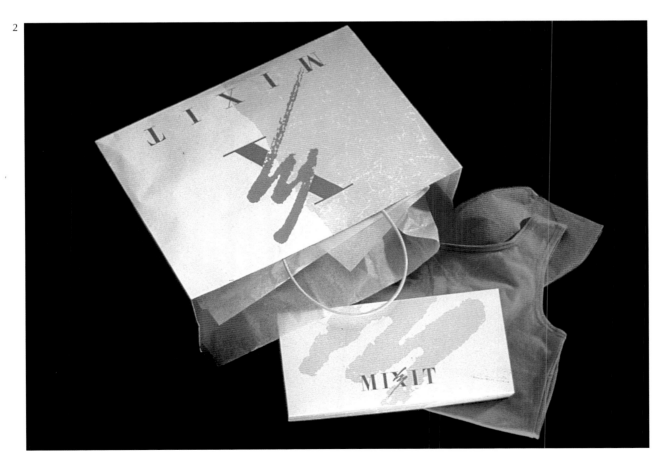

1, 2
Design Firm Landor Associates

1

2

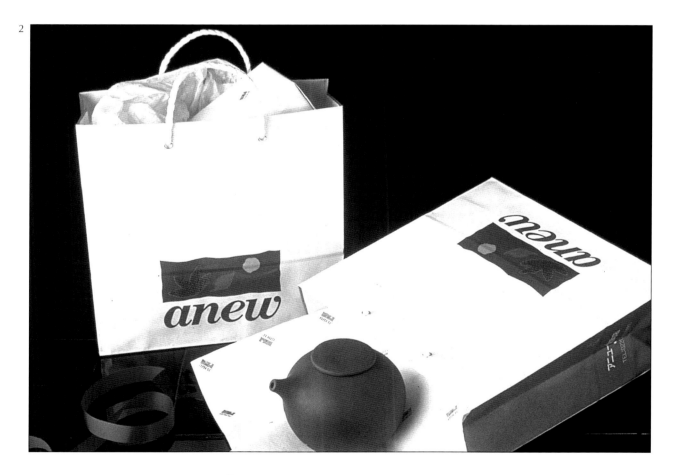

2
Design Firm Landor Associates
Project Director Y. Oba/Richard Kunj
Account Manager Jim Gillespie
Illustrator/Artist
Client/Store anew
Number of Colors

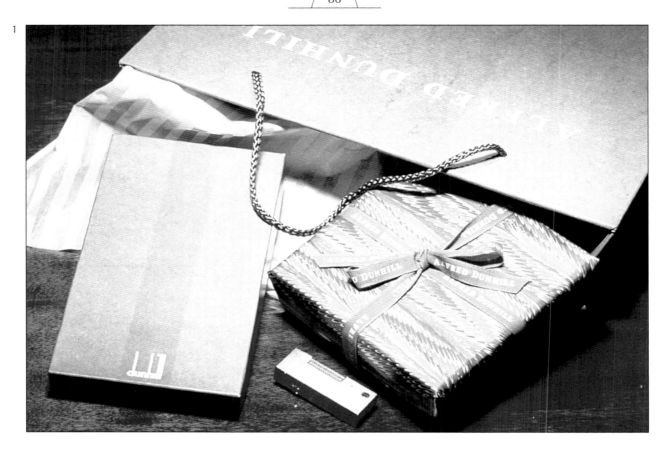

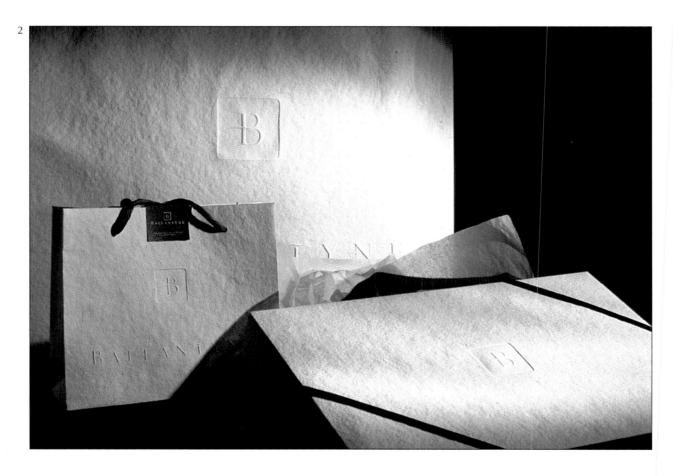

1, 2
Design Firm Landor Associates

1

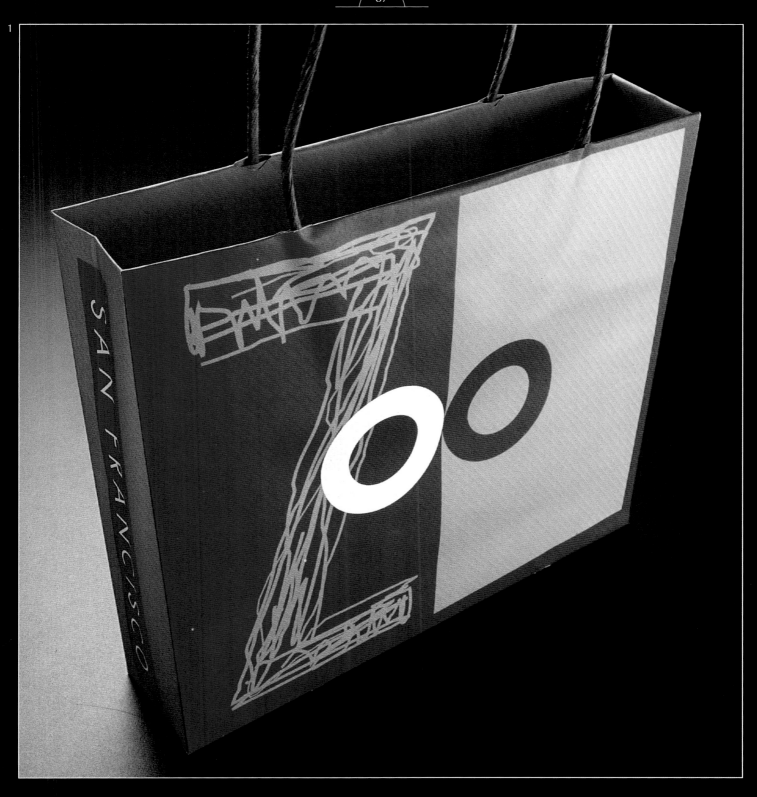

1
Design Firm Landor Associates
Art Director Courtney Reeser
Designer Sylvie Wada
Client/Store San Francisco Zoo
Number of Colors 2

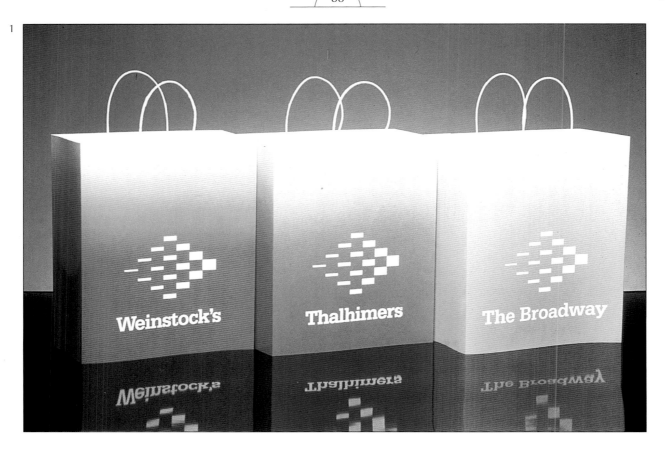

1
Design Firm Landor Associates
Art Director Tracy Moon
Designer Tracy Moon
Client/Store Carter, Hawley, Hale
Number of Colors 6

2
Design Firm MC Marketing & Design
Art Director Anna Mack
Designer Emilia Perussi
Illustrator/Artist Emilia Perussi
Client/Store Kolor Kollar
Number of Colors 4

1

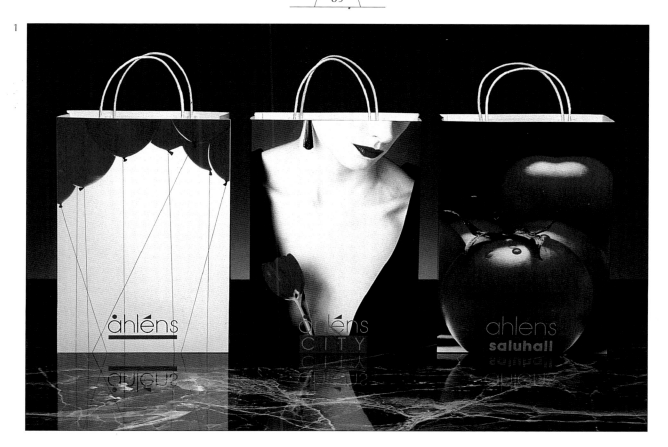

2

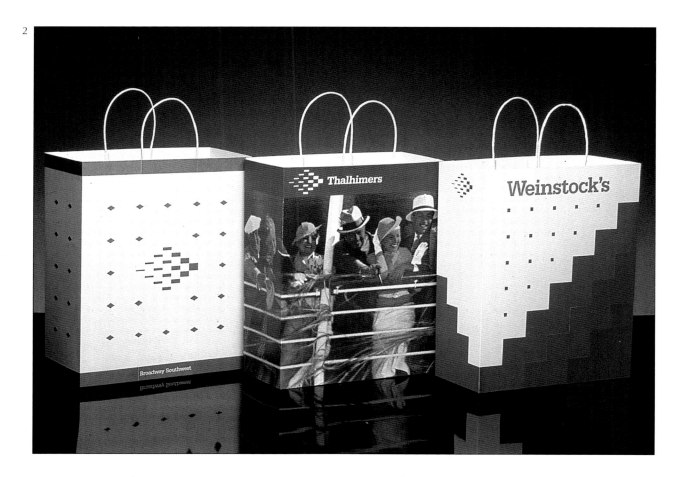

1
Design Firm Landor Associates
Art Director Craig Siegel
Designer Bobbie Long
Client/Store Ahléns
Number of Colors 4

2
Design Firm Landor Associates
Art Director Tracy Moon
Designer Tracy Moon
Client/Store Carter, Hawley, Hale
Number of Colors 6

1

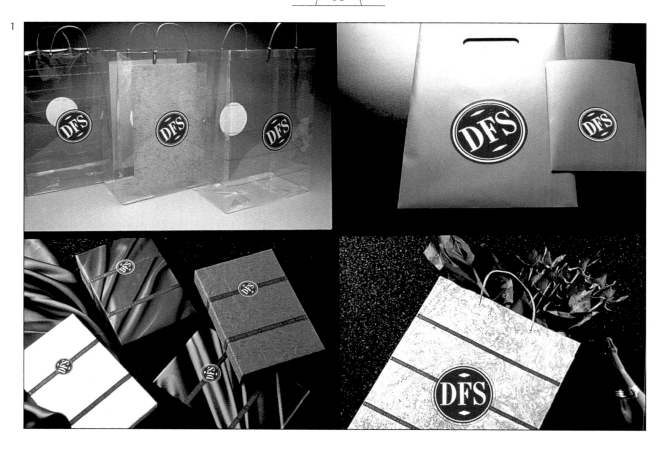

2

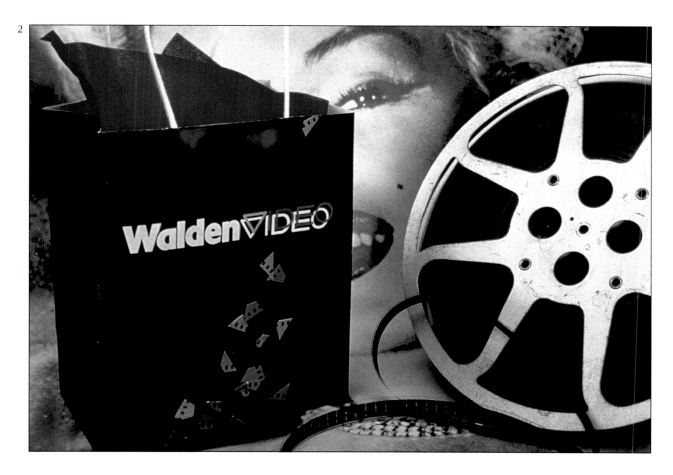

1
Design Firm Landor Associates
Art Director Fumi Sasada
Designer Hidetaka Matsunaga
Client/Store Duty Free Shoppers (DFS)
Number of Colors 4

2
Design Firm Landor Associates
Client/Store Walden Video

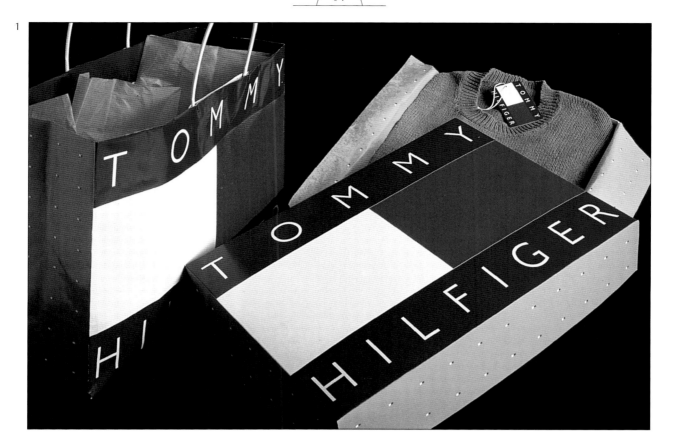

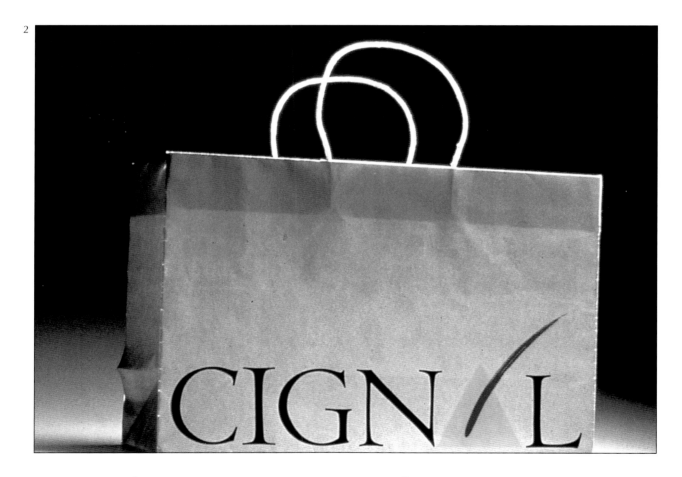

1
Design Firm Landor Associates
Art Director Ken Cooke
Designer Courtney Reeser
Client/Store Murjani/Tommy Hilfiger
Number of Colors 3

2
Design Firm Landor Associates
Client/Store Cignal

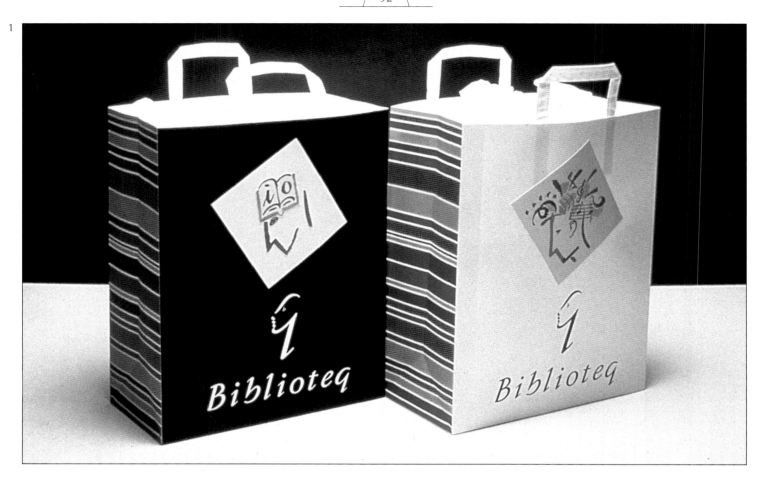

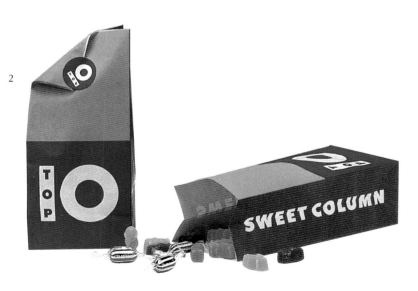

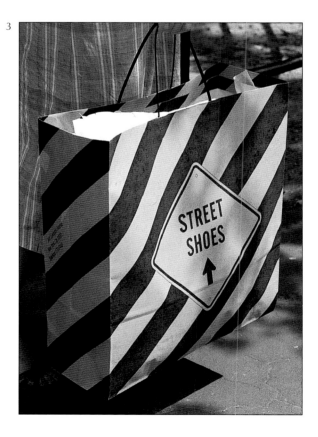

1
Design Firm Landor Associates
Client/Store Bibliotec

2
Design Firm Landor Associates
Art Director Richard Ford
Designer Fran Lane
Illustrator/Artist Fran Lane
Client/Store News International
Number of Colors 3

3
Design Firm Pentagram Design
Art Director Colin Forbes
Designer Dan Friedman
Client/Store Street Shoes
Number of Colors 1 and black

1

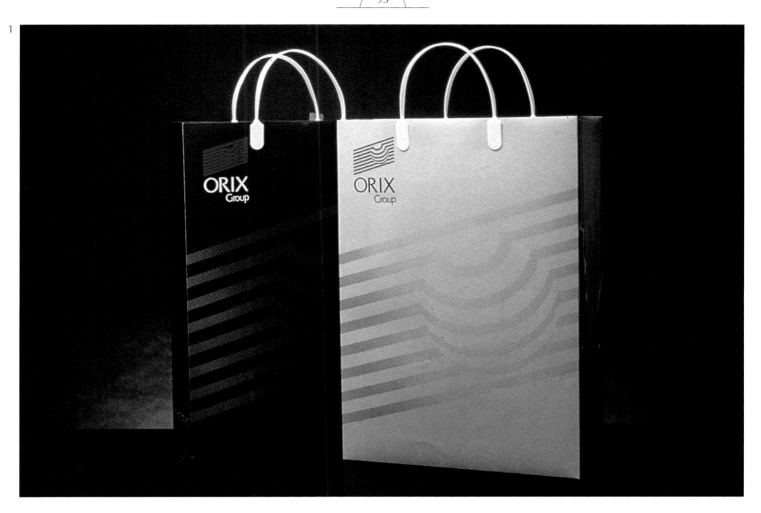

2

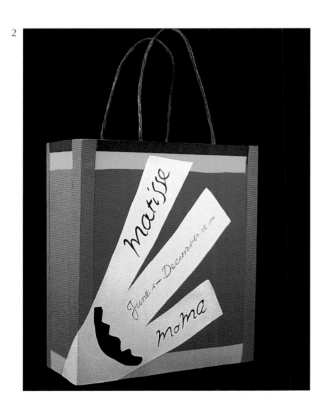

3

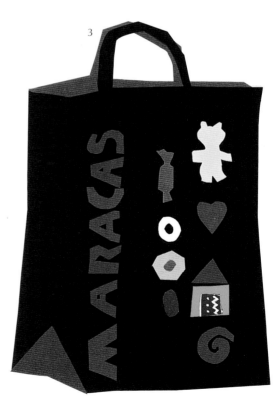

1
Design Firm Landor Associates
Art Director Taku Miyamura
Designer Yoko Yorikuni
Client/Store Orix Rent-A-Car
Number of Colors 5

2
Art Director Alexandra Marculewicz
Designer Alexandra Marculewicz
Illustrator/Artist Alexandra Marculewicz
Client/Store Museum of Modern Art
Number of Colors 4

3
Design Firm Karyl Klopp Design
Art Director Karyl Klopp
Designer Karyl Klopp
Illustrator/Artist Karyl Klopp
Client/Store Maracas (Candy Distributor)
Number of Colors 6

1

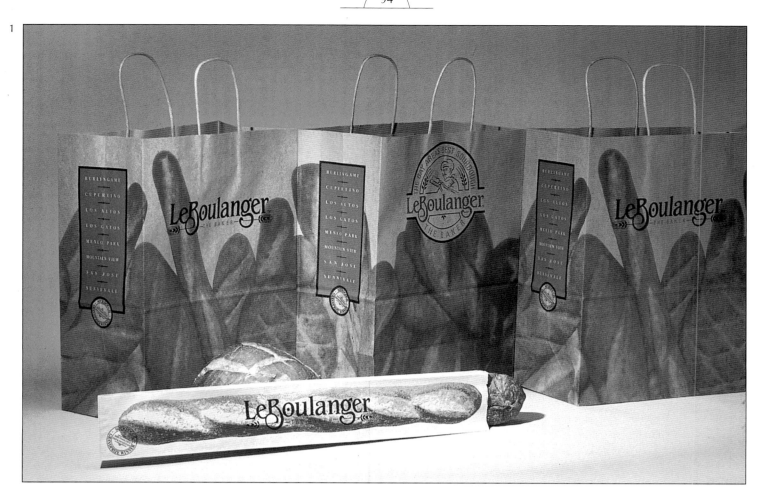

2

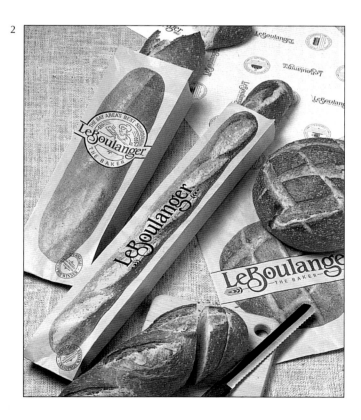

1
Design Firm THARP DID IT
Art Director Rick Tharp
Designer Rick Tharp/Jean Mogannam
Photographer Kelly O'Connor
Client/Store Le Boulanger (bakeries)
Number of Colors 3

The photo wraps around the bag and creates a mural effect when placed in multiple groupings.

2
Design Firm THARP DID IT
Art Director Rick Tharp
Designer Rick Tharp/Jean Mogannam
Photographer Kelly O'Connor
Client/Store Le Boulanger (bakeries)
Number of Colors 2

1

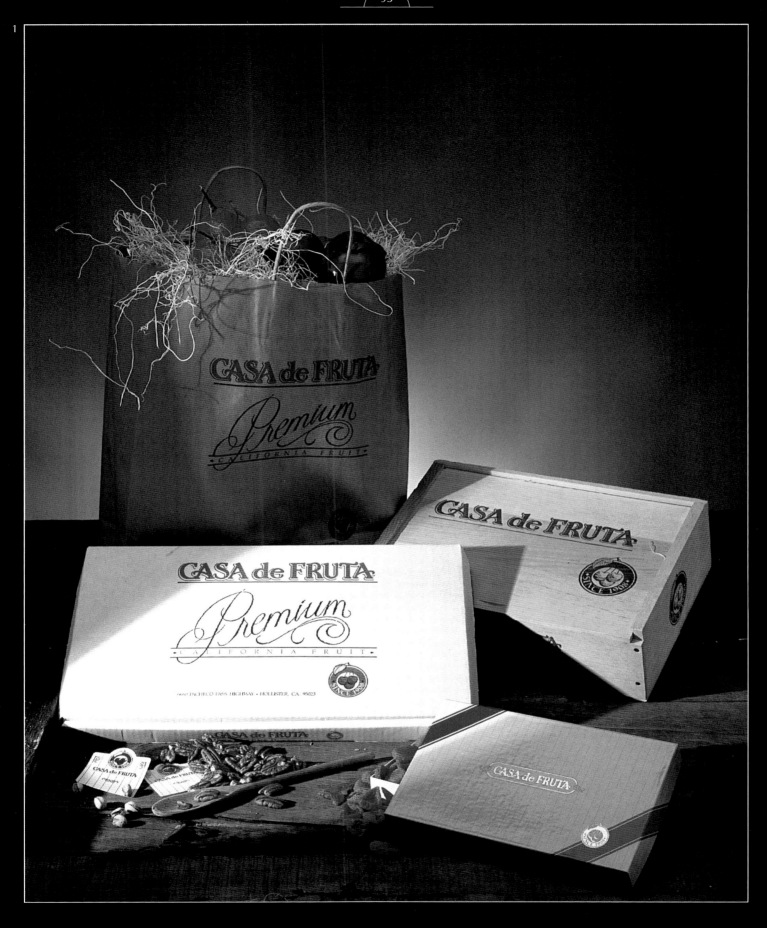

1
Design Firm THARP DID IT
Art Director Rick Tharp
Designer Rick Tharp/Kim Tomlinson
Client/Store Casa de Fruta
Number of Colors 2

1

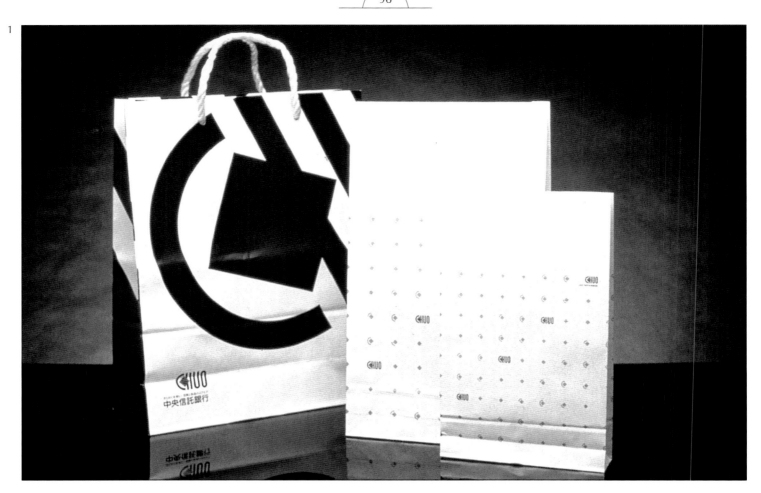

2

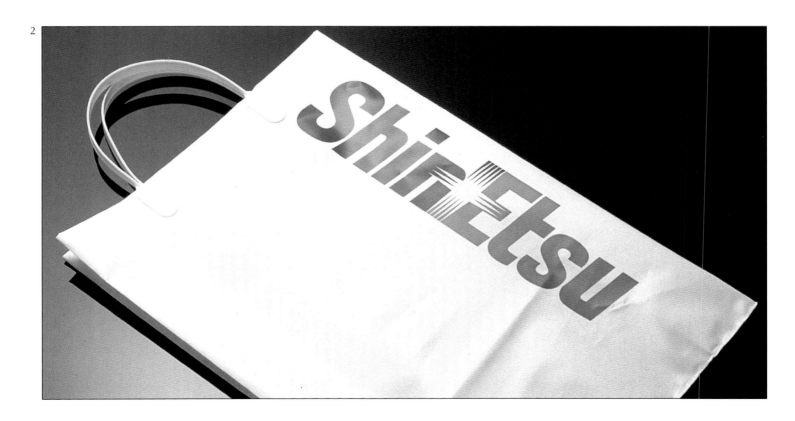

2
Design Firm Landor Japan
Design Director Osamu Ieda
Account Director Mikimo Myazawa
Client/Store Shin Etsu Chemical

1

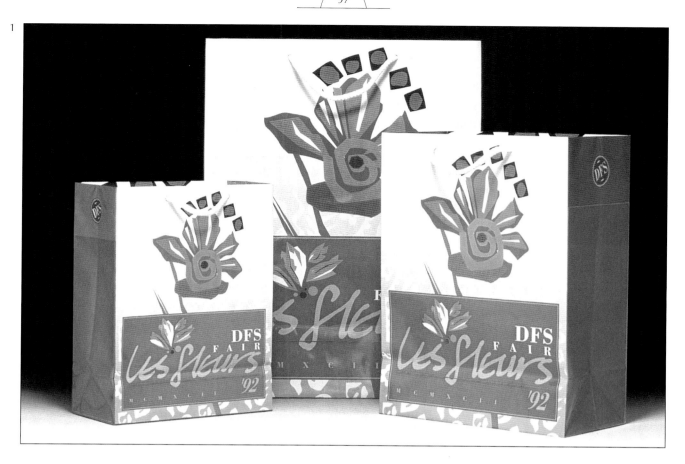

2

2
Design Firm Landor Japan
Design Director Osamu Ieda
Account Director Mikimo Miyazawa

1
Design Firm Landor Japan
Client/Store Jusco

2
Design Firm Landor Japan
Project Director Jerry Kuyper/Fumi Sasada
Account Manager Mim Ryan
Client/Store Fuji Bank

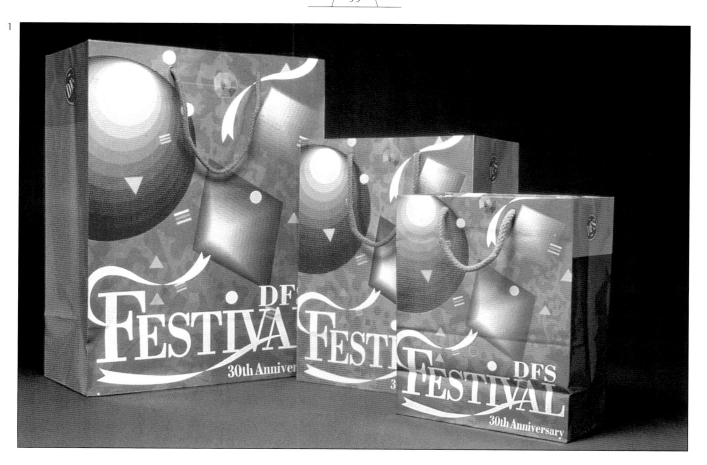

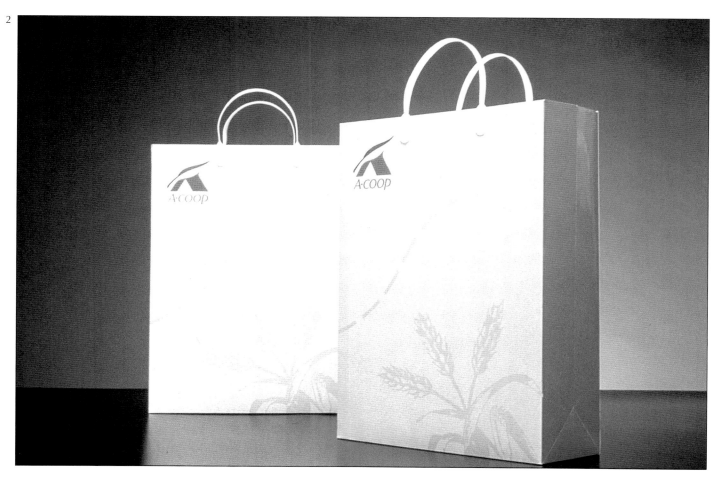

1
Design Firm Landor Japan
Client/Store DFS Festival

2
Design Firm Landor Japan
Design Director Taku Miyamura
Account Director Shyetaka Saka
Client/Store A Coup

1

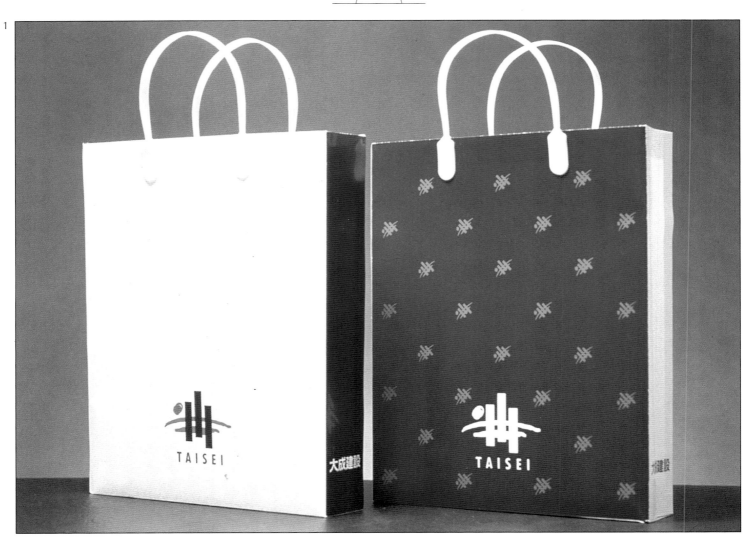

2

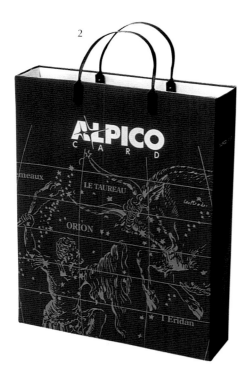

3

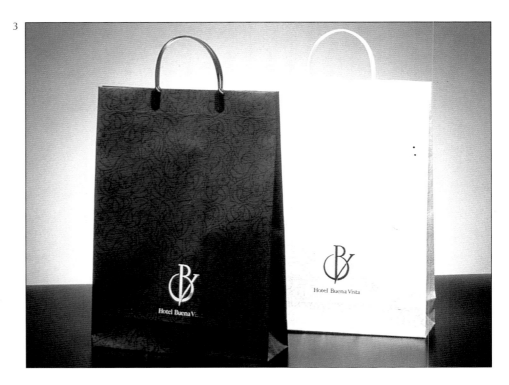

1
Design Firm Landor Japan
Design Director Taku Miyamura
Account Director Shyetaka Saka
Client/Store Taisei Corp.

2
Design Firm Landor Japan
Design Director Taku Miyamura
Account Director Shyetaka Saka
Client/Store Alpko Grop

3
Design Firm Landor Japan
Client/Store Hotel Buena Vista

1

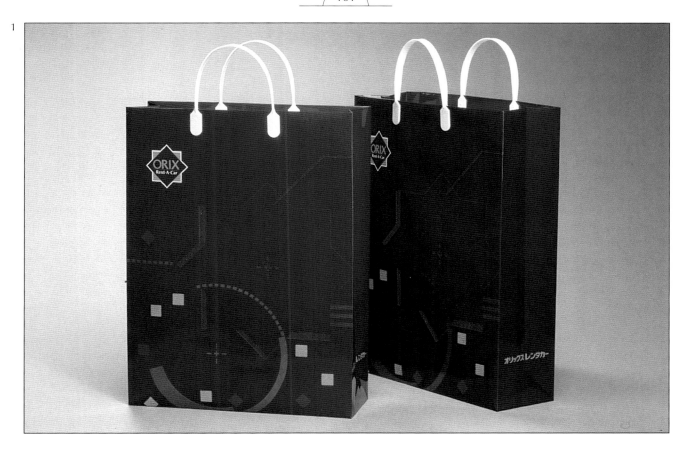

2

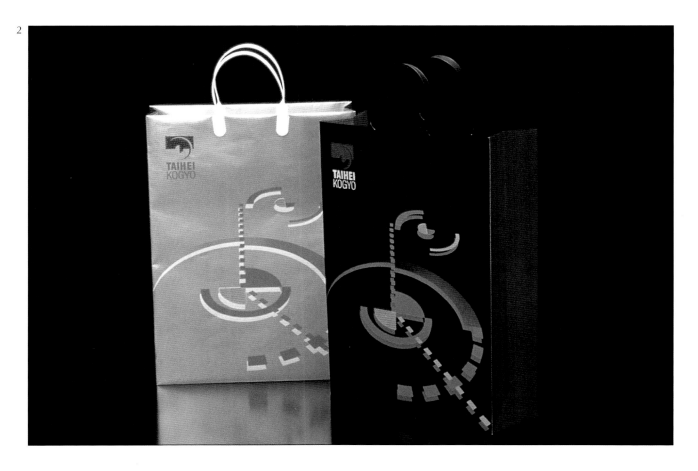

1
Design Firm Landor Japan
Design Director Osamu Ieda
Account Director Mikimo Miyazawa
Client/Store Taihei Kojyou Co. Ltd.

2
Design Firm Landor Japan
Art Director
Designer
Illustrator/Artist
Client/Store
Number of Colors

1

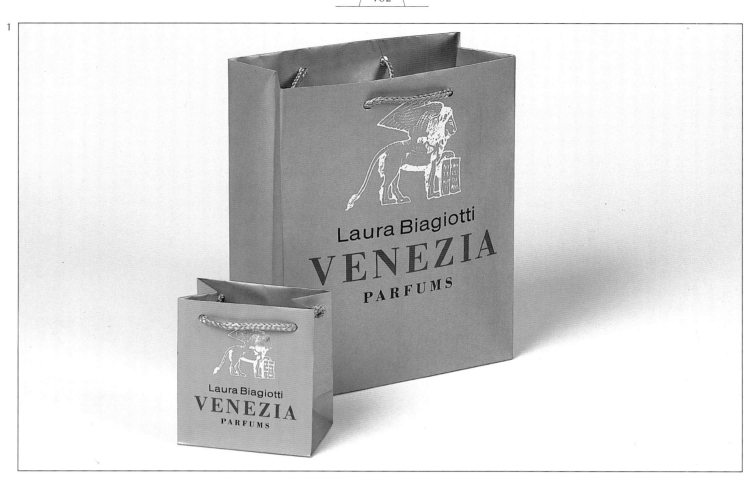

2

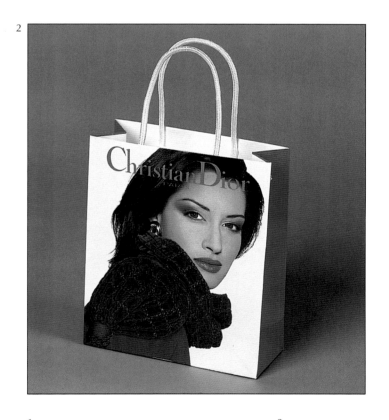

3

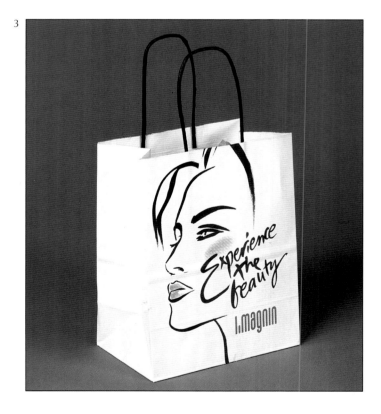

1
Design Firm S. Posner Sons Inc.
Designer Santo Fareri/Ketan Patel
Client/Store Eurocas U.S.A. for
 Laura Biagiotti - Venezia
Number of Colors 3 color and gold stamp

2
Design Firm S. Posner Sons Inc.
Art Director Berett Fisher
Client/Store Christian Dior
Number of Colors 4 color process + 1

3
Design Firm I. Magnin Advertising
Art Director Robert Corder
Designer Robert Corder
Illustrator/Artist Mary Hinkley/R. Corder
Client/Store I. Magnin & Co.
Number of Colors 2

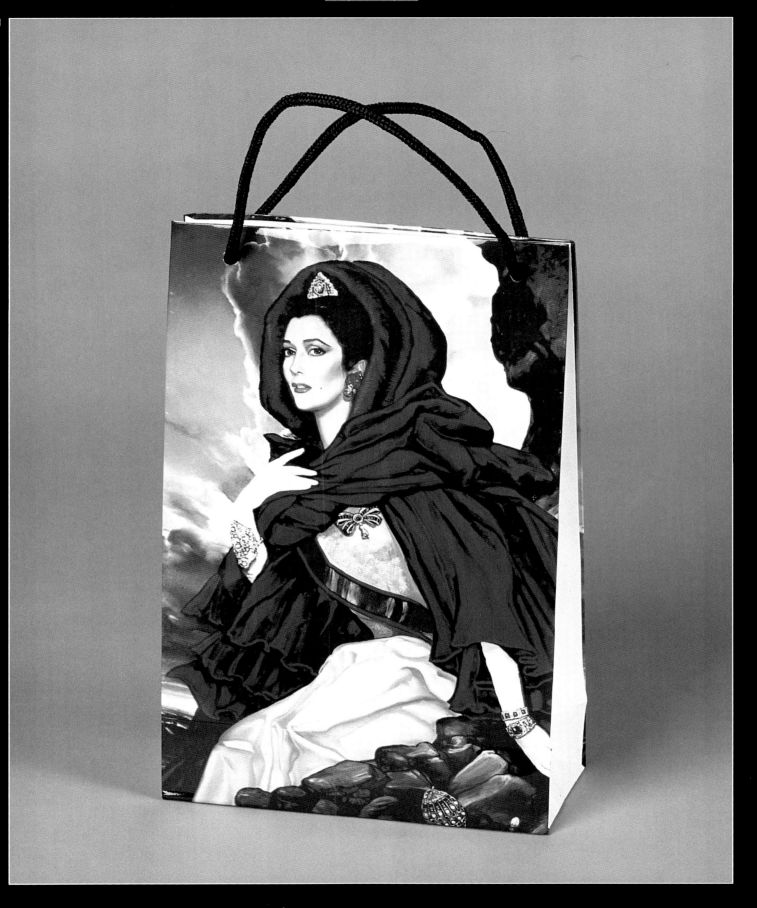

1
Design Firm S. Posner Sons Inc.
Illustrator/Artist Ralph Wolfe Cowan
Client/Store Lilly Lawrence
Number of Colors 4 color process

1

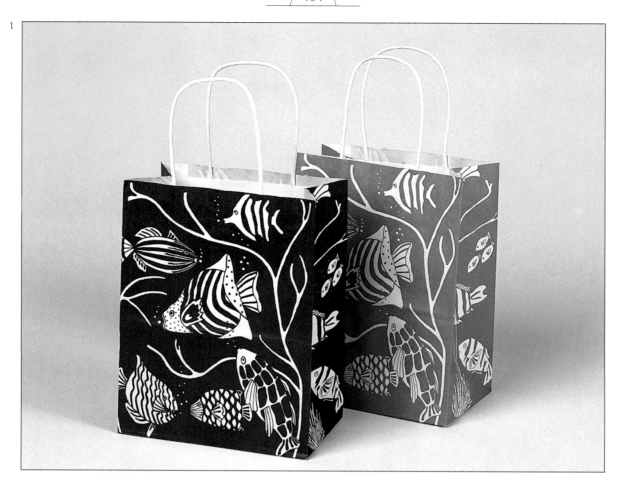

2

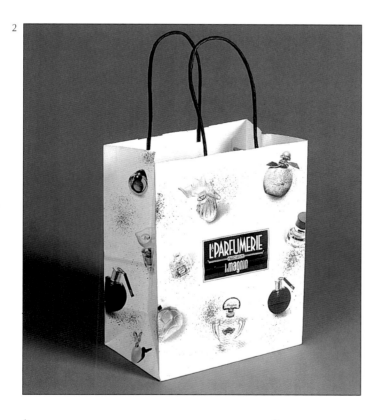

3

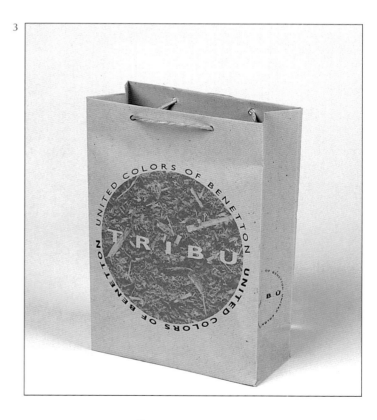

1
Art Director Dana Riddle
Client/Store SampleHouse
Number of Colors 1

2
Design Firm I. Magnin Advertising
Art Director Robert Corder
Designer Robert Corder
Photography Paul Berg
Client/Store I. Magnin & Co.
Number of Colors 2

3
Design Firm Tamotsu Yagi
Illustrator/Artist Tamotsu Yagi/
 Giorgio Baravelle
Client/Store Benetton - TRIBU
Number of Colors 3 on Speckletone Kraft
 uncoated

1

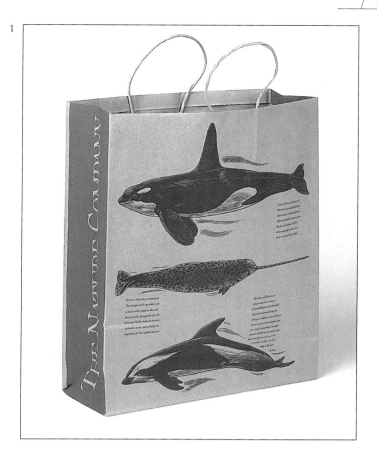

2

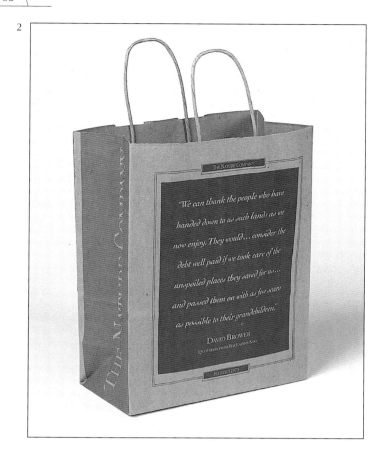

3

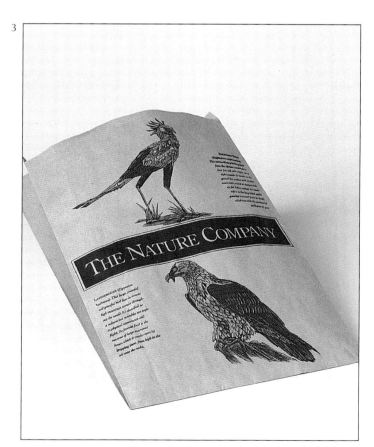

4

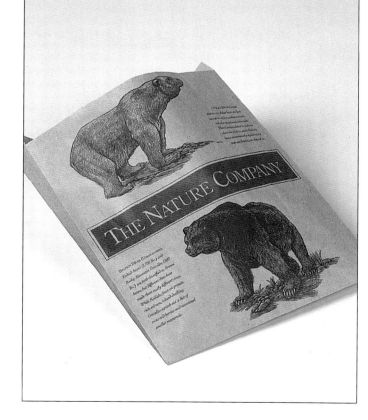

1/2
Design Firm The Nature Company Graphics Dept.
Art Director Amy Knapp
Designer Jane McCampbell
Illustrator/Artist Rik Olson
Client/Store The Nature Company
Number of Colors 2 soy based inks on Kraft paper

3/4
Design Firm The Nature Company Graphics Dept.
Art Director Amy Knapp
Designer Jane McCampbell
Illustrator/Artist Rik Olson
Client/Store The Nature Company
Number of Colors 2 soy based inks on Kraft paper

1

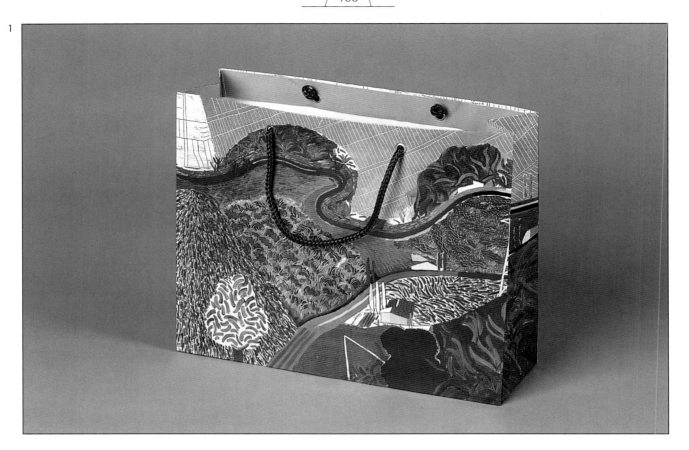

2

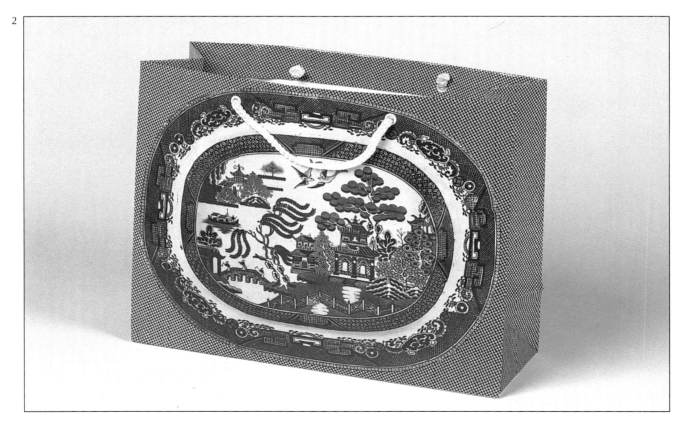

1
Design Firm Los Angeles County Museum of Art -
 Graphic Design Department
Designer Sandy Bell
Illustrator/Artist David Hockney "Mulholland
 Drive: The Road to the Studio" 1980
Client/Store Los Angeles County Museum of Art -
 Museum Shops
Number of Colors 4

2
Art Director Dana Riddle
Client/Store SampleHouse

1

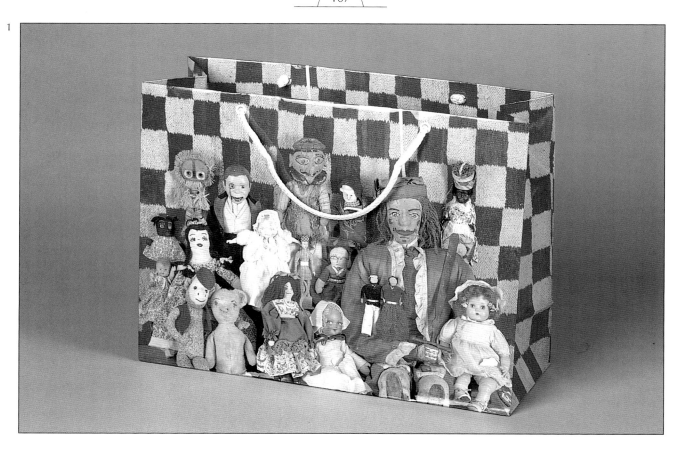

2

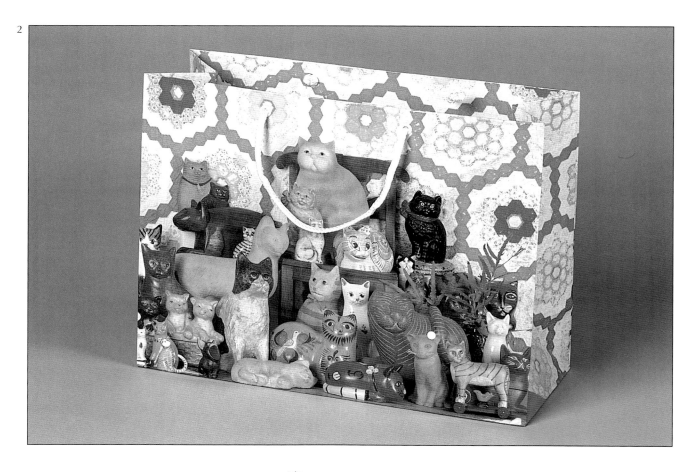

1/2
Art Director Dana Riddle
Client/Store SampleHouse

1

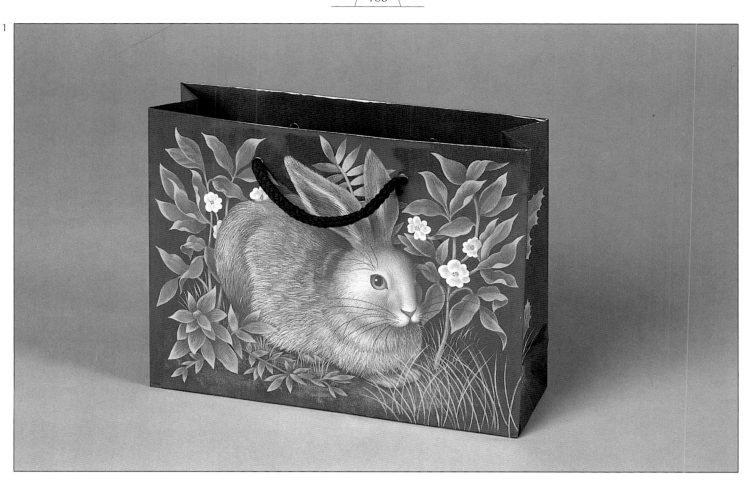

2

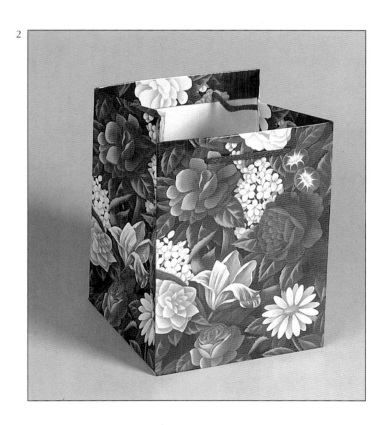

3

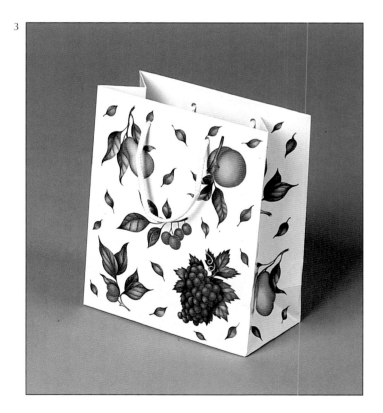

1
Art Director Paul Bilsky
Designer Linda DeVito Soltis
Illustrator/Artist Linda DeVito Soltis
Client/Store The Stephen Lawrence Company

2/3
Art Director Linda DeVito Soltis
Designer Linda DeVito Soltis
Illustrator/Artist Linda DeVito Soltis
Client/Store The Stephen Lawrence Company

1

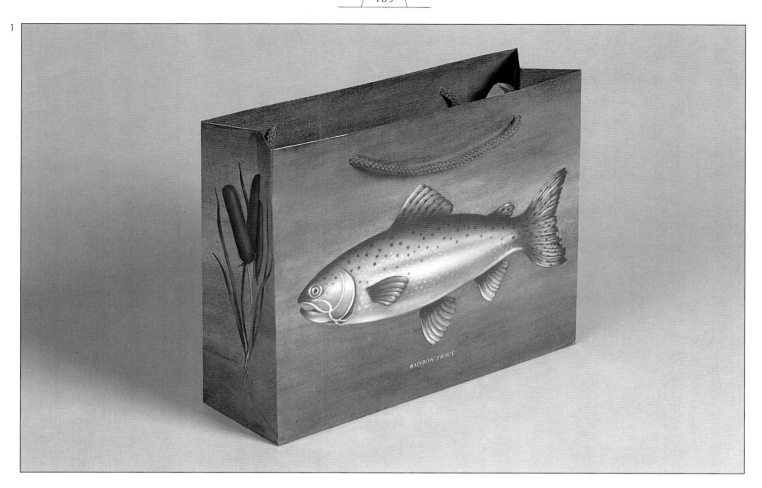

2

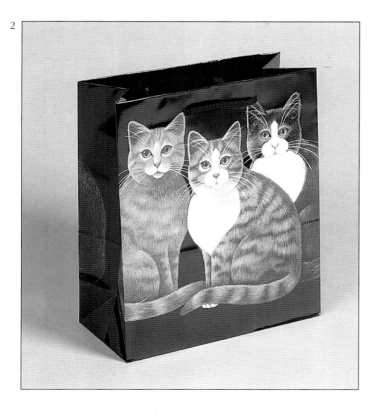

3

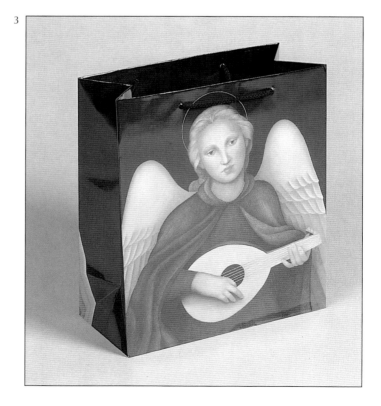

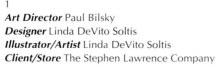

1
Art Director Paul Bilsky
Designer Linda DeVito Soltis
Illustrator/Artist Linda DeVito Soltis
Client/Store The Stephen Lawrence Company

2/3
Art Director Linda DeVito Soltis
Designer Linda DeVito Soltis
Illustrator/Artist Linda DeVito Soltis
Client/Store The Stephen Lawrence Company

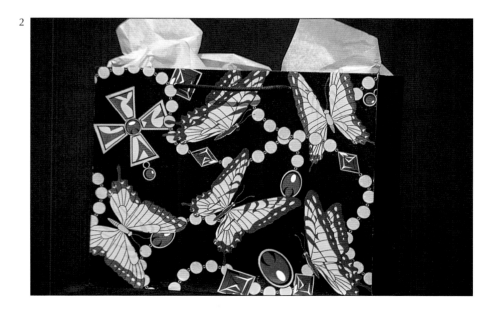

1
Design Firm Sayles Graphic Design
Art Director John Sayles
Designer John Sayles
Illustrator/Artist John Sayles
Client/Store 801 Steak & Chop House
Number of Colors 3

2
Design Firm The Watermark Collection
Art Director Lori Wynn-Ferber
Designer Zorch Designs
Illustrator/Artist Joel Shafor
Client/Store Matisse pour Elle
Number of Colors 6

1

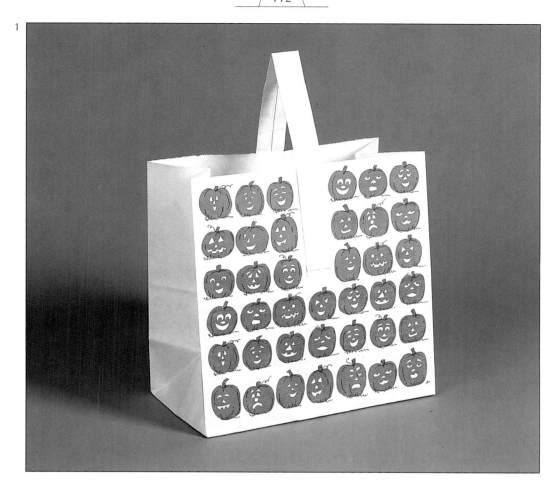

2

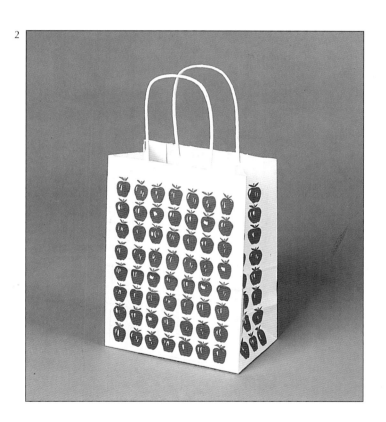

3

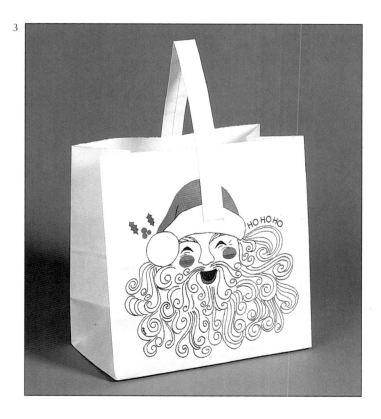

1–3
Art Director Dana Riddle
Client/Store SampleHouse

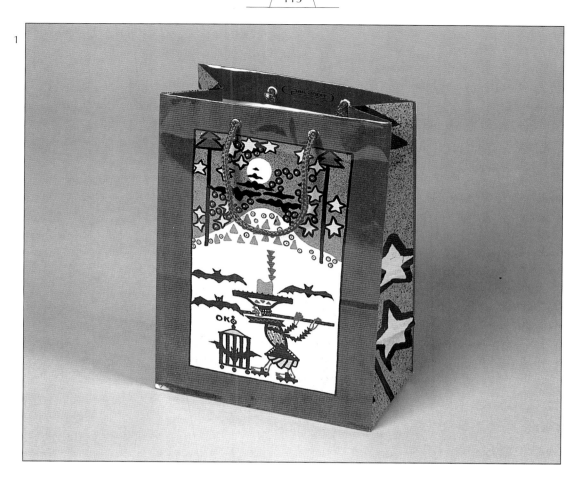

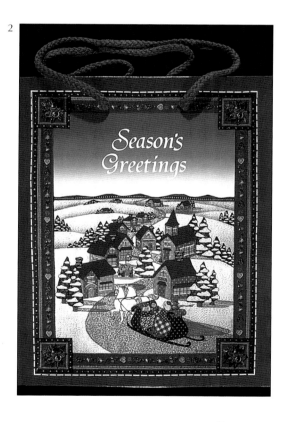

1
Design Firm Los Angeles Museum of Art -
 Graphic Design Department
Designer Jim Drobka
Illustrator/Artist Oskar Kokoschka "Flautist and
 Bats" 1906-1908
Client/Store Los Angeles Museum of Art -
 Museum Shops
Number of Colors 4

2
Illustrator/Artist Margaret Cusak
Client/Store Berwick Industries

3
Art Director Dana Riddle
Client/Store SampleHouse

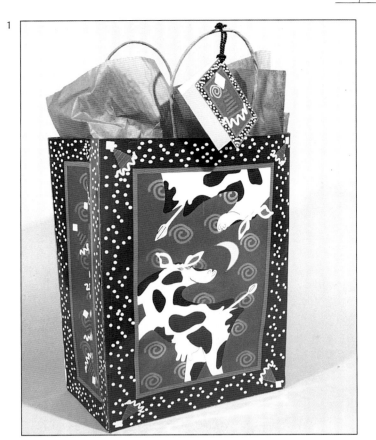

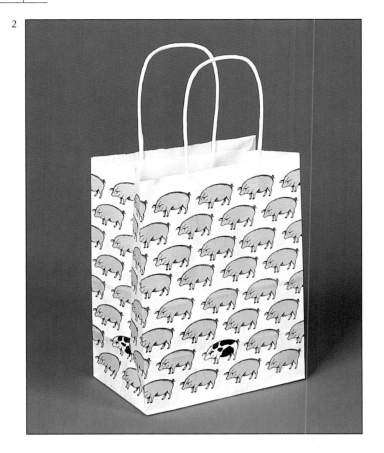

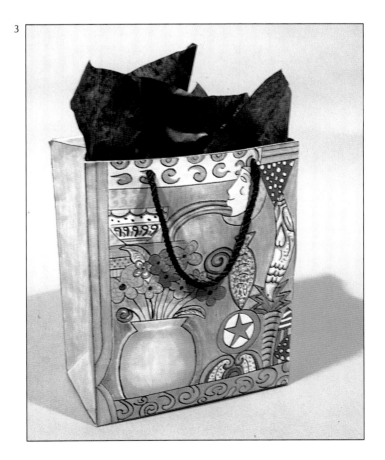

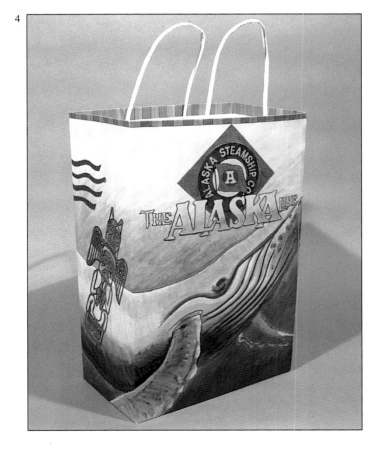

1
Design Firm ACA College of Design
Art Director Cyndi Mendell/
 Dan Devlin
Illustrator/Artist Pat Meissner
Number of Colors 4

2
Art Director Dana Riddle
Client/Store SampleHouse

3
Design Firm ACA College of Design
Art Director Cyndi Mendell/
 Dan Devlin
Designer Annee Galtier
Illustrator/Artist Annee Galtier
Number of Colors 4

4
Design Firm ACA College of Design
Art Director Roy Waits/
 Cyndi Mendell
Designer Nanci Geideman
Illustrator/Artist Nanci Geideman
Number of Colors 4

1

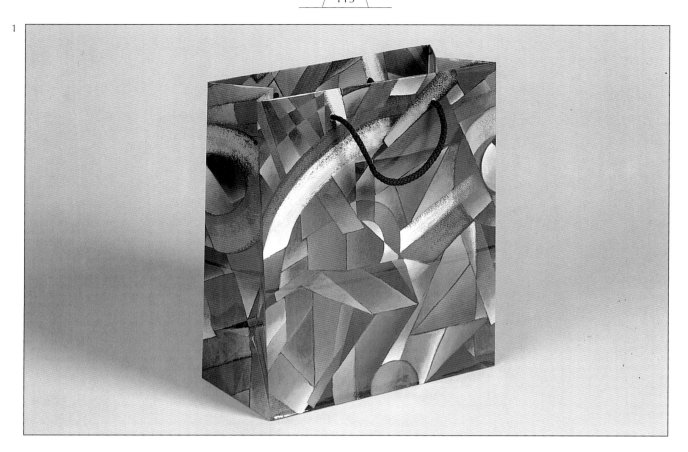

2

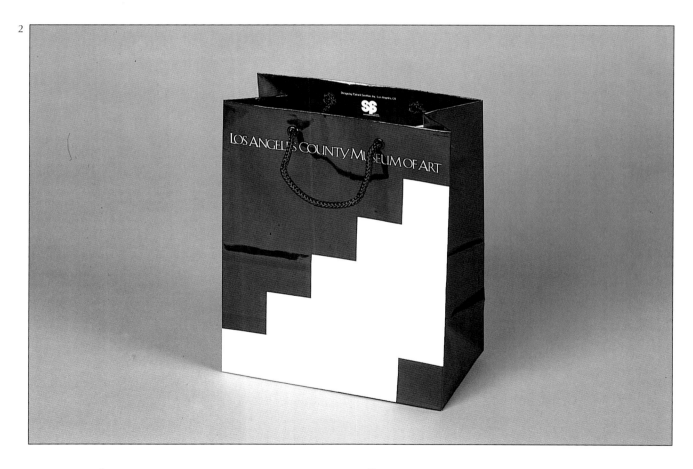

1
Art Director Linda DeVito Soltis
Designer Linda DeVito Soltis
Illustrator/Artist Linda DeVito Soltis
Client/Store The Stephen Lawrence Company

2
Design Firm Garber SooHoo Design
Designer Patrick SooHoo
Illustrator/Artist Patrick SooHoo
Client/Store Los Angeles County Museum of Art -
 Museum Shops

1

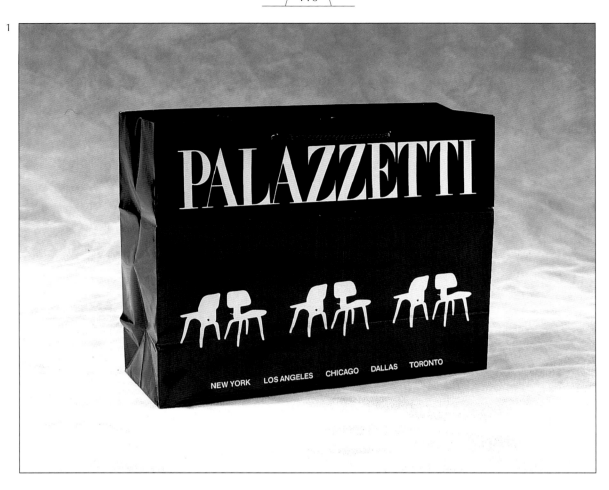

2

3

1
Design Firm Palazzetti
Art Director Jimi Napoli
Designer Lucia Palazzetti
Number of Colors 2

2
Design Firm Shelby Designs & Illustrates
Shopping Bag Manufacturer Duro Designers
Grocery Bag Manufacturer Longview Fibre Co.
Butcher Tape Manufacturer Printed Tape Assoc.
Distributor Brilliant Bags & Boxes
Number of Colors 1

3
Design Firm Art & Function, Santiago
Art Director Suzanne De Loughry/José Neira
 Délano
Designer Suzanne De Loughry
Client/Store Ripley Department Stores

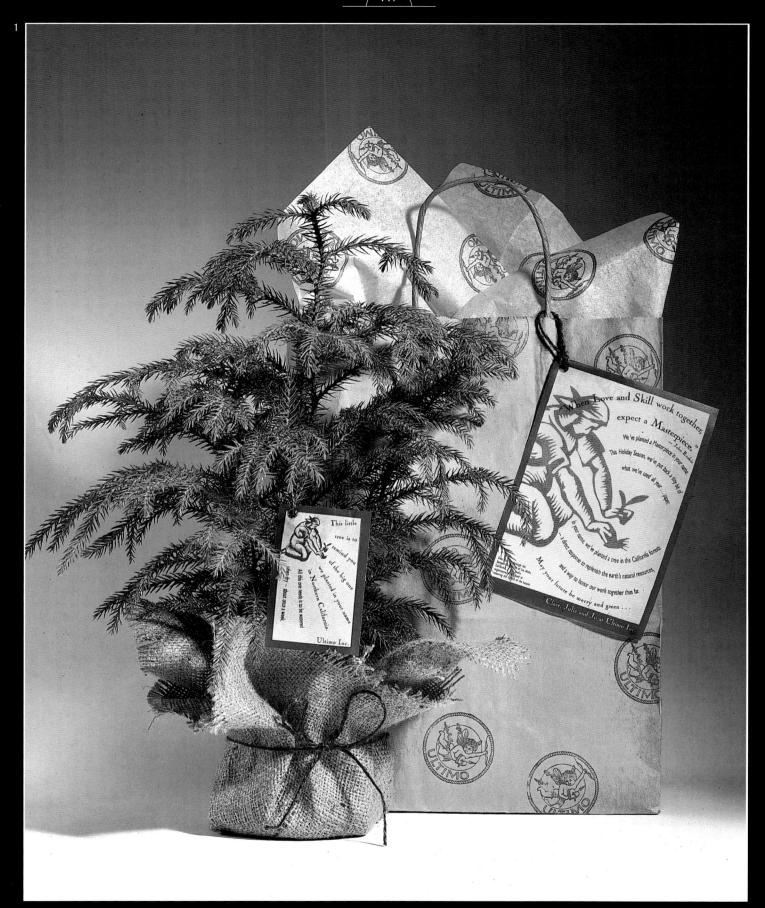

1

Design Firm Ultimo, Inc.
Art Director Clare Ultimo
Designer Clare Ultimo/Julie Hubner
Client/Store Ultimo, Inc.
Number of Colors 1

In giving holiday gifts to our clients for the 1990 season, we decided to "give back" to our environment as well. Since graphic designers become part of the problem when it comes to wasting our forests, we donated money to have trees planted by a preservation group in California, in honor of each of our clients. Then we gave each client a small tree to mark the event. The paper used for the gift cards was recyclable, and the inks were non-toxic PMS colors.

1

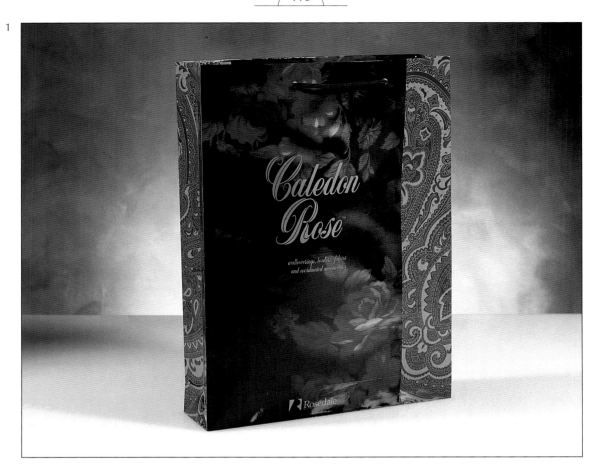

2

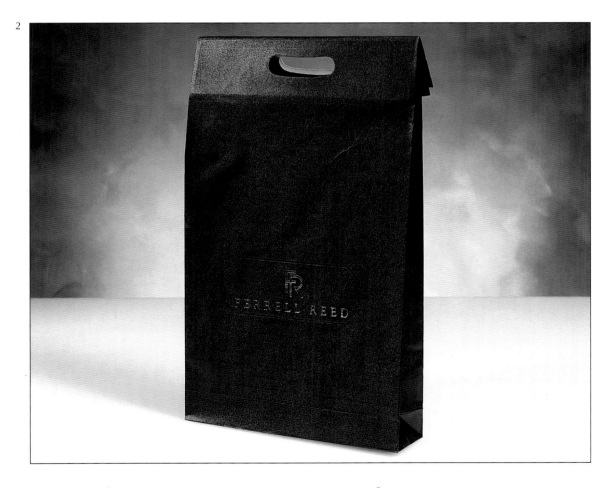

1
Title/Project Name Caledon Rose
Client/Store Rosedale Wallcoverings, Inc.
Manufacturer Pacobond, Inc.

2
Client/Store Ferrell Reed
Distributor Nationwide Paper
Manufacturer Pacobond, Inc.

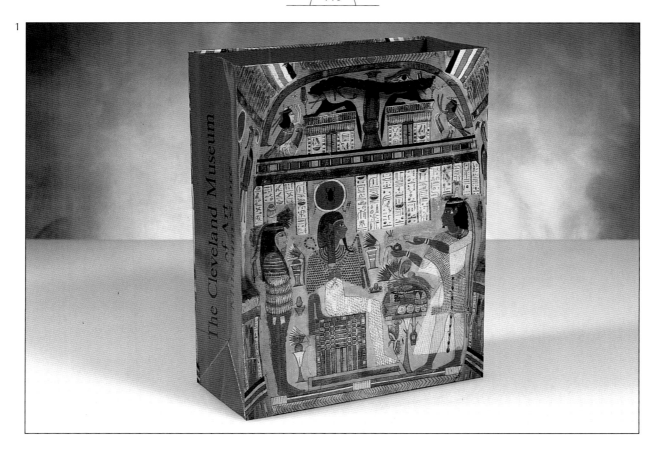

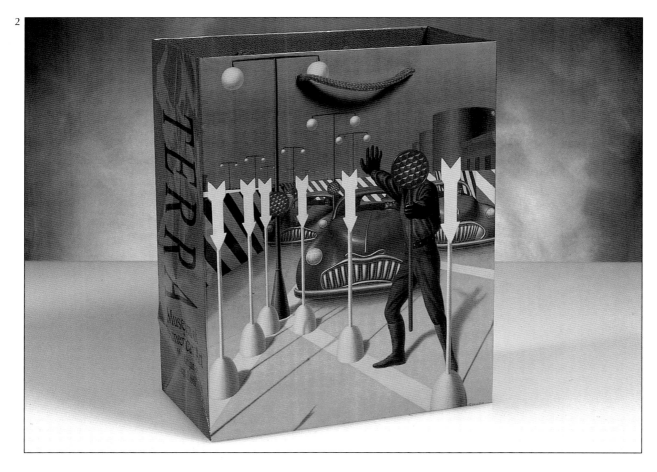

1
Title/Project Name Egyptian Bag
Client/Store Cleveland Museum of Art
Manufacturer Pacobond, Inc.

2
Title/Project Name Highway
Client/Store Terra Museum of American Art
Illustrator/Artist George Tooker
Distributor N.P. Packaging Company
Manufacturer Pacobond, Inc.

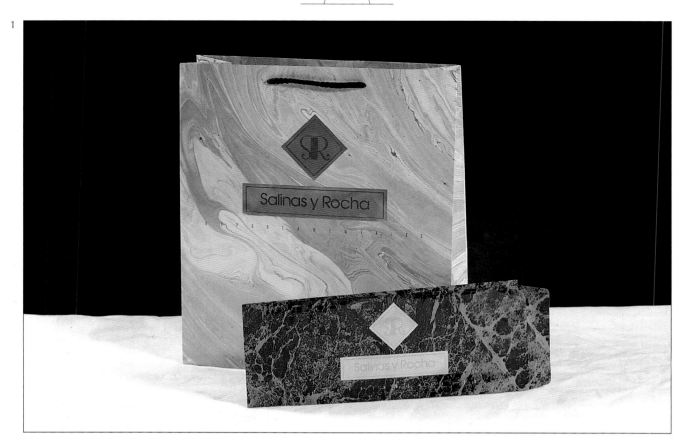

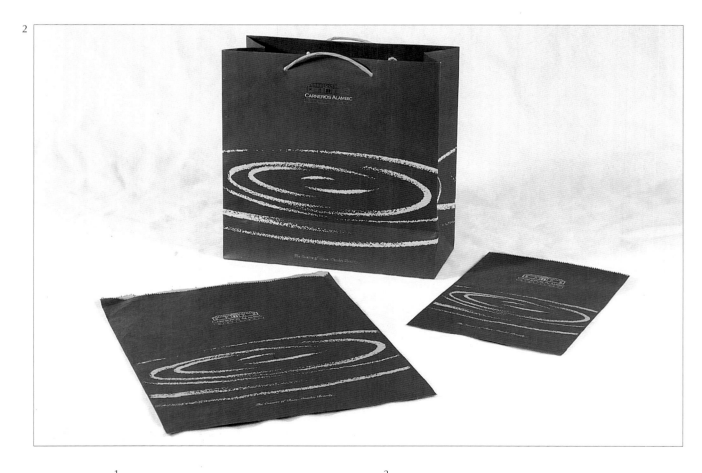

1
Design Firm Emery Designs
Client/Store Salinas Y Rocha
Distributor Dixon Paper Company
Manufacturer Pacobond, Inc.

2
Design Firm Profile Design
Client/Store Carneros Alambic
Illustrator/Artist George Tooker
Distributor Brilliant Bags & Boxes
Shopping Bag Manufacturer Pacobond, Inc.
Merchandise Bag Manufacturer Bonita Pioneer

1

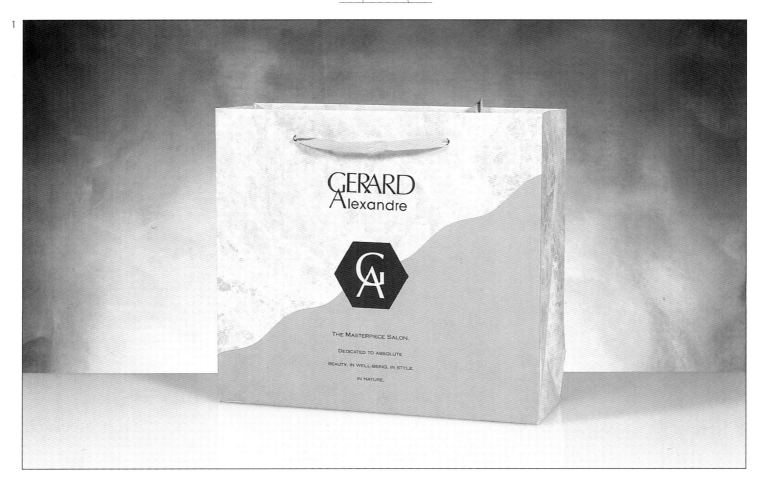

2

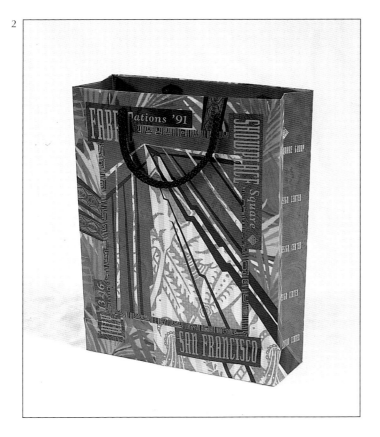

3

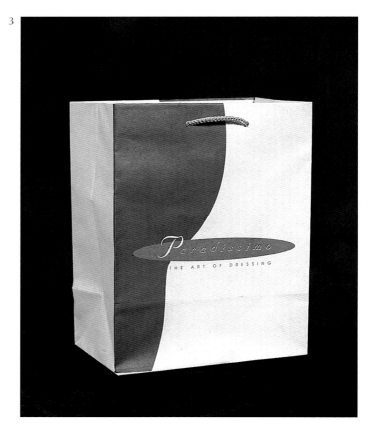

1
Client/Store Gerard Alexandre
Distributor Reuben Schneider
Manufacturer Pacobond, Inc.

2
Design Firm STG Graphic Communications Inc.
Distributor Brilliant Bags & Boxes
Manufacturer Pacobond, Inc.
Number of Colors 4 color process

3
Client/Store Paradissimo
Distributor Armor Packaging
Manufacturer Pacobond, Inc.

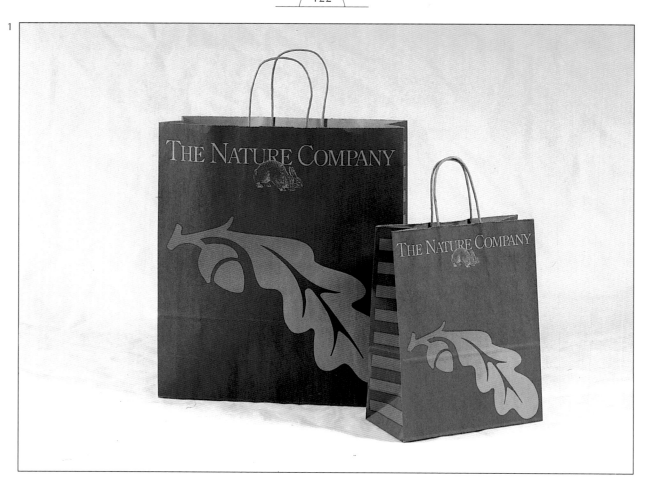

1

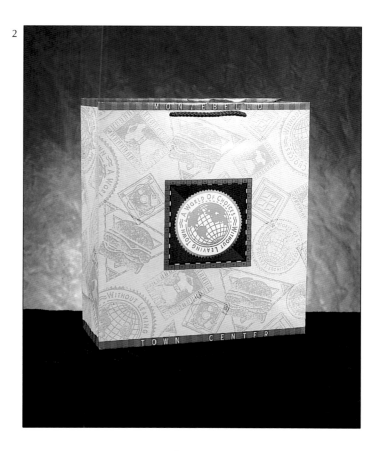

2

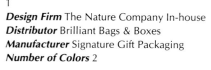

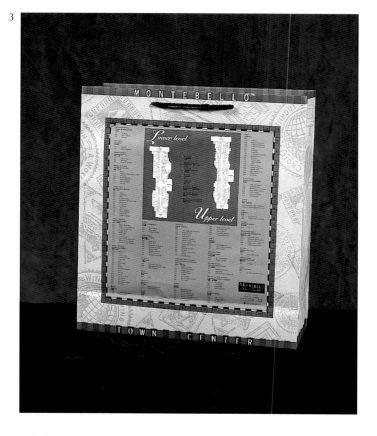

3

1
Design Firm The Nature Company In-house
Distributor Brilliant Bags & Boxes
Manufacturer Signature Gift Packaging
Number of Colors 2

2, 3
Design Firm Patton & Malone Design
Client/Store Montebello Town Center
Distributor Accent Packaging
Manufacturer Pacobond, Inc.
Number of Colors 4 color process

1

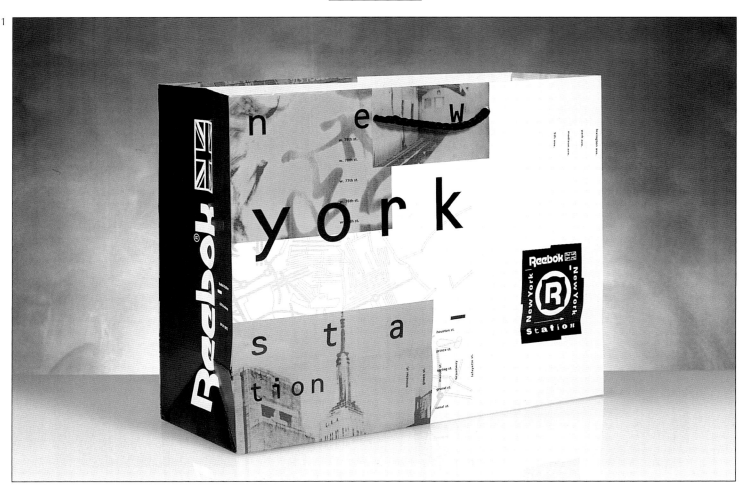

2

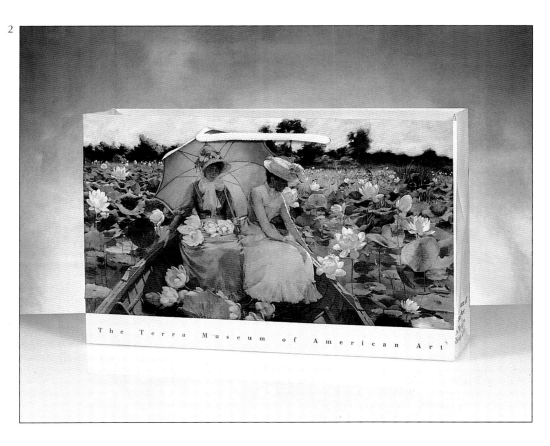

3

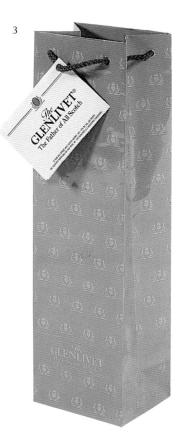

1
Title/Project Name Reebok
Distributor Anderson Printing
Manufacturer Pacobond, Inc.

2
Title/Project Name Lotus Lilies
Illustrator/Artist Charles Courtney Curran
Client/Store Terra Museum of American Art
Distributor M.P. Packaging
Manufacturer Pacobond, Inc.

3
Title/Project Name Glenlivet
Distributor Modern Arts
Manufacturer Pacobond, Inc.

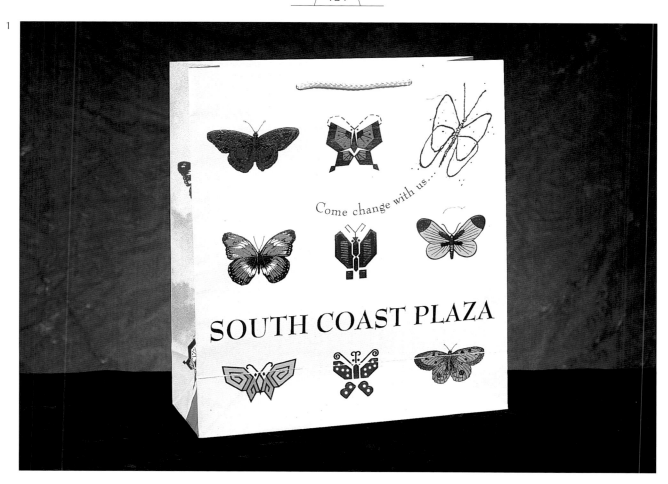

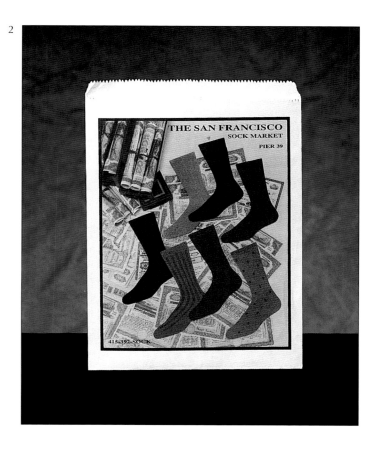

1
Design Firm The Graphics Studio
Title/Project Name Come Change With Us...
Client/Store South Coast Plaza
Distributor Accent Packaging
Manufacturer Pacobond, Inc.

2
Design Firm S F Sock Market In-house
Distributor Brilliant Bags & Boxes
Manufacturer Pacobond, Inc.
Number of Colors 4 color process

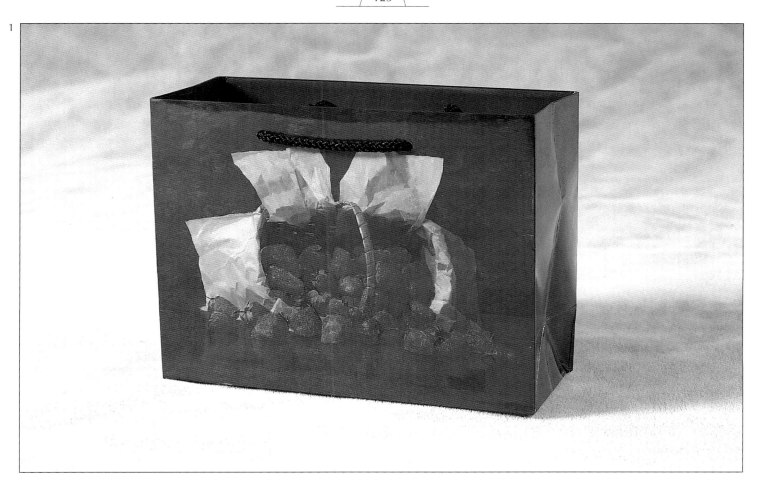

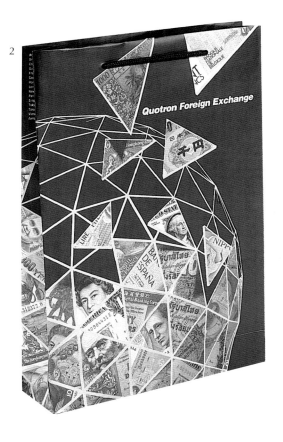

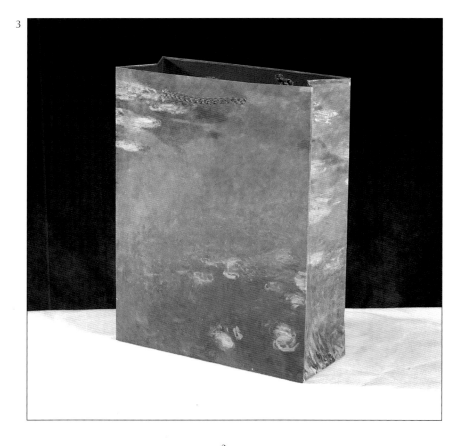

1
Title/Project Name Strawberries
Artist/Illustrator William J. McCloskey
Client/Store Terra Museum of American Art
Distributor M. P. Packaging
Manufacturer Pacobond, Inc.

2
Client/Store Quotron Foreign Exchange
Distributor North American Packaging
Manufacturer Pacobond, Inc.

3
Title/Project Name Water Lilies by Monet
Client/Store Cleveland Museum of Art
Manufacturer Pacobond, Inc.

1

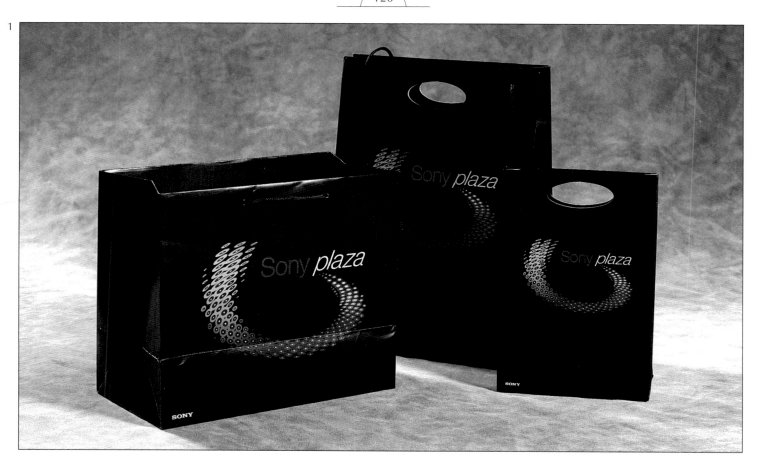

2

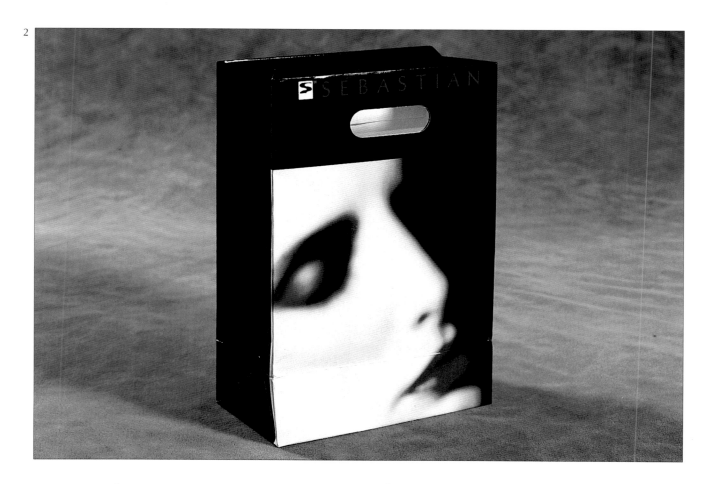

1
Design Firm Frankfurt, Gips, Balkind
Designer Laurel Shoemaker
Client/Store Sony
Number of Colors 4 color process

2
Design Firm Sebastian International In-house
Client/Store Sebastian International
Number of Colors 6

1

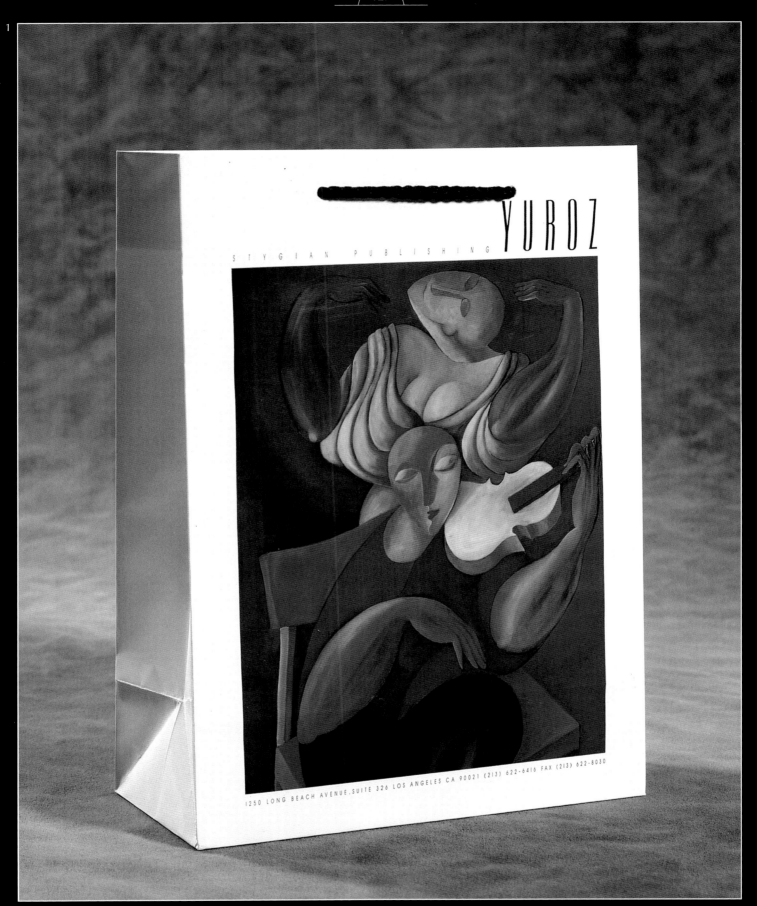

1
Title/Project Name YUROZ
Designer Yuroz
Client/Store Stygian Publishing
Distributor 20/20 Graphics
Manufacturer Pacobond, Inc.

1

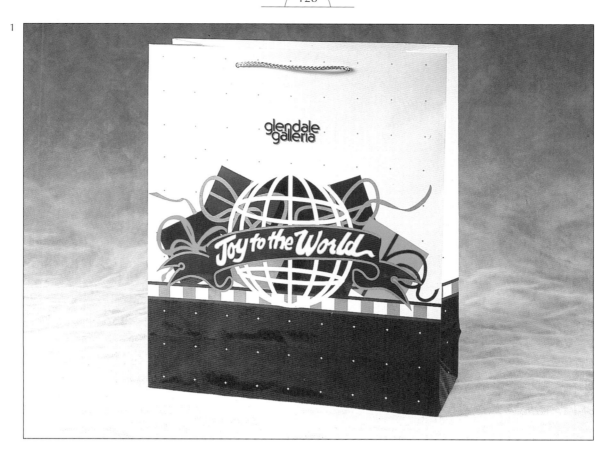

2

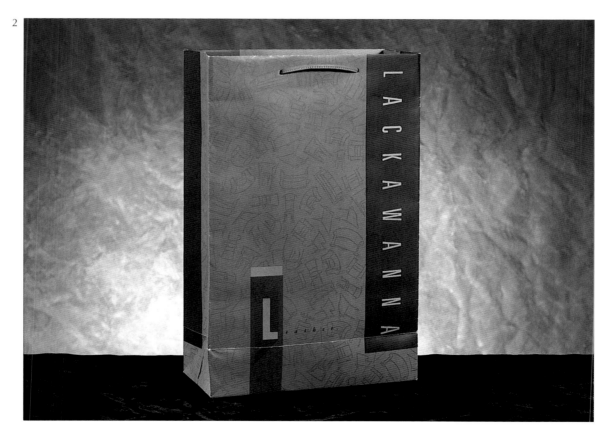

1
Title/Project Name Joy to the World
Client/Store Glendale Galleria
Distributor Accent Packaging
Manufacturer Pacobond, Inc.

2
Design Firm Joan Hantz Design
Designer Jayne Burmaster
Client/Store Lackawanna
Distributor Armor Packaging
Manufacturer Pacobond, Inc.
The Lackawanna Leather Co. supplied the
leather handles.

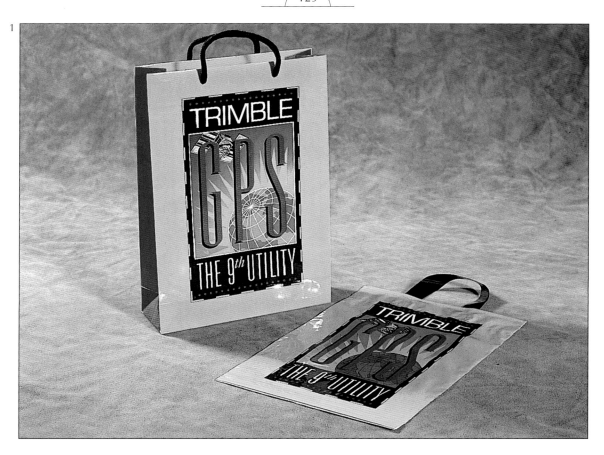

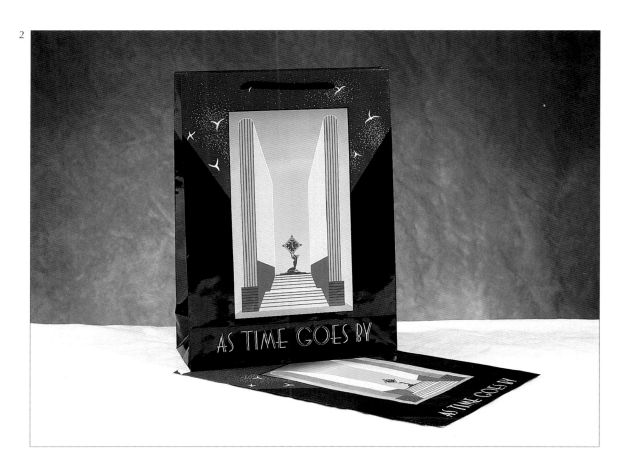

1
Design Firm Frazier Design
Distributor Brilliant Bags & Boxes
Shopping Bag Manufacturer Pacobond, Inc.
Plastic Bag Manufacturer Plastic Packaging
Number of Colors 6

2
Project Name As Time Goes By
Designer Richard Fishman
Client/Store As Time Goes By
Distributor Brilliant Bags & Boxes
Shopping Bag Manufacturer Pacobond, Inc.
Merchandise Bag Manufacturer Bonita Pioneer

1

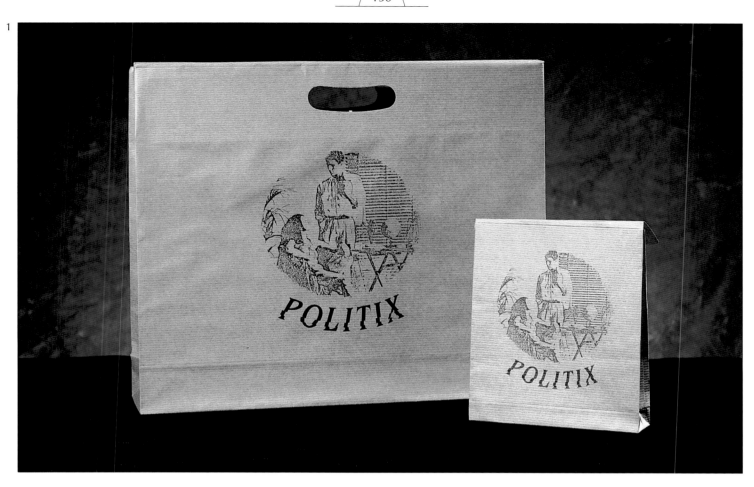

2

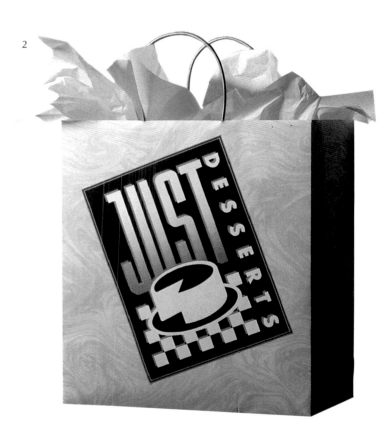

3

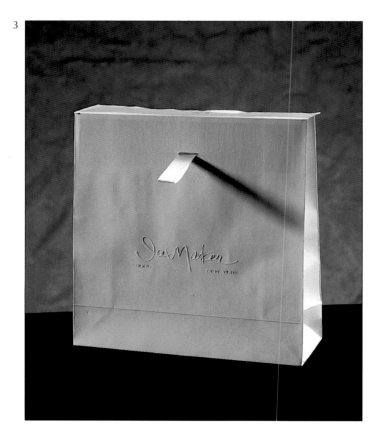

1
Client/Store Politix
Manufacturer Pacobond, Inc.

2
Design Firm Primo Angeli Inc.
Art Director Primo Angeli
Designer Philippe Becker/Ray Honda
Client/Store Just Desserts

3
Client/Store IceMaker
Distributor ZT Merchandising
Manufacturer Pacobond, Inc.
This bag features blind embossing and ribbon handles.

1

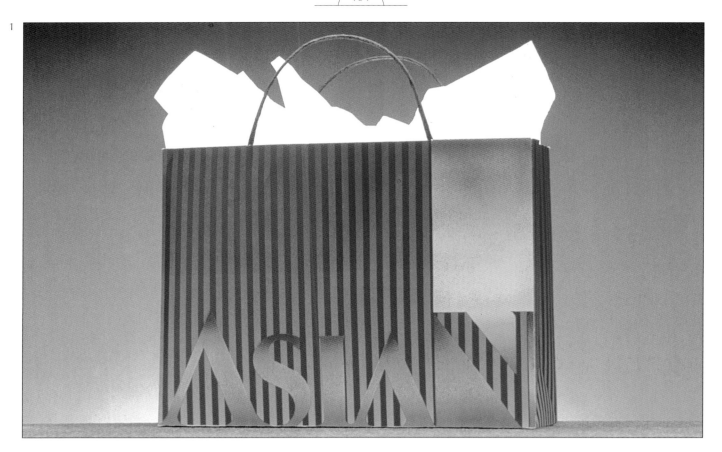

2

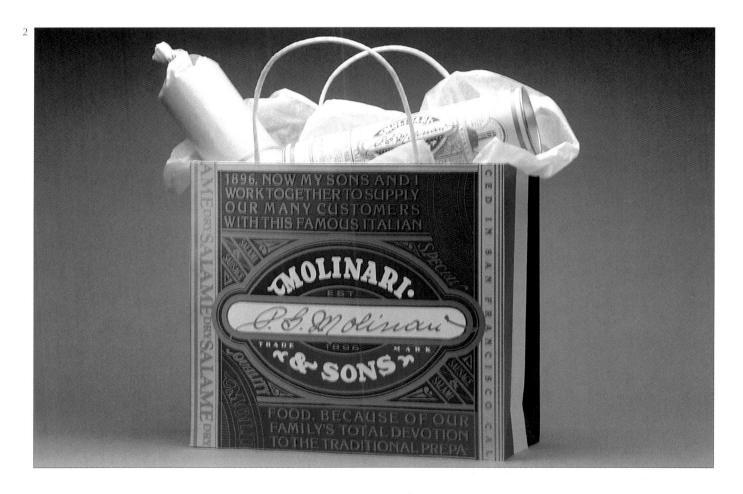

1
Design Firm Primo Angeli Inc.
Art Director Primo Angeli
Designer Ray Honda/Ian McLean/Mark Crumpacker
Client/Store Asian Art Museum

2
Design Firm Primo Angeli Inc.
Art Director Primo Angeli
Designer Mark Jones/Primo Angeli
Client/Store P. G. Molinari & Sons

1

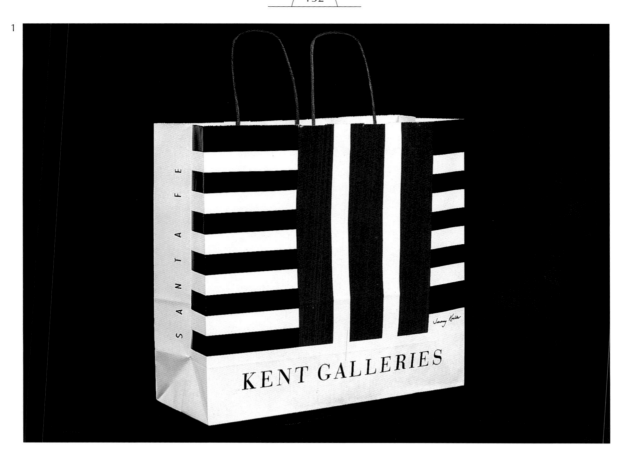

2

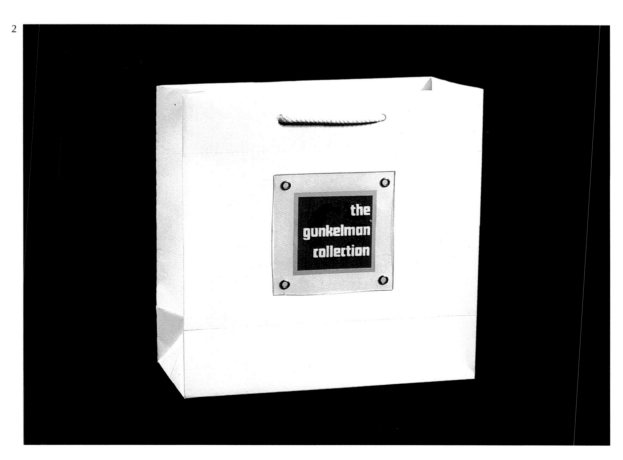

1
Designer Michael Motley
Client/Store Kent Galleries–The Contemporary
 Craftsman
Distributor Dixon Paper Company
Manufacturer Signature Gifts Packaging Inc.
Number of Colors 2 on White Crystal cote Paper

This bag was based on a woven tapestry by
Jeremy Koehler and features a twisted paper
handle.

2
Client/Store Gunkelman
Distributor Benson Graphics
Manufacturer Pacobond, Inc.

1

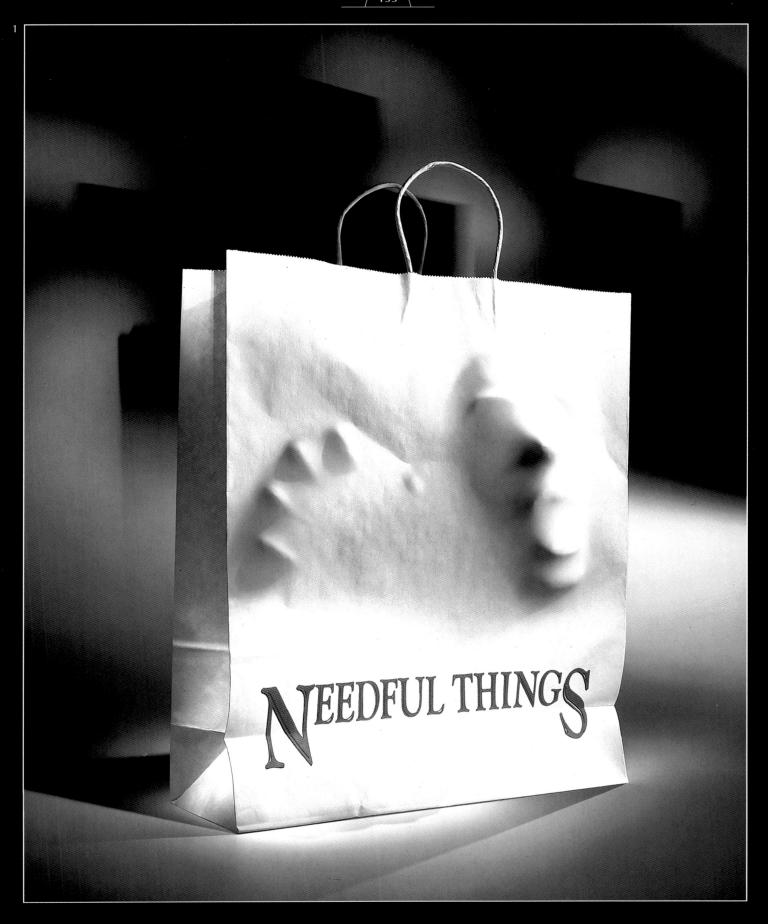

1
Design Firm Frankfurt, Gips, Balkind
Art Director Steven Elowe
Client/Store Castle Rock
 Entertainment "Needful Things"
Number of Colors 5

1

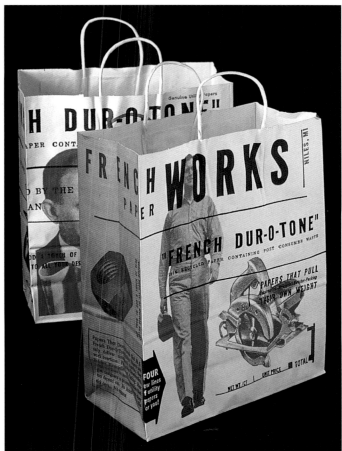

2

3

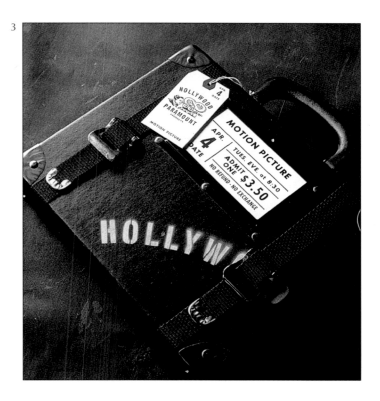

4

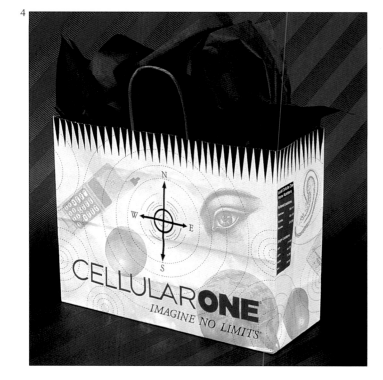

1
Design Firm Charles S. Anderson
 Design Company
Art Director Charles S. Anderson
Designer Charles S. Anderson/
 Paul Howalt
Copy Lisa Pemrick
Client/Store French Paper Co.
Number of Colors 3

2
Design Firm Charles S. Anderson
 Design Company
Art Director Charles S. Anderson
Designer Charles S. Anderson/
 Daniel Olsar
Illustrator/Artist Randall Dahll
Client/Store Levi Strauss
Number of Colors 4

3
Design Firm Charles S. Anderson
 Design Company
Art Director Charles S. Anderson
Designer Daniel Olsar
Client/Store Hollywood Paramount
 Products
Number of Colors 1

4
Design Firm/Manufacturer Bonita
 Pioneer
Art Director Jim Parker
Designer Jim Parker
Client/Store Cellular One
Number of Colors 3

1

1
Design Firm/Manufacturer Bonita Pioneer
Art Director Jim Parker
Client/Store Bonita Pioneer
 Promo Bag
Number of Colors 3
Printed flexographically using waterbased
 inks on Recycled Claycoat.

1

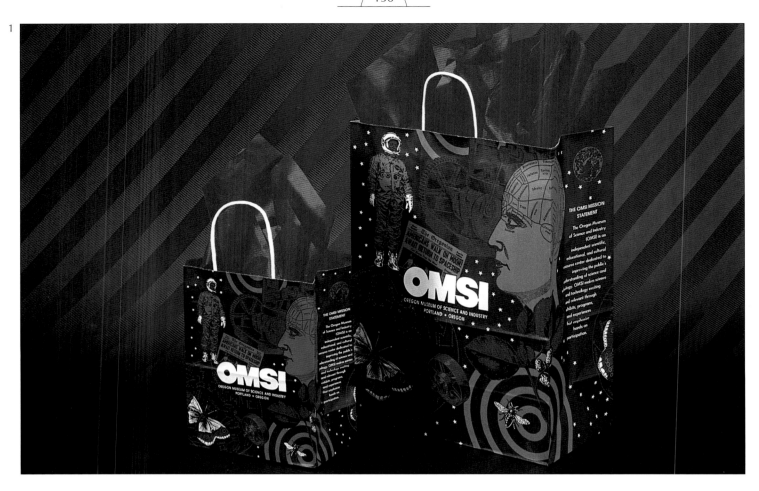

2

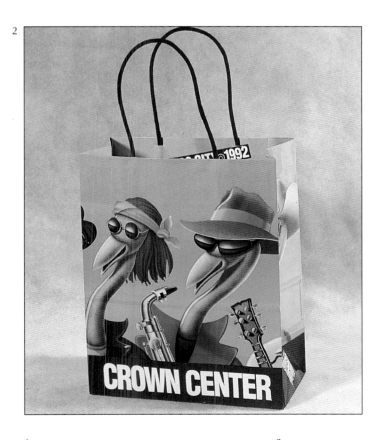

3

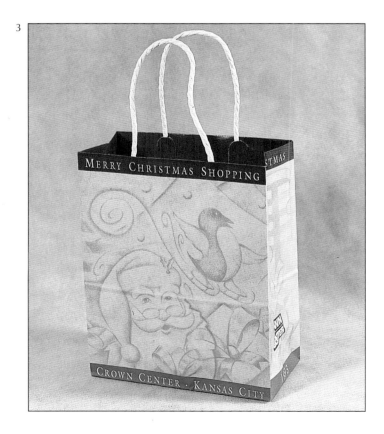

1
Design Firm/Manufacturer Bonita Pioneer
Art Director Jim Parker
Designer Jodi Schwartz
Illustrator/Artist Jodi Schwartz
Client/Store OMSI
Number of Colors 3

2
Design Firm Muller + Company
Art Director John Muller
Designer John Muller
Illustrator/Artist Marty Roper
Client/Store Crown Center
Number of Colors 4

3
Design Firm Muller + Company
Art Director John Muller
Designer Susan Wilson
Illustrator/Artist Mike Weaver
Client/Store Crown Center
Number of Colors 3

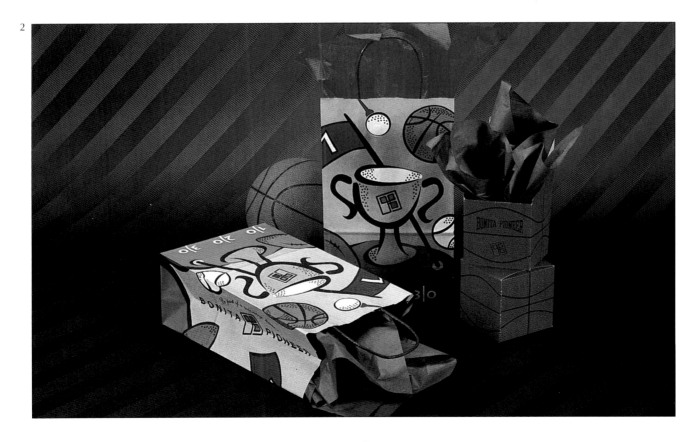

1
Design Firm/Manufacturer Bonita
 Pioneer
Art Director Jim Parker
Designer Jodi Schwartz
Client/Store PGA Packaging
Number of Colors 4

Printed flexographically using
waterbased inks on 50%
Recycled Natural Kraft.

2
Design Firm/Manufacturer Bonita
 Pioneer
Art Director Jim Parker
Client/Store Bonita Pioneer Trade
 Show Bag
Number of Colors 6

Printed flexographically using
waterbased inks on 50% Recycled
Natural Kraft and designed as a
promotional piece for "Be a Part of
a Winning Team."

1

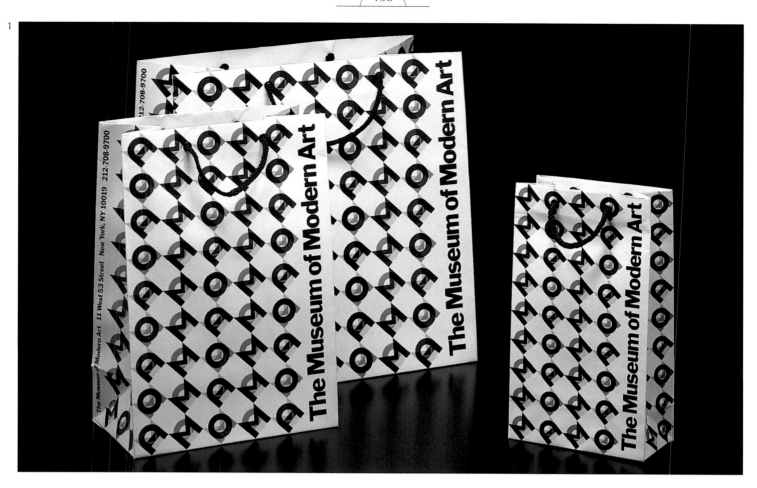

2

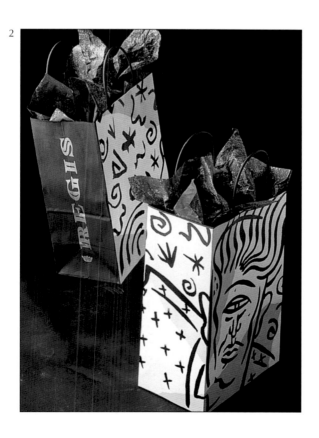

3

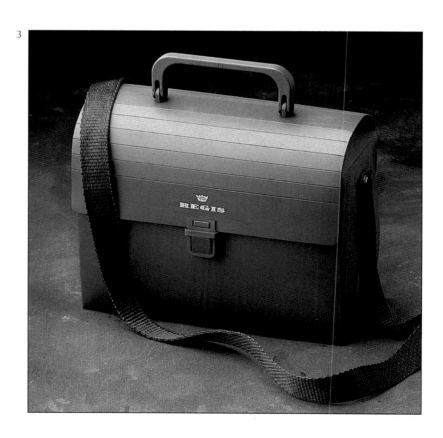

1
Design Firm Igarashi Studio
Art Director Takenobu Igarashi
Designer Takenobu Igarashi/Ross McBride
Client/Store The Museum of Modern Art,
New York
Number of Colors Black and White

2
Design Firm Charles S. Anderson Design Company
Art Director Charles S. Anderson
Designer Charles S. Anderson/Daniel Olsar
Illustrator/Artist Charles S. Anderson
Client/Store Regis Corp.
Number of Colors 6

3
Design Firm Charles S. Anderson Design Company
Art Director Charles S. Anderson
Designer Charles S. Anderson/Daniel Olsar
Illustrator/Artist Charles S. Anderson
Client/Store Regis Corp.

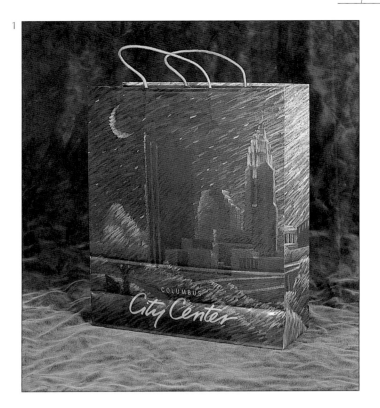

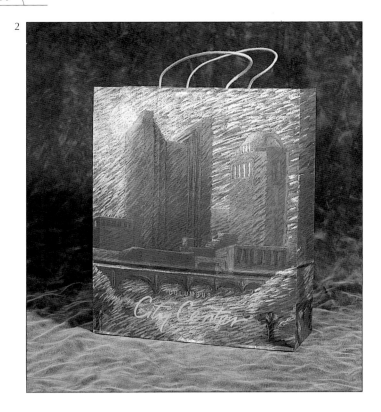

1, 2
Design Firm Lord, Sullivan and Yoder
Art Director Amy Howard
Designer Amy Howard
Illustrator/Artist Michael Linley
Vendor The Pack America Corp.
Client/Store Columbus City Center
Number of Colors 4

3
Design Firm Family Circle Marketing Dept.
Creative Director Susan Simmons
Vendor The Metro Packaging Group
Client/Store Family Circle Magazine
Number of Colors 4

1

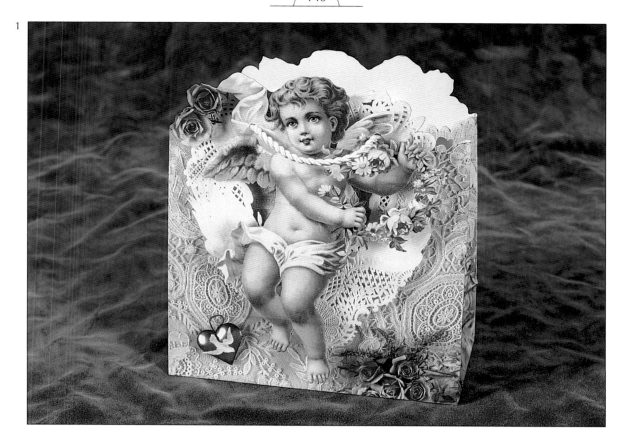

2

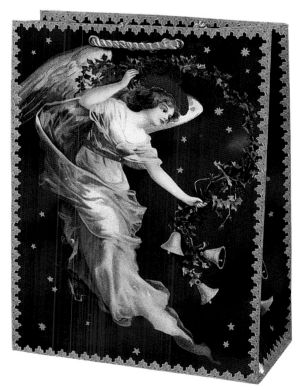

3

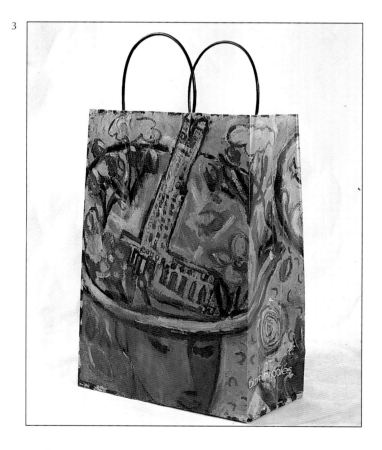

1, 2
Design Firm The Gifted Line
Art Director John Grossman
Number of Colors 4
Bag was created from Victorian ephemera circa
1820–1920 from the John Grossman
collection of antique images.

3
Design Firm Equitable Bag Co., Inc.
Client/Store Bloomingdales
Number of Colors 4

1

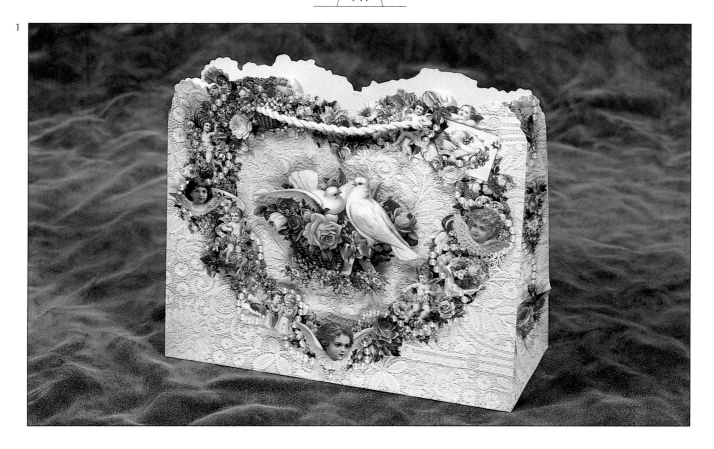

2

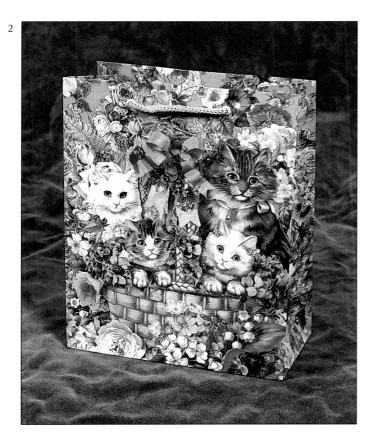

3

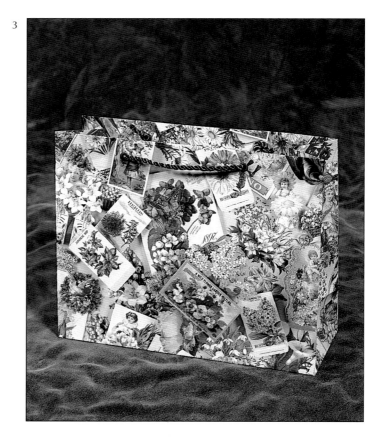

1, 2, 3
Design Firm The Gifted Line
Art Director John Grossman
Number of Colors 4
Bag was created from Victorian ephemera
 circa 1820–1920 from the John Grossman
 collection of antique images.

1

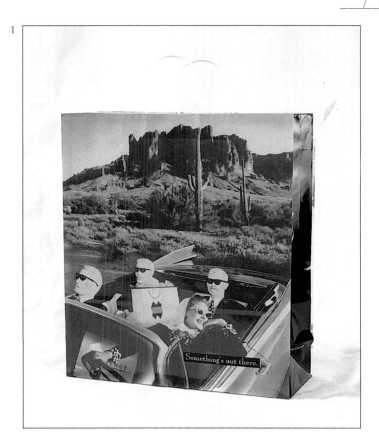

2

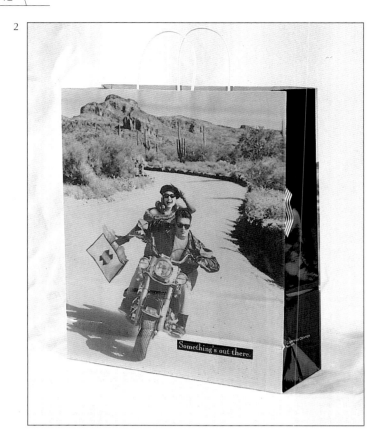

3

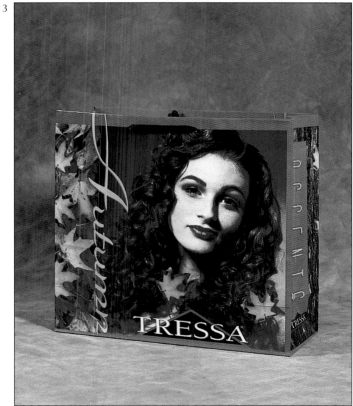

4

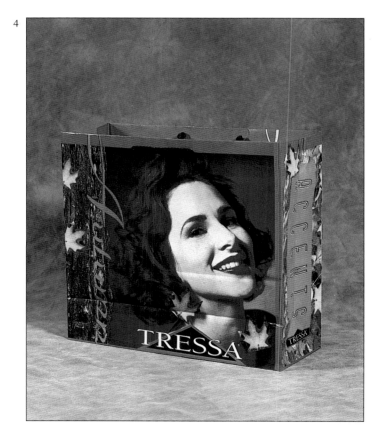

1, 2
Design Firm Hershey Communications
Art Director Hershey Communications
Designer Susie DePinto, Studio Q Productions
Illustrator/Artist Hershey Communications
Client/Store Superstition Spring Center
Number of Colors 2

3, 4
Design Firm Lion & Associates
Art Director John Foley
Designer Sherry Eberly
Illustrator/Artist John Foley
Client/Store Tressa
Number of Colors 4 color process

1

2

1

Design Firm Visual Merchandising, Women's
 Division, J.C. Penney
Art Director Jackie Collis
Designer Tim Chalmers, Manager
Illustrator/ Artist Cynthia Elliot
Client/Store J.C. Penney
Number of Colors 2

2

Design Firm/Manufacturer Bonita Pioneer
Art Director Jim Parker
Designer Jim Parker
Client/Store Bonita Pioneer Trade Show Bag
Number of Colors 6 outside, 1 inside
Designed as a promotional piece for
 "Get in Gear."

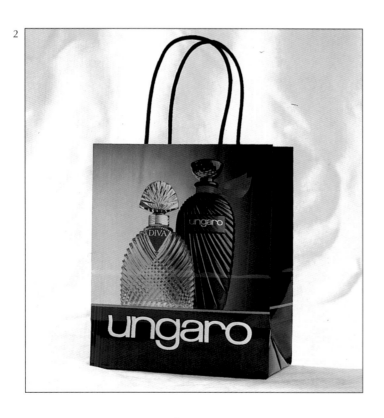

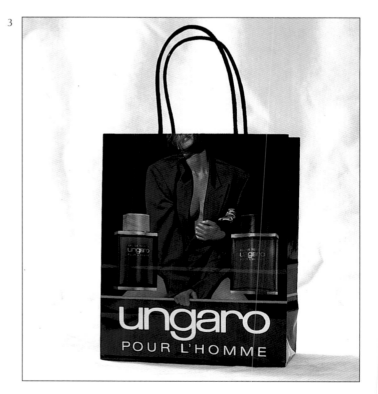

1
Design Firm/Manufacturer Bonita Pioneer
Art Director Jim Parker
Illustrator/Artist Jodi Schwartz
Distributor Packaging Specialties
Client/Store Blazers on Broadway
Number of Colors 3
Printed flexographically using waterbased inks
 on 50% recycled Natural Kraft.

2, 3
Design Firm Fragrances Exclusive
Client/Store Ungaro
Manufacturer The Pack America Corp.
Number of Colors 4

1

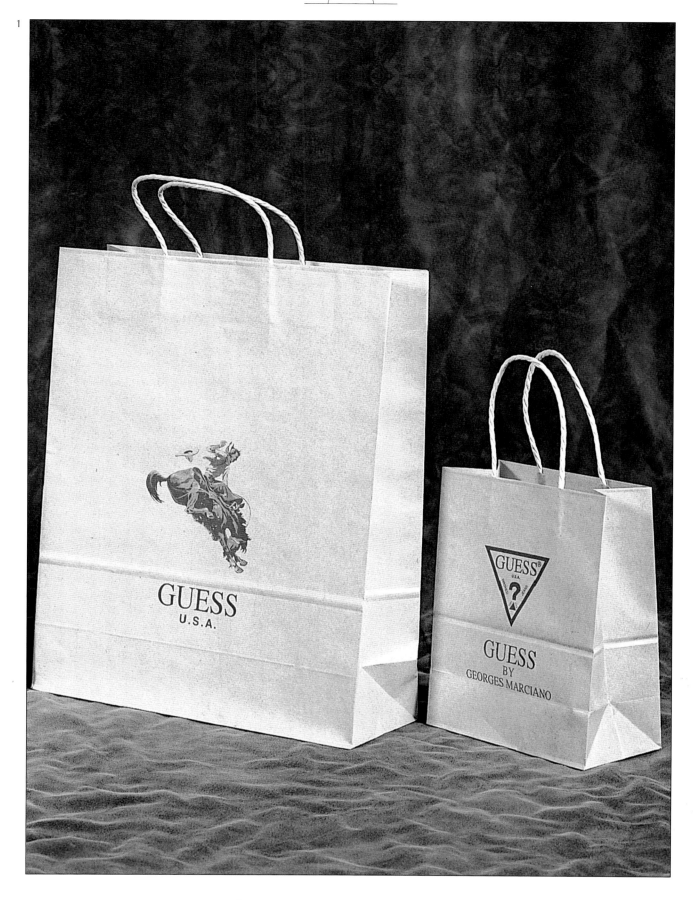

1
Design Firm Guess
Art Director Paul Marciano
Designer Leslie Oki
Illustrator/Artist Guess
Client/Store Guess Retail
Manufacturer The Pack America Corp.
Number of Colors 1

1

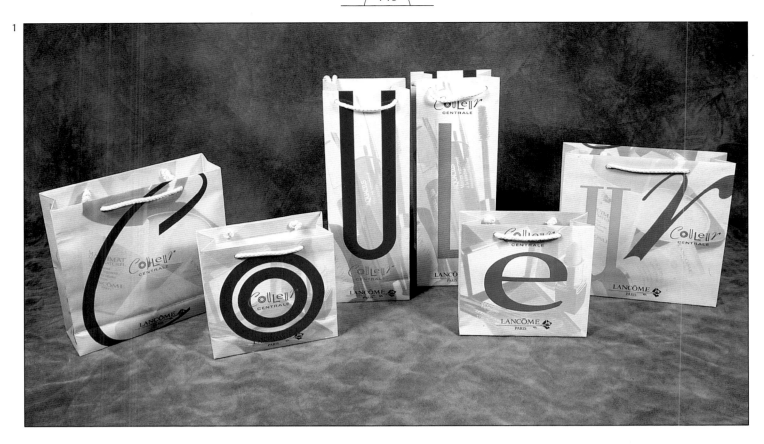

2

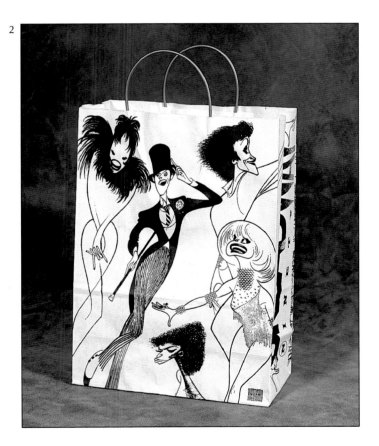

3

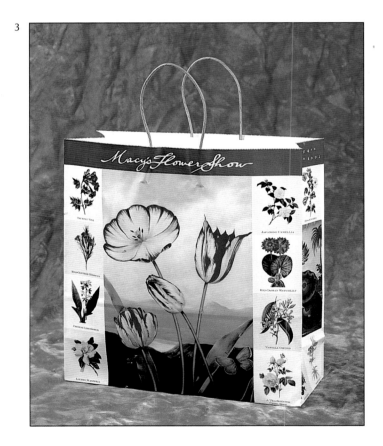

1
Project Name Couleur Centrale
Manufacturer Pacobond, Inc.
Distributor S. Posner Sons, Inc.
Client/Store Lancome

2
Design Firm The Equitable Bag Co., Inc.
Illustrator/Artist Al Hirschfeld
Client/Store Bloomingdales
Number of Colors 1

3
Design Firm Macy's
Art Director David Au
Designer David Au
Illustrator/Artist Jeffry Adams
Client/Store Macy's
Number of Colors 5

1

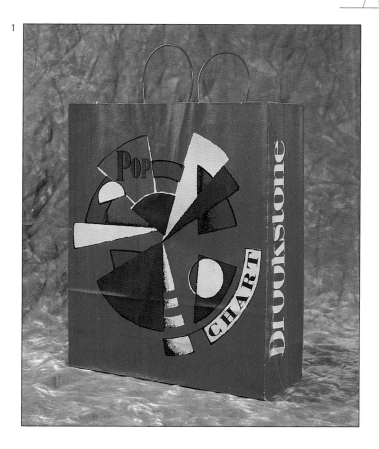

2

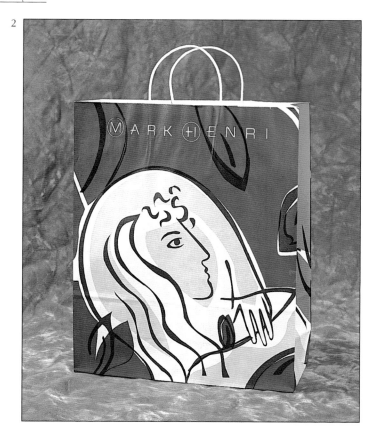

3

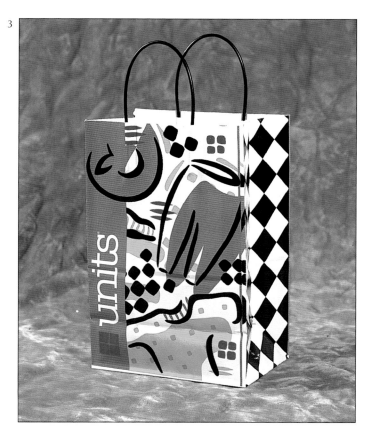

4

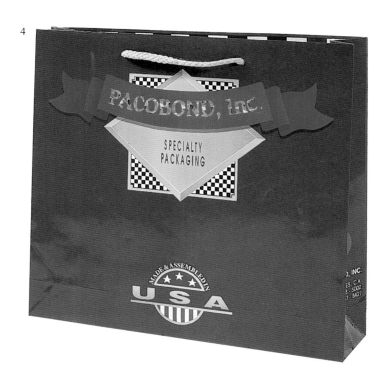

1
Design Firm Brookstone
Art Director Brookstone
Designer Brookstone Staff
Illustrator/Artist Brookstone
Client/Store Brookstone
Number of Colors 4 colors,
 matte varnish

2
Design Firm Space Design
 International
Client/Store Marc Henri
Number of Colors 4

3
Client/Store NFL Properties
Number of Colors Flexo 4 color
 process
Used to hand out promotional items
 at Superbowl '93 during the card
 show.

4
Design Firm Pacobond, Inc.
Project Name Trade Show Bag
Designer Pacobond, Inc.
Manufacturer Pacobond, Inc.

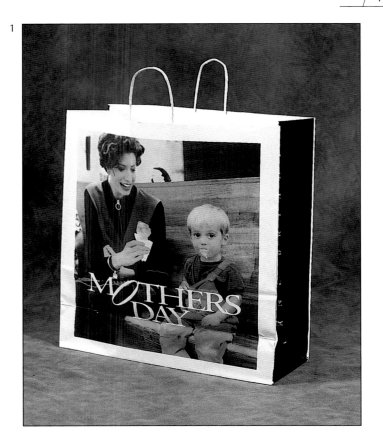

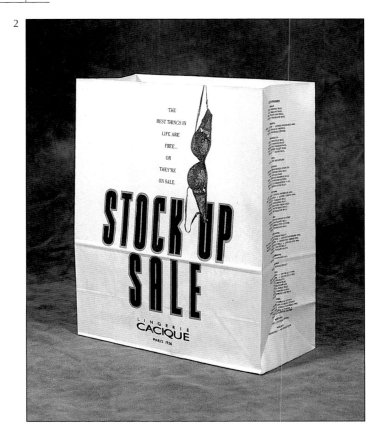

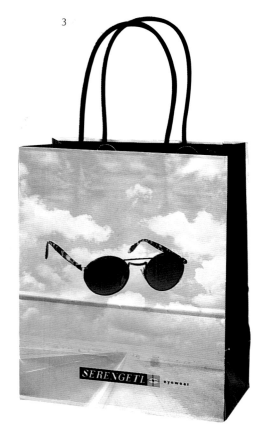

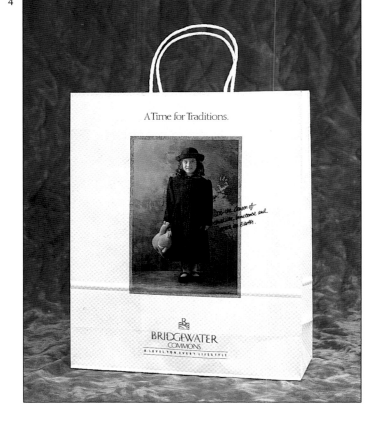

1
Design Firm Lane Bryant In-house
Client/Store Lane Bryant
Number of Colors 5

2
Design Firm Cacique
Illustrator/Artist Rose Krouse
Client/Store Cacique division of The Limited
Number of Colors 2
New space-saving bag with a fold-in handle for flatter packing and more comfort.

3
Design Firm Smart Design, Inc.
Art Director Davin Stowell
Designer Paul Hamburger
Illustrator/Artist Paul Hamburger
Vendor The Pack America Corp.
Client/Store Serengeti Eyewear
Number of Colors 4

4
Design Firm Brent Herridge & Associates
Art Director Stephanie Workman
Photographer Brent Herridge
Vendor The Pack America Corp.
Client/Store Bridgewater Commons
Manufacturer The Pack America Corp.

1

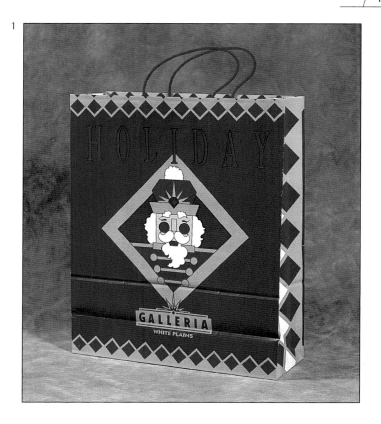

2

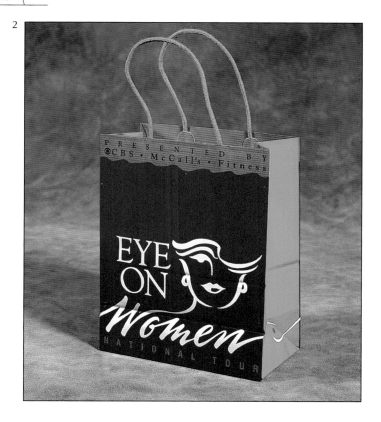

3

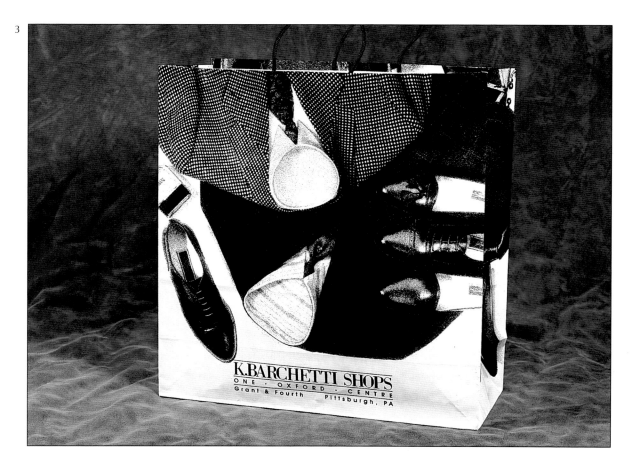

1
Design Firm W.T. Quinn, Inc.
Art Director Victoria Greiss
Designer Victoria Greiss
Illustrator/Artist The Becker Group
Vendor The Pack America Corp.
Client/Store The Galleria Mall at White Plains
Number of Colors 4, one metallic

2
Design Firm Marketing Mix, St. Louis
Creative Director Amy Fread, CBS
Designer Sally Harrison, MM
Client/Store CBS/The New York Times
Company Women's Magazines *Eye on
Women National Tour*
Manufacturer The Pack America Corp.
Distributor The Metro Packaging Group

3
Design Firm Jones Advertising
Art Director Donald R. Jones
Designer Christopher Kerr
Illustrator/Artist Mike Nicholson
Client/Store K. Barchetti Shops
Number of Colors 1

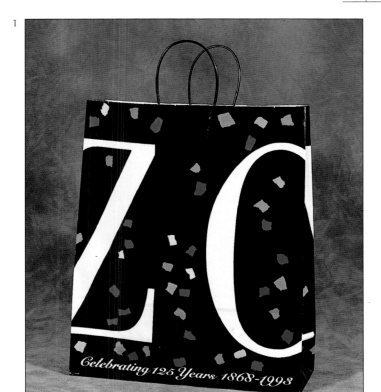

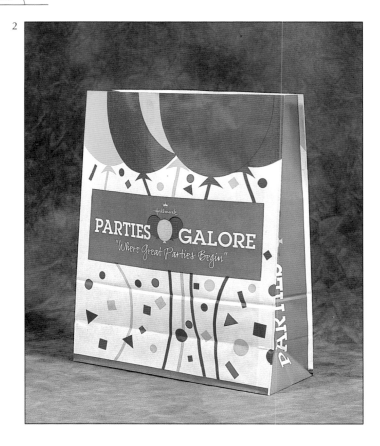

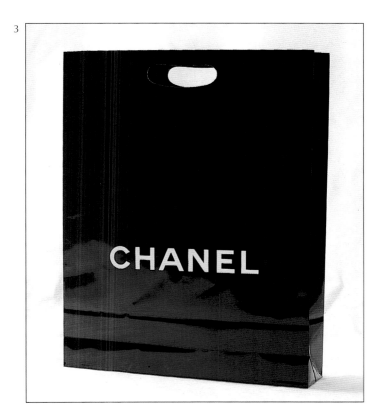

1
Design Firm Z.C.M.I. Display Dept.
Art Director Mike Stephens
Designer Mike Stephens
Illustrator/Artist Mike Stephens
Client/Store Z.C.M.I.
Number of Colors 5

2
Design Firm Hallmark
Client/Store Hallmark "Parties
 Galore"
Number of Colors 4
Omni bag, a new space-saving bag
 with a fold-in handle for flatter
 packing and more comfort.

3
Design Firm Chanel
Client/Store Chanel
Number of Colors Black (double
 hit)
Manufacturer The Pack America
 Corp.

4
Design Firm 2M&G Marketing Arts
Art Director Gil Wright
Designer Dev Murats
Photographer James Randkleiv
Client/Store The Hines Interests,
 Houston & Dallas Galleries
Vendor The Pack America Corp.
Manufacturer The Pack America
 Corp.
Number of Colors 4 plus varnish

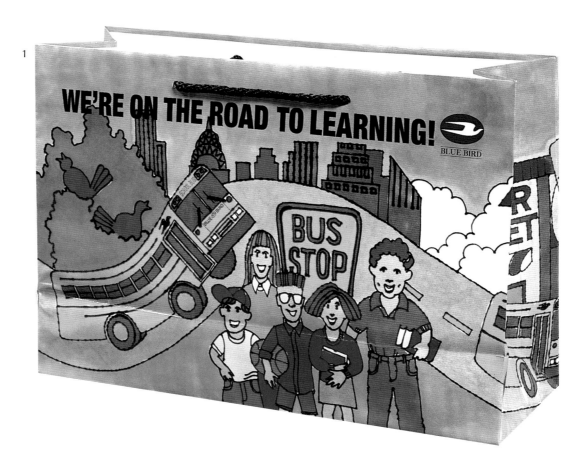

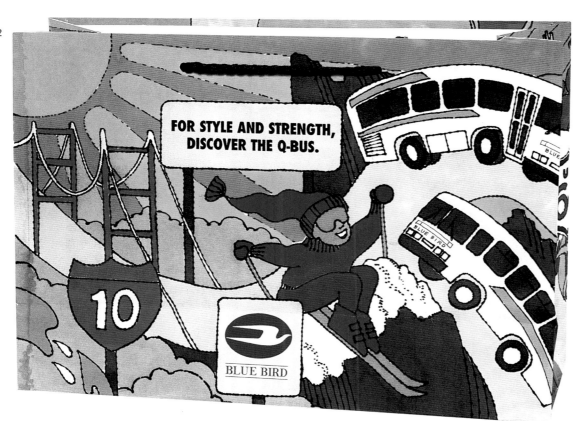

1, 2
Project Name School Bus/Q-Bus
Client/Store Blue Bird
Distributor Bob Erwin Designs
Manufacturer Pacobond, Inc.

1

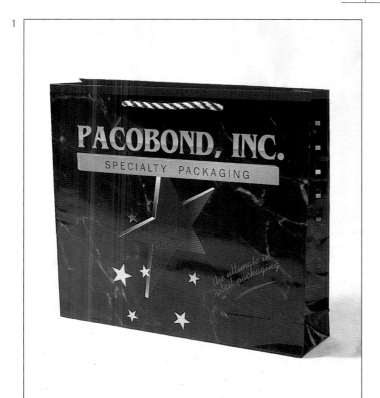

2

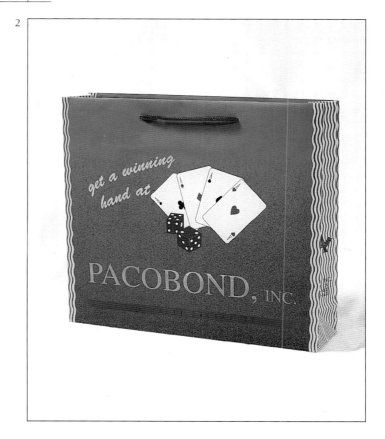

3

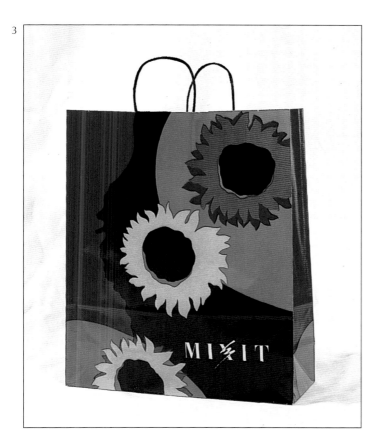

4

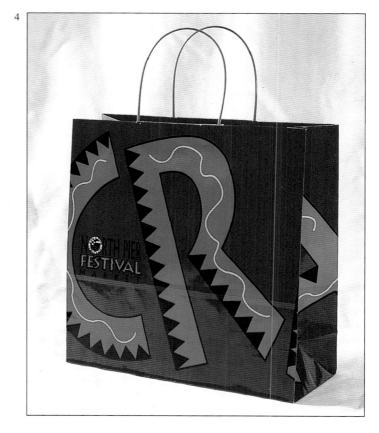

1, 2
Project Name Trade Show Bags
Designer Pacobond, Inc.
Client/Store Pacobond, Inc.
Manufacturer Pacobond, Inc.

3
Design Firm J.C. Penney–Mixit In-house
Art Director Toni Schuster
Designer Toni Schuster
Illustrator/Artist Toni Schuster
Client/Store J.C. Penney–Mixit
Number of Colors 5

4
Distributor Howard Decorative Packaging
Client/Store North Pier Festival Market
Number of Colors Flexo 4 color, U.V. coating

1
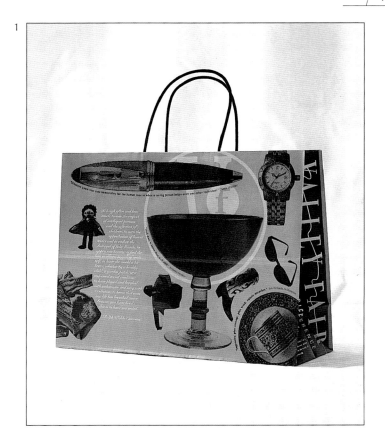

2
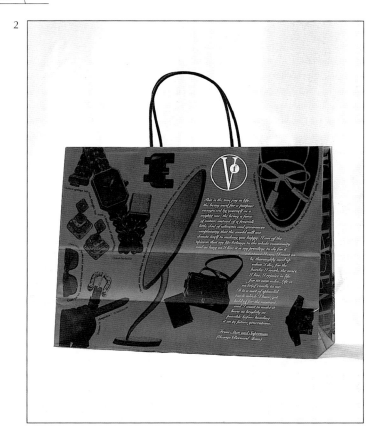

3
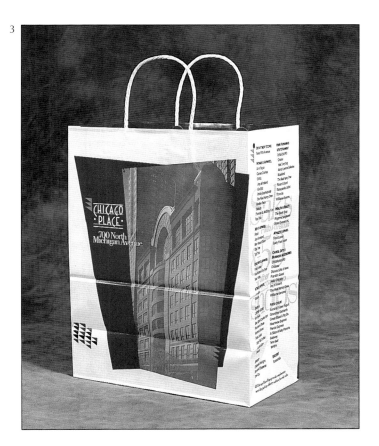

4
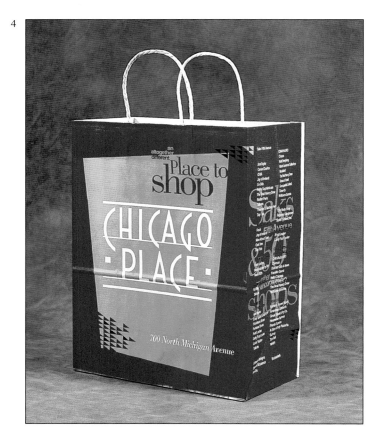

1, 2
Design Firm 2M&G Marketing Arts
Art Director Gil Wright
Designer Dev Murats
Photographer Geoff Nilsen
Copy Writer John Frazier
Client/Store The Hahn Company's Valley Fair
Vendor The Pack America Corp.
Number of Colors 3 plus varnish

3, 4
Design Firm Laughing Dog Creative, Inc.
Designer Joy Panos Stauber/Jamie Apel
Client/Store Chicago Place
Vendor The Pack America Corp.
Manufacturer The Pack America Corp.
Number of Colors 3

1

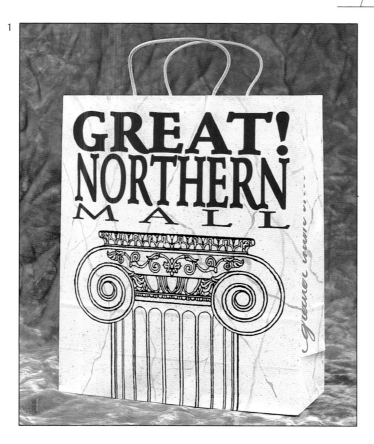

2

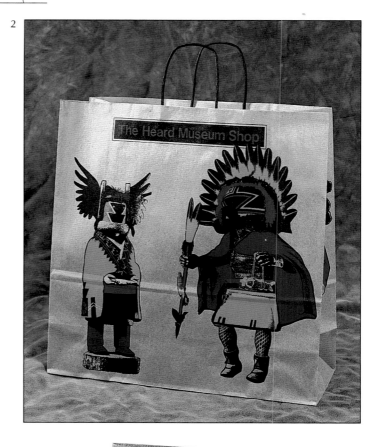

3

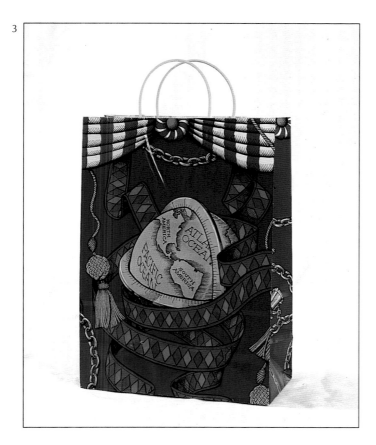

4

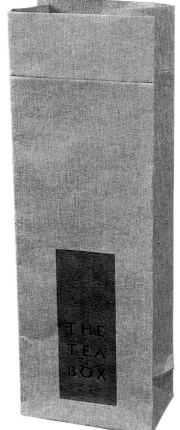

1
Design Firm Lintas Marketing
 Communication
Art Director Michael Delgorio
Designer Michael Delgorio
Illustrator/Artist Michael Delgorio
Client/Store Great Northern Mall,
 Edward J. DeBartolo Corporation
Number of Colors 4

2
Design Firm The Reuben
 Schneider Co.
Art Director Rosanne Schneider
Designer Rosanne Schneider
Illustrator/Artist Rosanne Schneider
Client/Store The Heard Museum
 Shop
Number of Colors 4

3
Design Firm Equitable Bag Co., Inc.
Client/Store Bloomingdales

4
Project Name The Tea Box
Designer M/W Design
Client/Store Takashimaya
Distributor Modern Arts
Manufacturer Pacobond, Inc.
Letters on the bag are laser die cut.

INDEX

DIRECTORY

Abraham & Straus
420 Fulton Street
Brooklyn, NY 11201
718-802-7230

ACA College of Design
2528 Kemper Lane
Cincinnati, OH
513-751-1206

Alan Chan Design Company
2/F. Shiu Lam Building
23 Luard Road
Wanchai
Hong Kong
852 527-8228

Art & Function
Julio Prado 1903 Nunoa
Santiago, Chile
562-225-1518

The Bon Marche
3rd & Pine Street
Seattle, WA 98181
206-344-8759

Bonita Pioneer
7333 S. Bonita Road
Portland, OR 97224

Carre Noir
82, Bd des Batignolles
75850 Paris France
33 1 42 94 02 27

Castle Rock Entertainment
335 N. Maple Drive #183
Beverly Hills, CA 90210
310-205-2751

Cato Gobe & Associates
411 Lafayette Street
2nd Floor
New York, NY 10003
212-979-8900

Clifford Selbert Design
2067 Massachusetts Avenue
Cambridge, MA 02140
617-497-6605

CR Communication & Design Services
Reina Victoria, 24, 2a - 08021
Barcelona (Spain)
03 209 99 99

Margaret W. Cusack
124 Hoyt Street
Brooklyn, NY 11217
718-237-0145

Debra Nichols Design
468 Jackson Street
San Francisco, CA 94111
415-788-0766

Equitable Bag Company, Inc.
37-11 35th Avenue
Long Island City, CT 11101
718-472-7300

Frazier Design
600 Townsend Street
Suite 412 West
San Francisco, CA 94105

Goldstein Gallery & Collections
University of Minnesota
1985 Buford Avenue
St. Paul, MN 55108
612-624-3292

Gregory Group, Inc.
2811 McKinney Avenue
#216, LB125
Dallas, TX 75204
214-522-9360

Harry N. Abrams, Inc.
100 Fifth Avenue
New York, NY 10011
212-206-7715

Hornall Anderson Design Works
1008 Western Avenue
Suite 600
Seattle, WA 98104
206-467-5800

Hunt Weber Clark Design
51 Federal Street #205
San Francisco, CA 94107
415-882-5770

Hurley Design Associates
6021 Hughes Road
Lansing, MI 48911

I. Magnin & Company
135 Stockton Street
San Francisco, CA 94108
415-403-2800

JRDC
950 Battery Street
3rd Floor
San Francisco, CA 94111
415-986-1138

Jager De Paola Kemp Design
308 Pine Street
Burlington, VT 05401
802-864-5884

Kan Tai-keung Design & Associates Ltd.
28/F Great Smart Tower
230 Wanchai Road
Hong Kong
574-8399

K.S. Design
Av Candido de Abreu
140 cj 1105
Curitiba-PR Brasil 80 530-901
041 233-0905

Karyl Klopp Design
5209 8th Street
Charlestown, MA 02129
617-242-7463

Landor Associates
1001 Front Street
San Francisco, CA 94111
415-955-1472

Leslie Chan Design Co., Ltd.
9F, 118 Nan King E Road
Section 5
Taipei, Taiwan R.O.C.
02 766-7136

L.A. County Museum of Art
5905 Wilshire Boulevard
Los Angeles, CA 90036
213-857-6140

Marsh, Inc.
34 West Sixth Street
Suite 1100
Cincinnati, OH 45202
513-421-1234

Modern Arts
38 West 39th Street
New York, NY 10018
212-221-6300

Monnens-Addis Design
250 Emery Bay Marketplace
Emeryville, CA 94608
510-652-1331

Morla Design
463 Bryant Street
San Francisco, CA 94107
415-543-6548

Muller + Company
4739 Belleview Avenue
Kansas City, MO 64112
816-474-1983

Museum of Fine Arts Boston
295 Huntington Avenue
Boston, MA 02116
617-267-6008 X634

Nike, Inc.
One Bowerman Drive
Beaverton, OR 97228
503-671-4383

Pacobond
9800 Glen Oaks Blvd.
Sun Valley, CA 91352
818-768-5002

Palazzetti Inc.
515 Madison Avenue
New York, NY 10022
212-832-1199

Penn State University
102 Visual Arts Building
University Park, PA 16802
814-238-7484

Pentagram
212 Fifth Avenue
New York, NY 10010
212-683-7000

Pier 1 Imports
301 Commerce Street
Ft. Worth, TX 76102
817-878-8349

Primo Angeli
590 Folsom
San Francisco, CA 94105
415-974-6100

Qually & Company
2238 East Central Street
Evanston, IL 60201
708-864-6316

Richardson or Richardson
1301 East Bethany Home
Phoenix, AZ 85014
602-266-1301

Dana Riddle
4722 Bengal
Dallas, TX 75235
214-688-0751

S. Posner Sons
950 Laird Avenue
New York, NY 10022
212-486-1360

Samenwerkende Ontwerpers
Merengracht 160
1016 BN Amsterdam
The Netherlands

Sayles Graphic Design
308 Eighth Street
Des Moines, IA 50309
515-243-2922

Shelby Designs & Illustrates
155 Filbert Street
Suite 216
Oakland, CA 94607

Linda DeVito Soltis
137 Barn Hill Road
Woodbury, CT 06798
203-263-4019

Sullivan Perkins
2811 McKinney Avenue
Suite 320
Dallas, TX 75204
214-922-9080

THARP DID IT
50 University Avenue
Suite 21
Los Gatos, CA 95030

Tilka Design
1422 West Lake Street
Suite 314
Minneapolis, MN 55408
612-822-6422

Ultimo, Inc.
41 Union Square West #209
New York, NY 10003
212-645-7858

The Watermark Collection
P.O. Box 958
Beverly Hills, CA 90213
310-277-6111